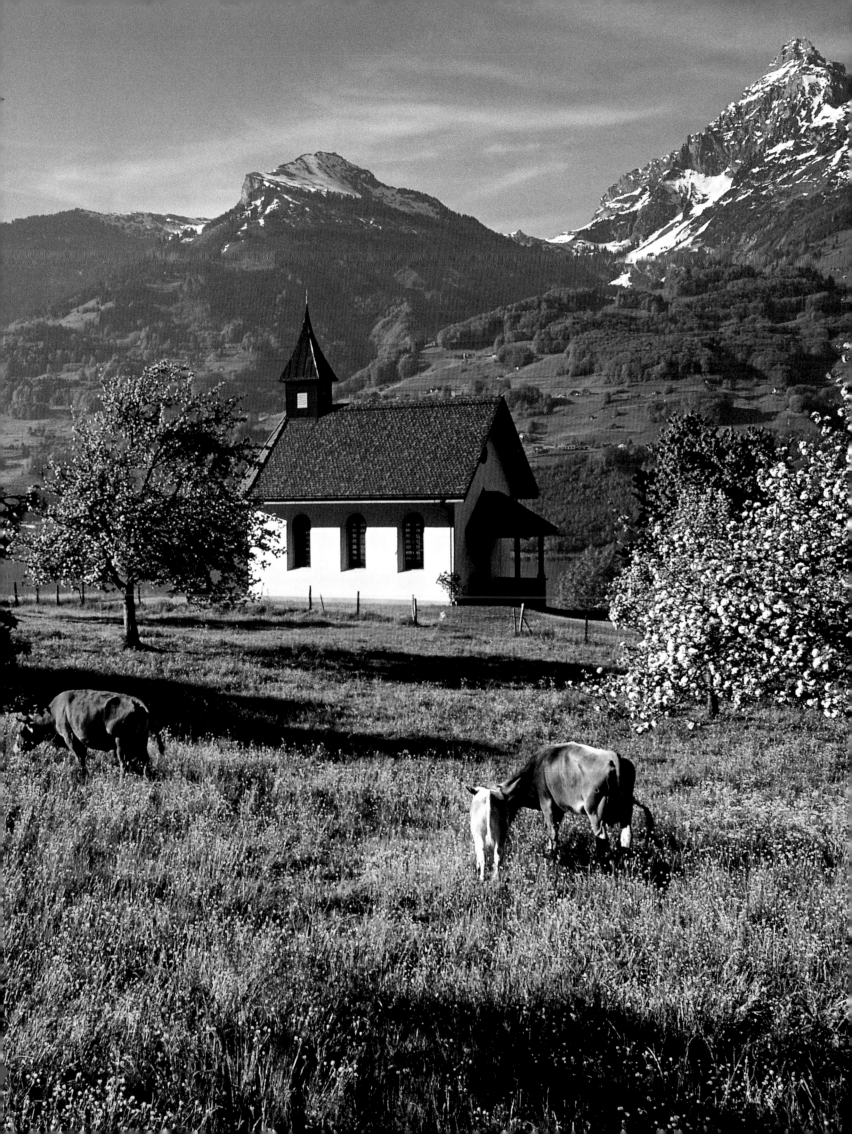

SWITZERLAND

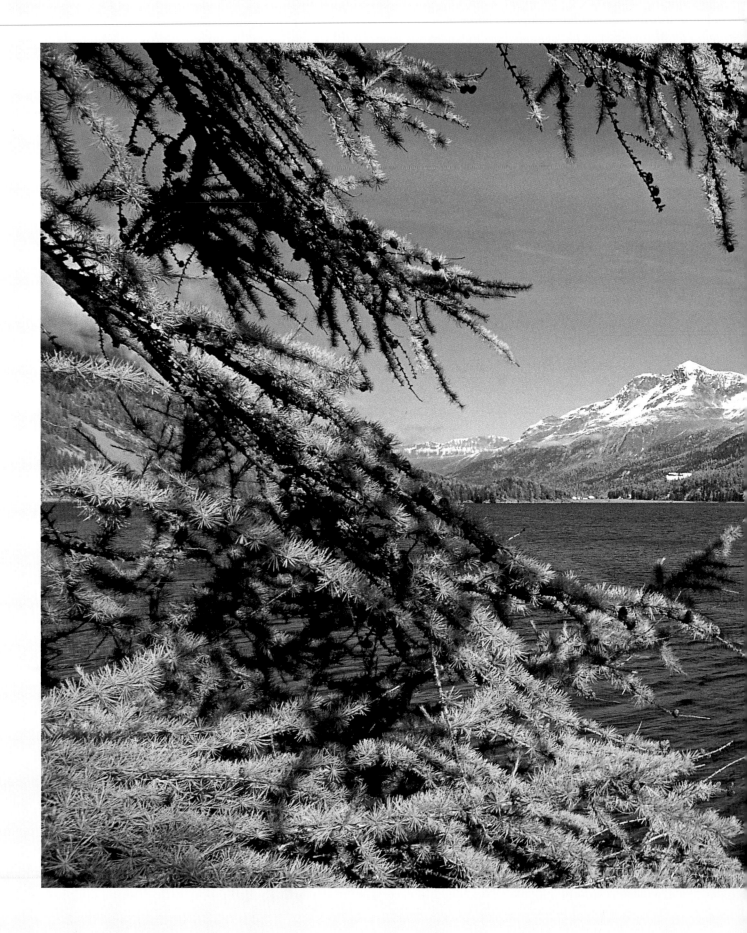

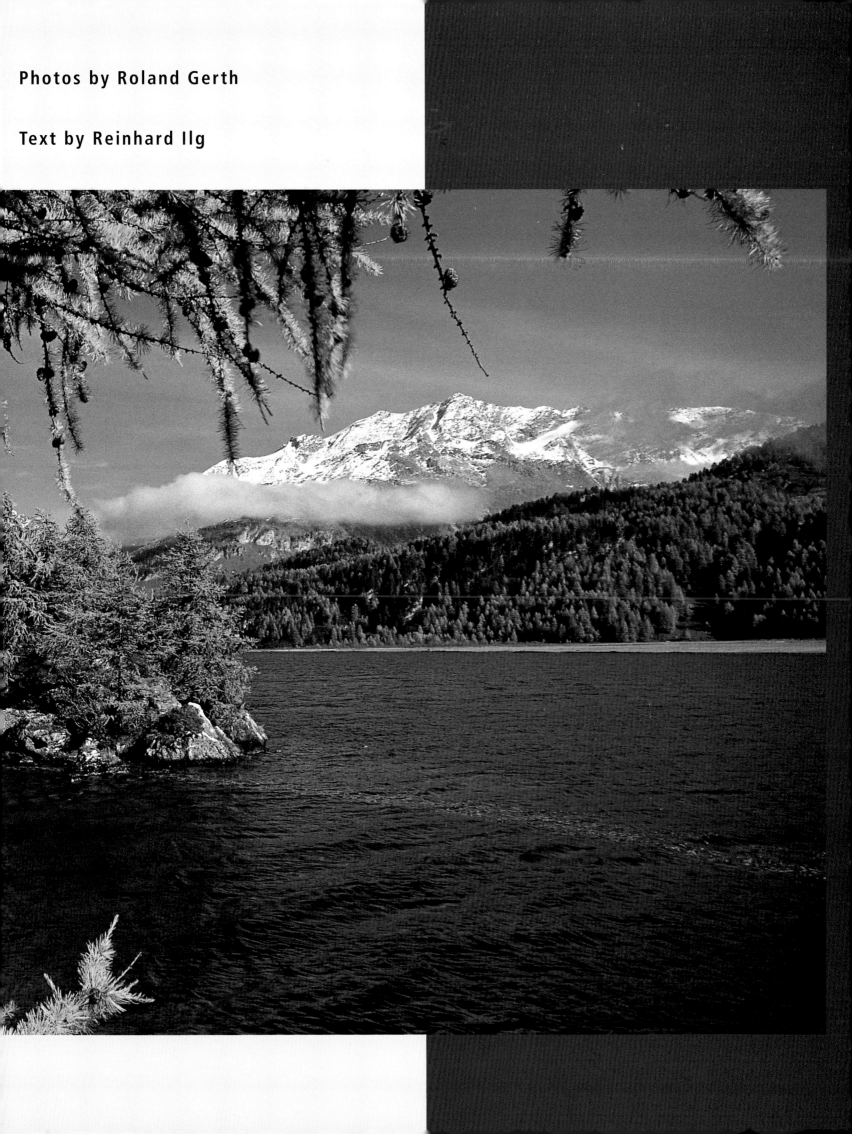

Photos by Roland Gerth

Text by Reinhard Ilg

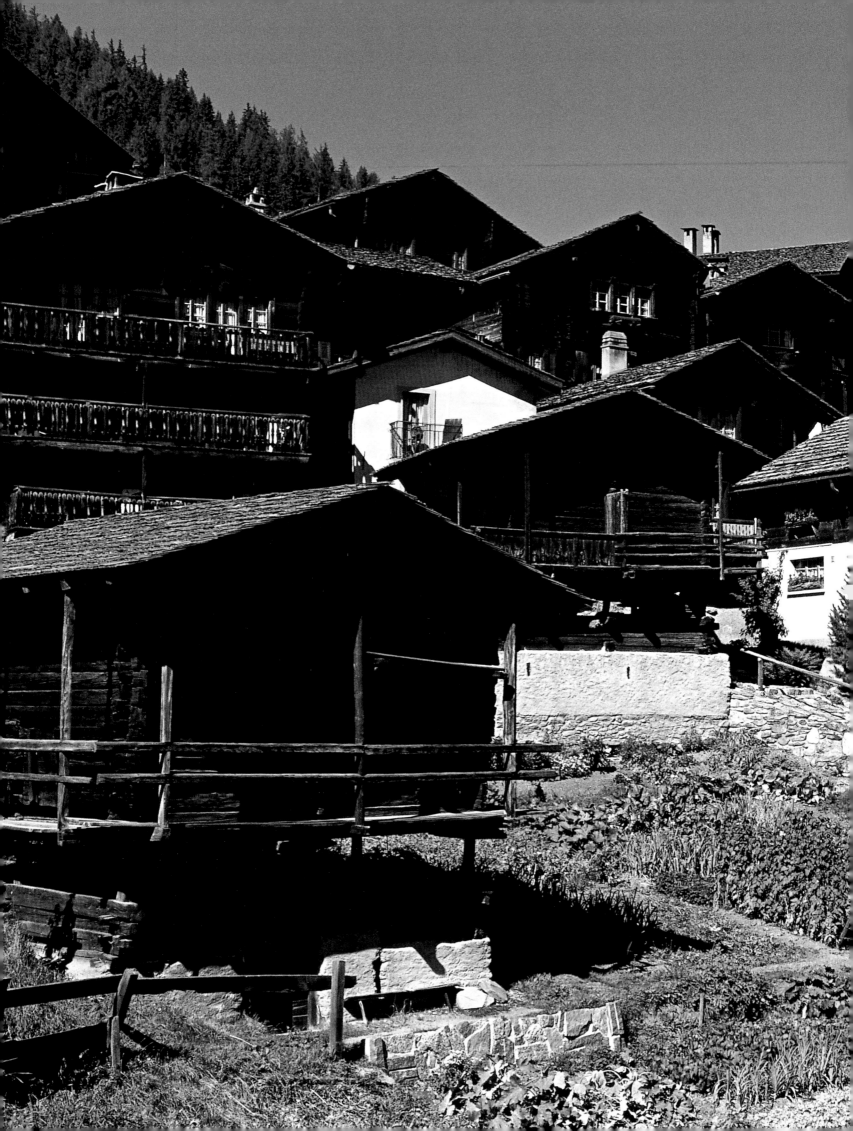

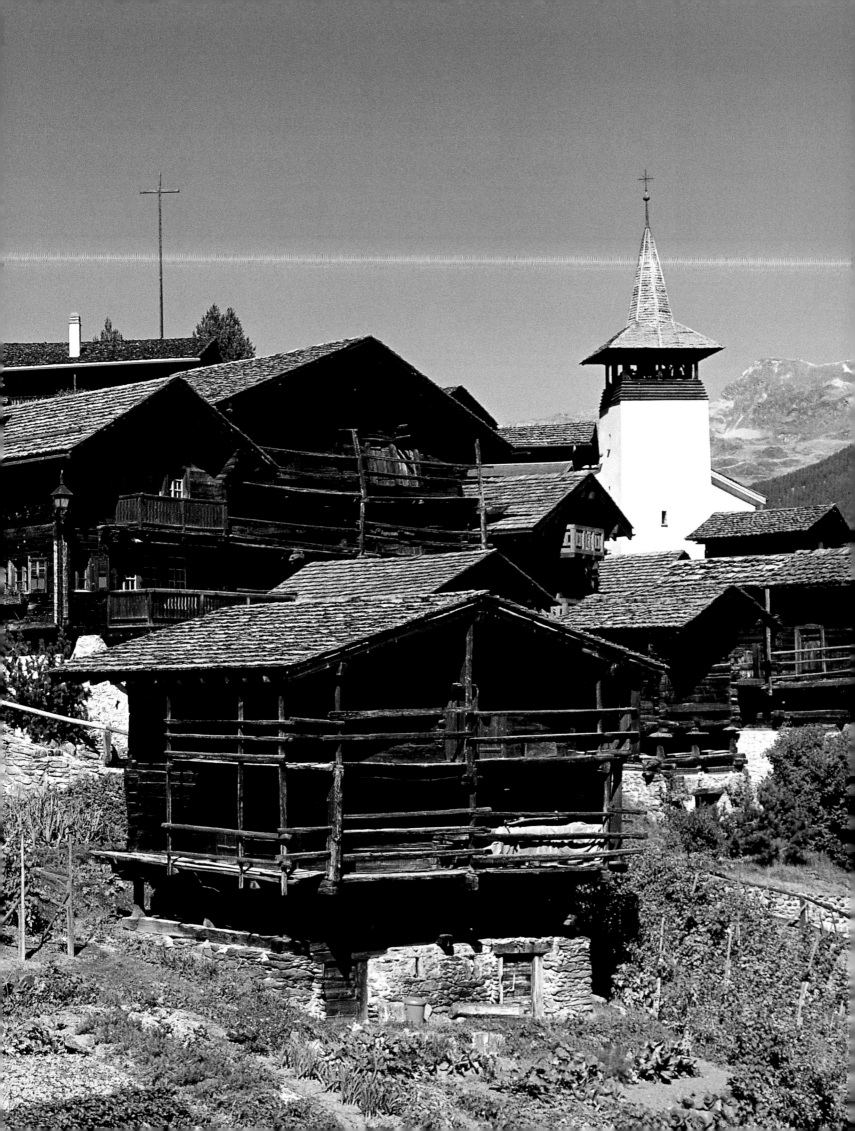

Contents

First page:
Betlis Chapel near
the Walensee in the
canton of St Gallen
provides a contempla-
tive place of refuge
from the noisy traffic
churning through
the valley below.

Page 2/3:
Autumn on the Silser
See or Lej da Segl, to
give it its Romansch
name. Tucked in
between the Maloja
Pass and the quiet
little village of Sils,
from its shores there
are fantastic views
zof the mountains
of the Upper
Engadine. Together
with its neighbour,
the Silvaplaner See,
the lake covers most
of the flat plateau
west of St Moritz.

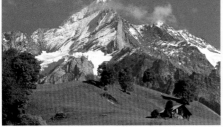

Page 4/5:
At the intersection of
the Val d'Anniviers
and the Val de Moiry
(Valais) the Alpine
village of Grimentz
clings to the slopes
of the mountains
1,570 m (5,151 ft)
up. The hamlet is
famous not only
for its weathered
'tower' houses from
the 16th century but
also for its "Gletscher-
wein" or glacier wine,
made from grapes
harvested from the
clement valley of the
River Rhône.

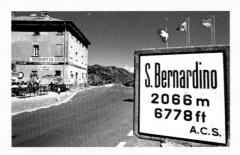

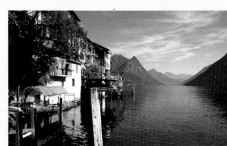

160 DOWN SOUTH: TICINO AND GRAUBÜNDEN

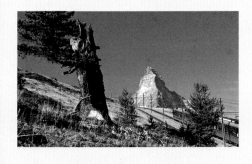

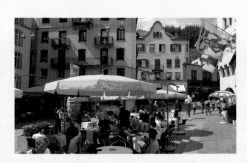

Page 8/9:
The gorge of the Schöllenenschlucht is synonymous with the wildness of the Alps and the dangers of the wilds. It was the first Alpine obstacle many travellers in centuries past had to master in order to be able to continue their passage south. Today the precipitous valley of the Reuss is easier to traverse, with tunnels for trains and cars now blasted through the rock.

Page 10/11:
Near Ronco on Lake Maggiore. The little village southwest of Ancona is one of the many pearls of Ticino. The views from Kirchplatz of the lake are particularly splendid. Writer Erich Maria Remarque, he of "All Quiet on the Western Front", is buried in the cemetery in Ronco.

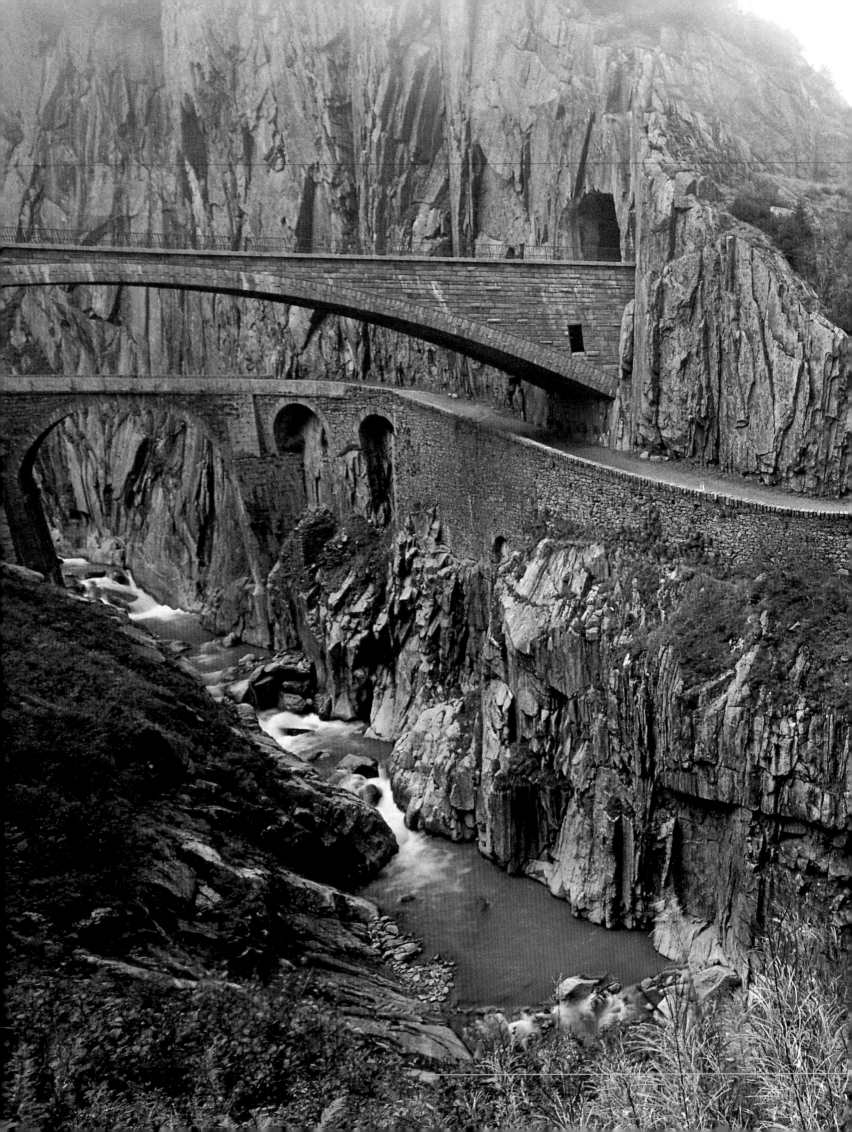

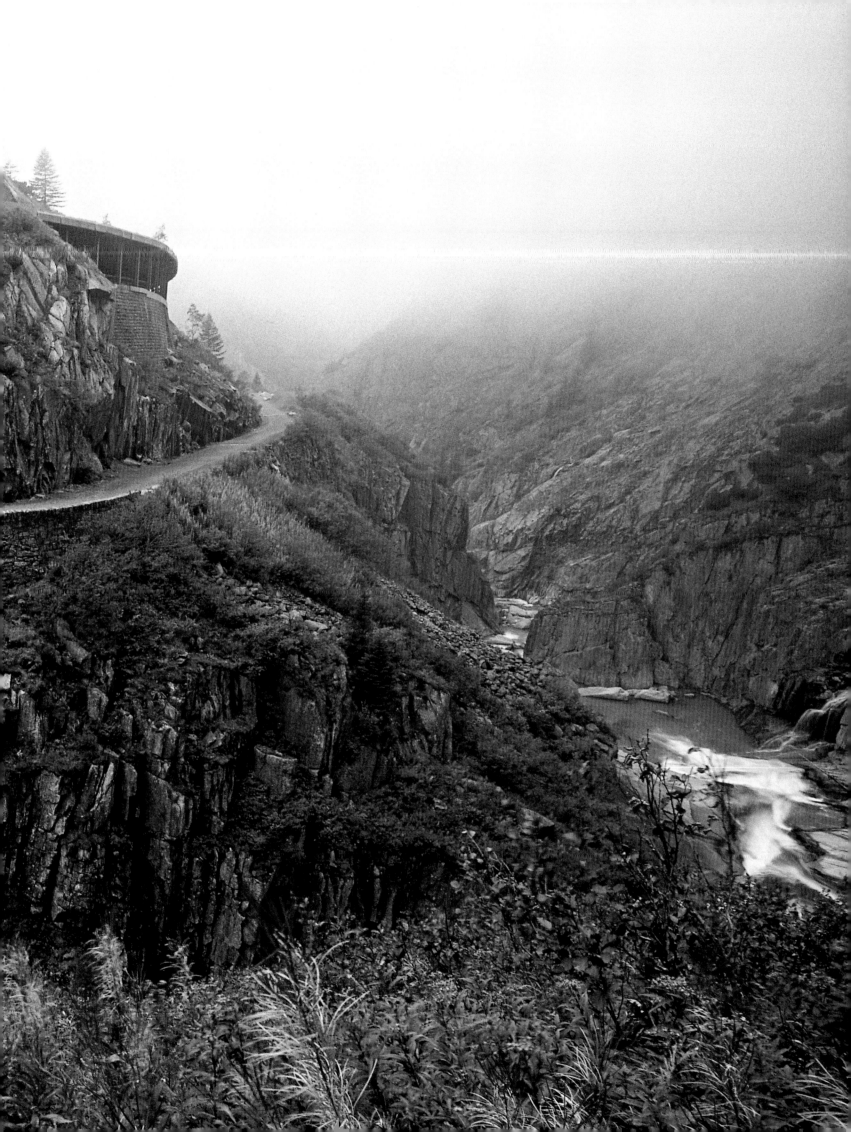

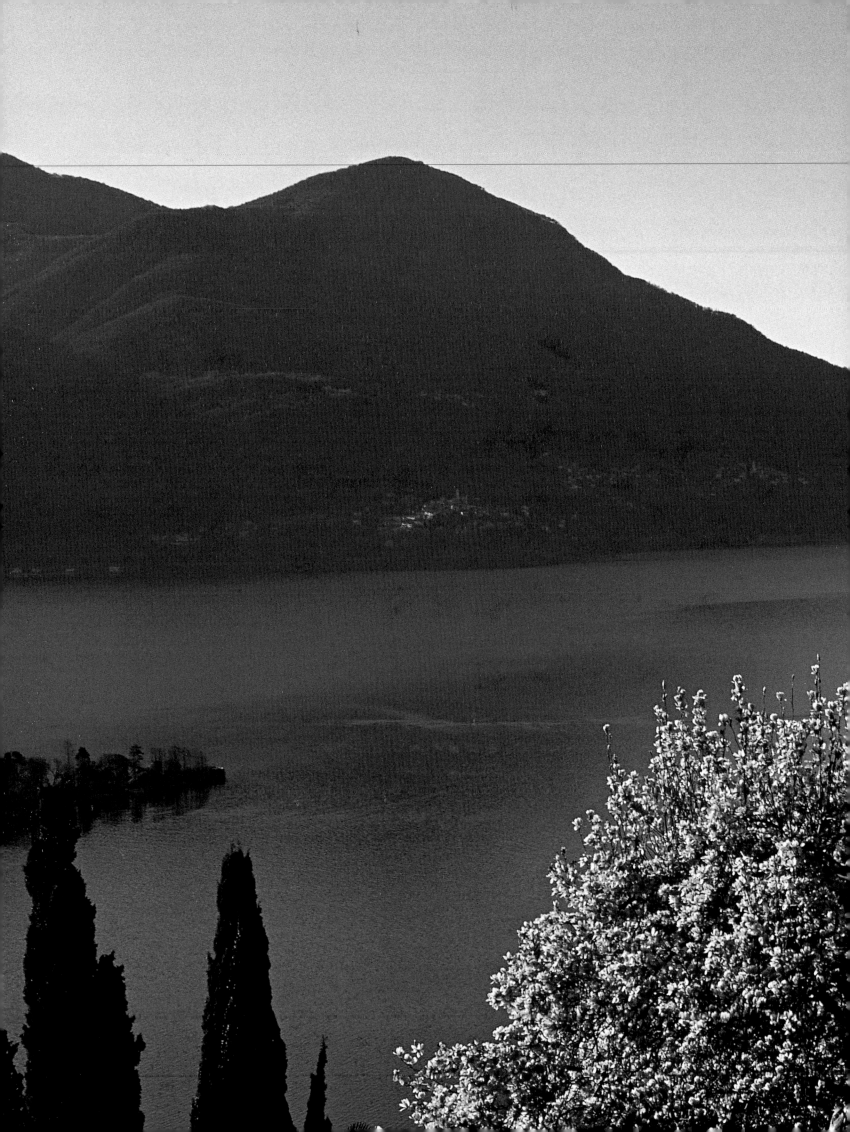

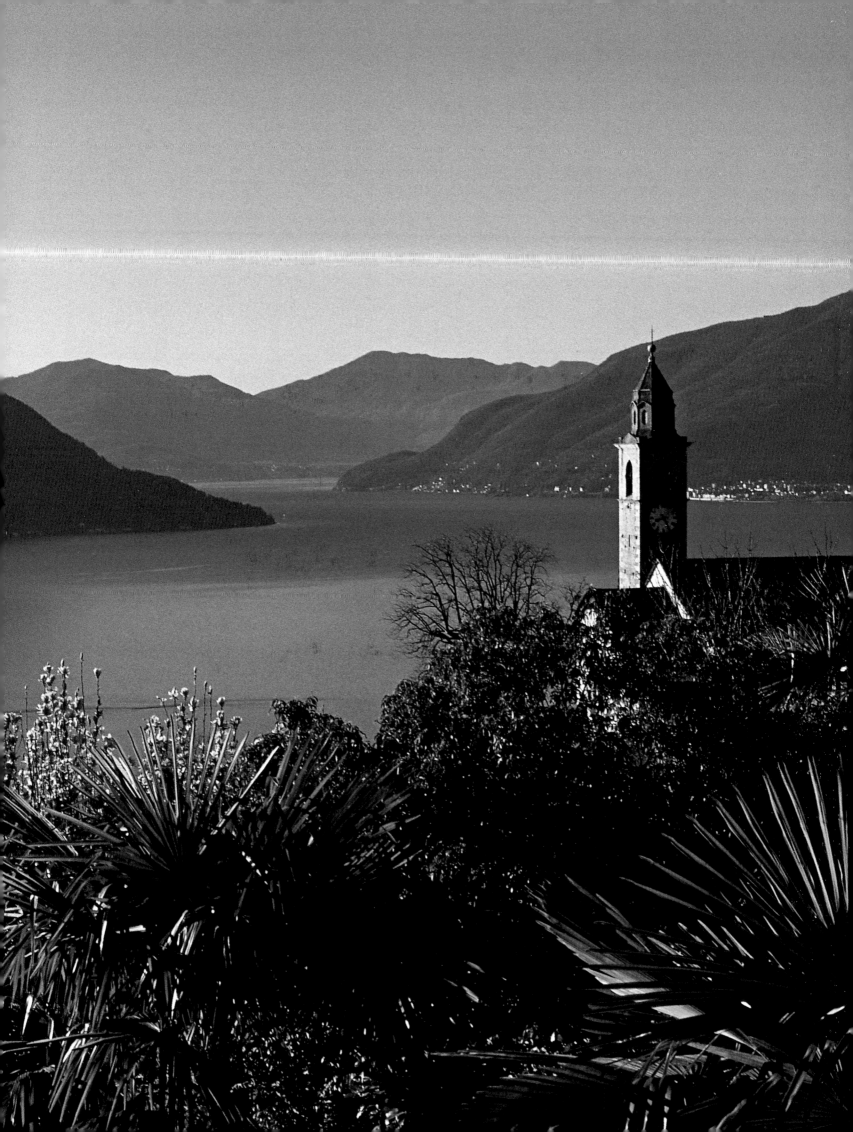

A SMALL COUNTRY.
A SMALL WORLD.

The Alpstein Massif with Mount Säntis glows proudly in the soft hue of the evening sun. The ridge separates the cantons of Appenzell and the parts of St Gallen which border on Lake Constance from the Rhine Valley in the east. From the top of the Säntis and the Hoher Kasten the neighbouring countries of Germany and Austria seem very close.

A SMALL COUNTRY.
A SMALL WORLD.

For most she's the epitome of scenic beauty, for some a hoard for large sums of money, for others simply the last obstacle to the exuberance of the Mediterranean. Switzerland's image may be shaped by clichés yet her soul remains largely hidden. Despite the millions of tourists who have visited over the past 150 years she remains a great unknown in the heart of Europe – possibly due to the fact that she isn't so much a small country as a small world of her own.

How we see size and distance is, of course, totally subjective. In the old days of East Germany, travelling from the Baltic Sea to the elevations of the Erzgebirge along roads full of potholes in an ancient Trabant must have seemed like crossing the wide expanses of the USA. In Switzerland the feeling is similar; here it's the massive chains of mountains, elongated, jagged lakes, narrow valleys and language barriers which make the country seem enormous. In surface area the Confederatio Helvetica is about twice the size of Wales and half the size of the Republic of Ireland – and has just 7.5 million inhabitants. Size isn't everything, however; Switzerland may be tiny but it more than makes up for it with a superlative greatness of international calibre.

At Schaffhausen the River Rhine is about as far from the dulcet tones of the Loreley as you can get. Here the raging torrent crashes down a drop of 23 m (75 ft) in a deafening roar, its furious spray and violent force composing an impressive symphonic interlude on the river's long and varied journey through five different countries of Europe.

One country, four languages, many mentalities

With a bird's eye view the geographical divisions of Switzerland are easy to ascertain. In the far west from Geneva along the French border to Basel runs the mountainous terrain of the Jura. From here to the northeast are the generous plains of the Swiss Mittelland or Central Switzerland; from the northern shores of Lake Geneva past Zürich to Lake Constance is a diagonal stretch of country which provides a fascinatingly faceted counterpoint to the drama of the Alps. The mighty massifs of the Alps dominate the south and east of Switzerland. The fact that these have an almost bewildering diversity despite their relatively focussed geographical categorisation is due to Alpine linguistic and cultural points of reference following a completely different pattern to the rest of the country. Even trying to apply the logic that a mountain ridge can be expected to separate two language groups is thwarted here; in the Valais valley of the Rhône, for example, both French and German are spoken. Studying the linguistic divisions of Switzerland can prove baffling.

Just to set one thing straight before we carry on: *Schwyzerdütsch* or Swiss German is not one language but a collective noun for the over

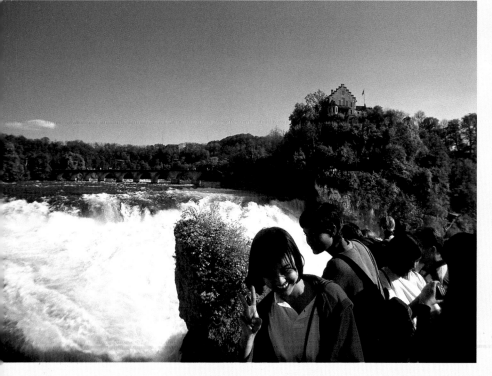

100 different Alemannic dialects spoken throughout the country. Try as hard as they might, Swiss people from Lake Constance will probably have trouble understanding their German-speaking cousins in Valais. Swiss High German, on the other hand, is a variant of High German, clearly distinguishable both in speech and writing from the standard German you might learn at school thanks to a wealth of idiosyncratic grammar and vocabulary.

The German-speaking part of Switzerland starts in the north at the Rhine and Lake Constance, runs east to the Austrian border down to Graubünden or The Grisons, takes in the tip of Valais and continues west with the Bernese Alps. Just a few kilometres west of the capital the great Rösti Divide separates German from French Switzerland. In the outermost reaches of Basel "Guten Tag" is already usurped by "Bonjour". Looking from the Swiss metropolis on the Rhine to the French bit of the country this runs southwest along the foothills of the Jura. At the three large lakes of the Mittelland (Lac de Bienne, Lac de Neuchâtel and Lac de Morat) it turns southeast; even in parts of the canton of Fribourg, in the entire Lake Geneva area and far into the Rhône Valley with its captivating scenery French is spoken.

And as if the bilingualism of the cantons of Valais, Fribourg and Bern wasn't enough, Graubünden in the southeast of the country, for example, is trilingual. In the northernmost reaches Swiss German is spoken; in the Upper Rhine Valley and Engadin you can still hear the now rare Romansch. South of the Bernina Group the Poschiavo area close to the local capital of the same name forms an Italian enclave. With this exception, plus the valleys of Bregaglia, Mesolcina and Calanca, Ticino is the political and geographical home of Switzerland's Italian-speaking population. The clear transition between the Mediterranean lifestyle of the south and the Germanic sentiments of the north of the country is marked by the thousand-year-old mountain passes of St Gotthard and San Bernadino. These classic Alpine routes are well worth abandoning the quicker yet anonymous tunnels for; they describe not only a Swiss but also a European cultural boundary.

The basic principle of freedom

Three little girls from Germany, Austria and Switzerland are talking about where children come from. The German is convinced that the stork brings them. The young Austrian claims it has something to do with men and women. The Swiss girl ponders a moment and then says: "It depends on what canton you're in". And there we have it. The political polynomial which is Switzerland, comprising no less than 26 different cantons, permits regional identities to thrive even within such a small nation. Since the birth of Switzerland the autonomy of the cantons – each has their own constitution, laws and government and, most importantly to ensure a certain degree of independence, the right

No other Alpine glacier seems to bear the signs of climatic change as drastically as that of the Rhône (canton Uri) up above the Furka Pass. Where it once crept silently down into the village of Gletsch, today visitors have to travel up to the highland plateau between the peaks of the Furkahorn and Gärstenhörner to catch a glimpse of the brilliant blue icy masses.

Here on the shores of Lake Maggiore Switzerland goes Mediterranean, with a mild climate which is guaranteed to uplift both body and soul. The lake's favourable location south of the Alps means that the sun shines here more frequently than on the main ridge itself, where rain and snow are more common.

to levy their own taxes – has formed a bracket around the country's cultural divergences. The basic principles of this successful state, which has enjoyed peace and prosperity over hundreds of years, are freedom and an eagerness to volunteer before being forced. In August 1291 envoys from the small countries of Uri, Unterwalden and Schwyz, "from the mountains, the forests and from across the lake", came to the Rütliwiese on Lake Lucerne to swear a common allegiance against the Habsburgs. This oath symbolically marks the founding of the Swiss Confederation; historically speaking it would be more accurate to quote the signing of the inaugural document in the same year. If we take a look at the wording of it, we get a good impression of how Switzerland sees itself:

"In the name of God. Amen. Public standing and wellbeing require that peace has a lasting effect. Thus with regard to the malice of this time all people of the valleys of Uri, all of the valley of Schwyz and the people's community in the lower valley of Unterwalden have, for their better protection and preservation, pledged one another assistance, counsel and support in person and assets with all their might within their valleys and beyond against each and every person who is violent towards them or one of them or does wrong to their person or property. And in any case each community has pledged by oath assistance at their own cost for defence and revenge against malicious attack and injustice by way of renewal of the old Confederation supported by oath, yet in a way in which every individual shall properly serve his lord according to his status. We have also unanimously sworn and stipulated that we in the valleys shall accept no judge who has taken up office through money or monetary value or who is not our inhabitant nor countryman. Should dispute arise among Confederates, then the most reasonable amongst them shall mediate

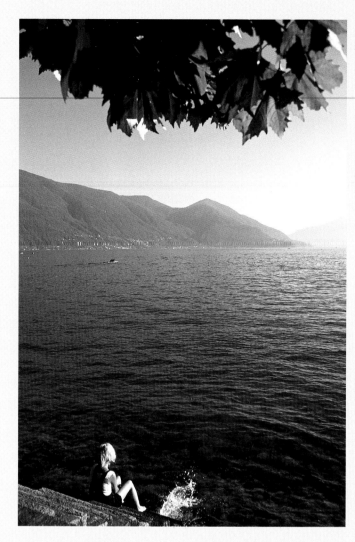

and act against the section who reject the ruling for the others."

Serving the individual

Willingness in place of force, agreement in place of conquest, consensus in place of confrontation: this is the essence of the Swiss state model. One of its most noted exceptions is the last internal armed conflict fought on Swiss soil in November 1847 to which the country owes its present makeup. In a brief scuffle, in which 150 people lost their lives, after forming a special allegiance in 1845 the largely Catholic cantons of Schwyz, Unterwalden, Zug, Lucerne, Uri, Fribourg and Valais were forced by the Confederate army to return to the fold. Following the event Switzerland's alliance of states was turned into a Confederation similar to the

model of the United States of America; representatives of the cantons work in the upper chamber and the delegates of the people in the National Council. Together these form the Swiss Federal Assembly which elects the seven members of the Council of Ministers. The members hereof not only constitute the government and form a collegiate where all have equal rights but together – and here's another Swiss anomaly – also act as the head of state.

Diversity within unity, similarity within diversity: this is what makes Switzerland strong. It's also very evident when you travel the country, whether to the Protestant French shores of Lake Geneva, the romantic Alpine villages of Graubünden, the mighty peaks of the Bernese Oberland or Ticino, Switzerland's very own Mediterranean outpost. People say Switzerland is a "nation of wills" which knows how to balance not only its various uses of language but also its many other marked differences, such as those between the rural and urban cantons, for example, between liberal and conservative regions, between rich and poor. Their singularity gives the people here a certain quality of life – and even if there is a general move towards larger political units, within the massive embrace of Europe Switzerland, often patronised, is a conglomeration which first and foremost serves the individual. If you buy food in Switzerland, for example, you will fill your shopping trolley with mass products of a quality otherwise reserved for top earners. A public transport system which really does offer a viable alternative to the expensive car even in the most remote areas of the country also boosts the overall standard of life. Maybe the Swiss are sometimes a little stubborn and often seem to shut themselves off from the outside world. But don't we love that little Gallic village of rebel Roman-bashers precisely because it refuses to surrender to its suppressers?! OK, so we can get all excited about the opaqueness of Switzerland's money dealings. But then we must also pay our due respects to the liberalism Switzerland owes modern pedagogues such as Piaget and Pestalozzi and writers such as Dürrenmatt, Frisch and Widmer to, who with sharp tongues have stood up for the individual within the whole.

Page 18/19:
In spring, once the snows have melted, the farmers of Appenzell don their glad rags and herd their cattle up to the Schwägalp where plenty of fresh juicy fodder awaits. Over the past few years the event has become something of a festival, pulling the crowds from far and wide.

Page 20/21:
The majestic trilogy of the Bernese Alps (from left to right: Eiger, Mönch and Jungfrau) is best appreciated from the mountains south of the lakes of Thun and Brienz.

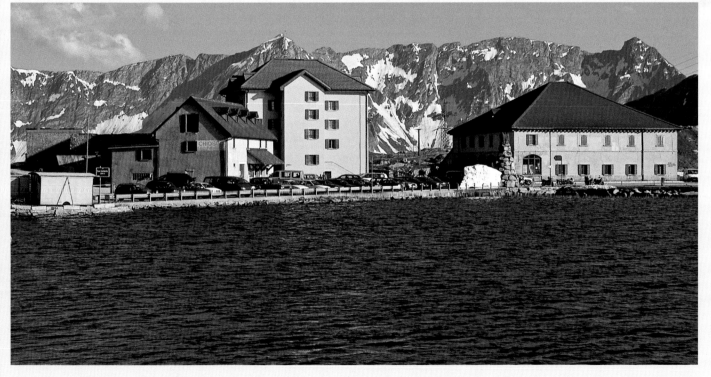

Left:
A cluster of buildings hugs the giddy heights of the Gotthard Pass which separates German Switzerland from its Italian-speaking cousin. The hospice, 2,095 m (6,873 ft) above sea level, has provided travellers with shelter since the 14th century.

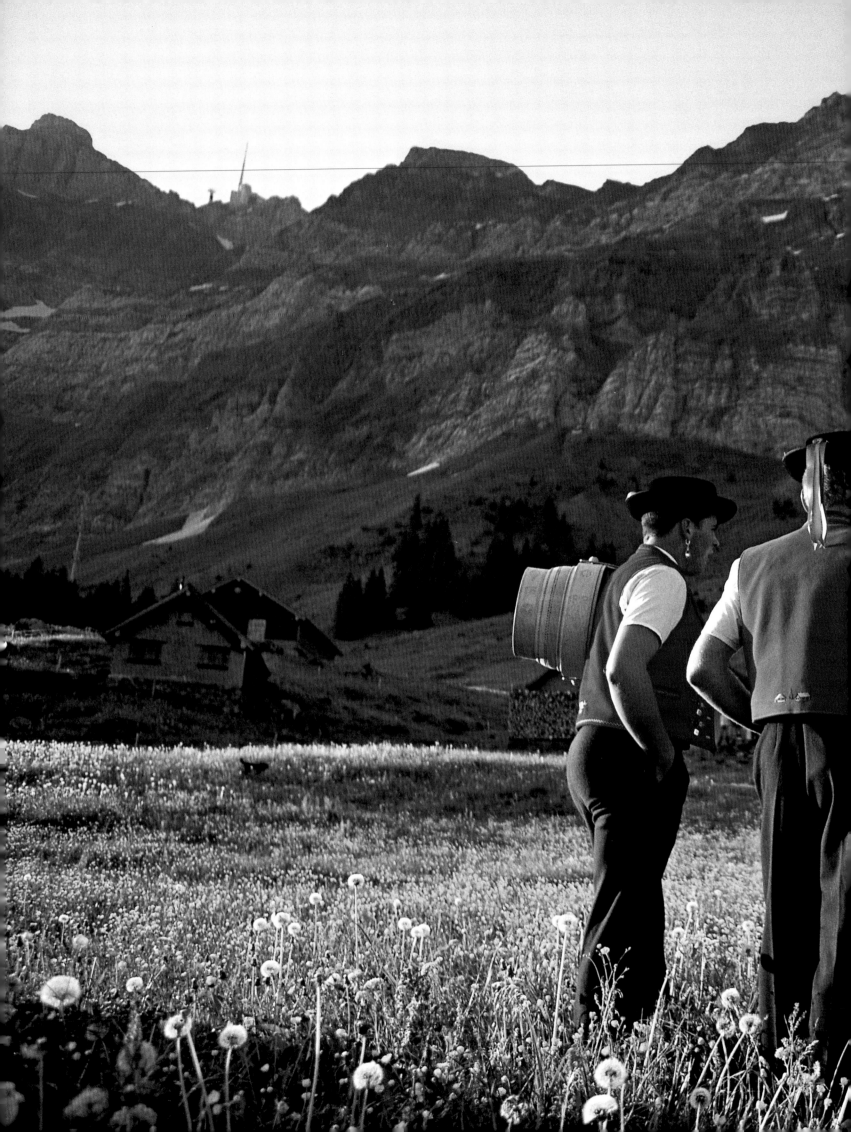

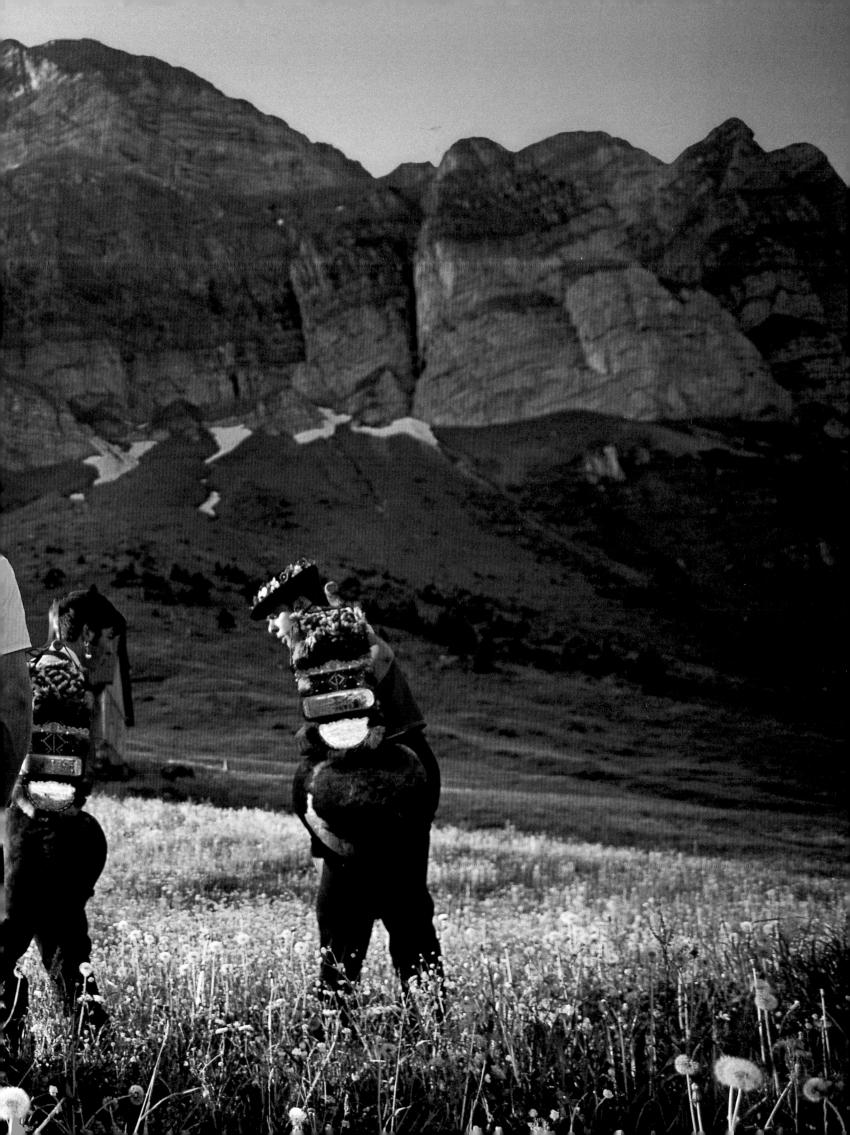

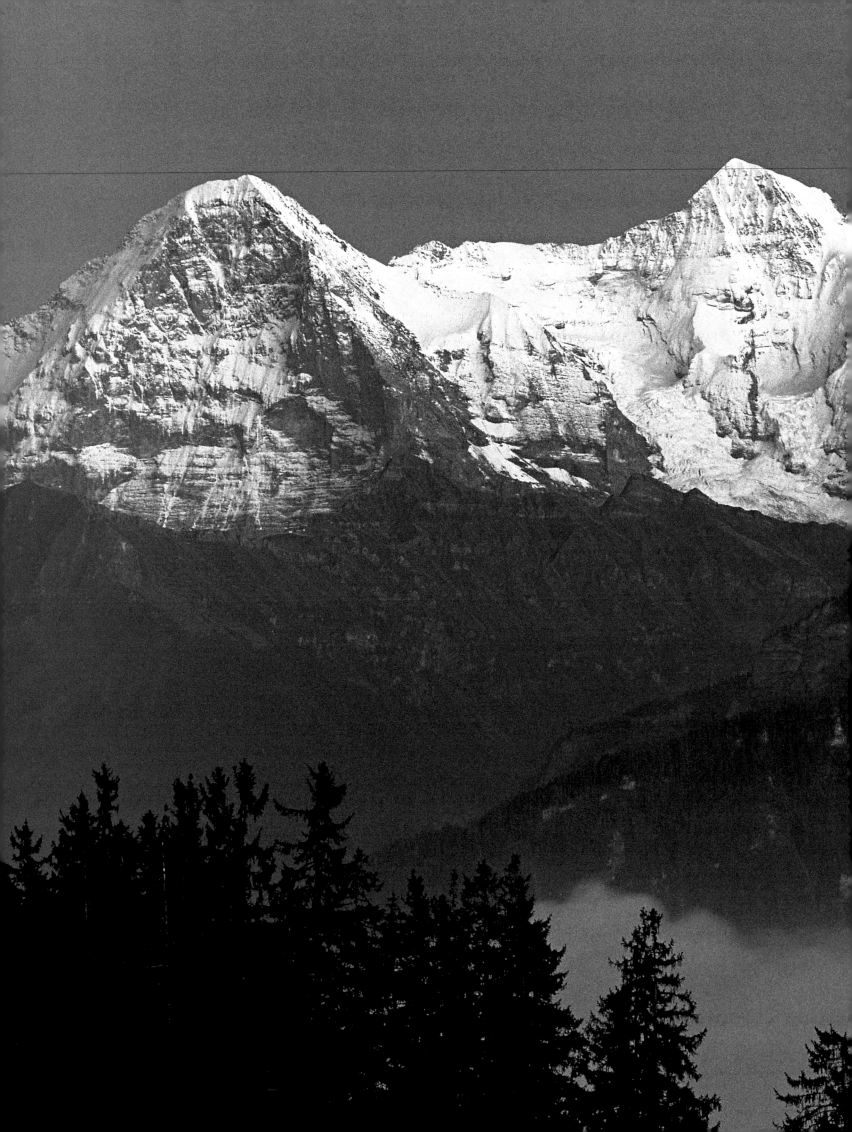

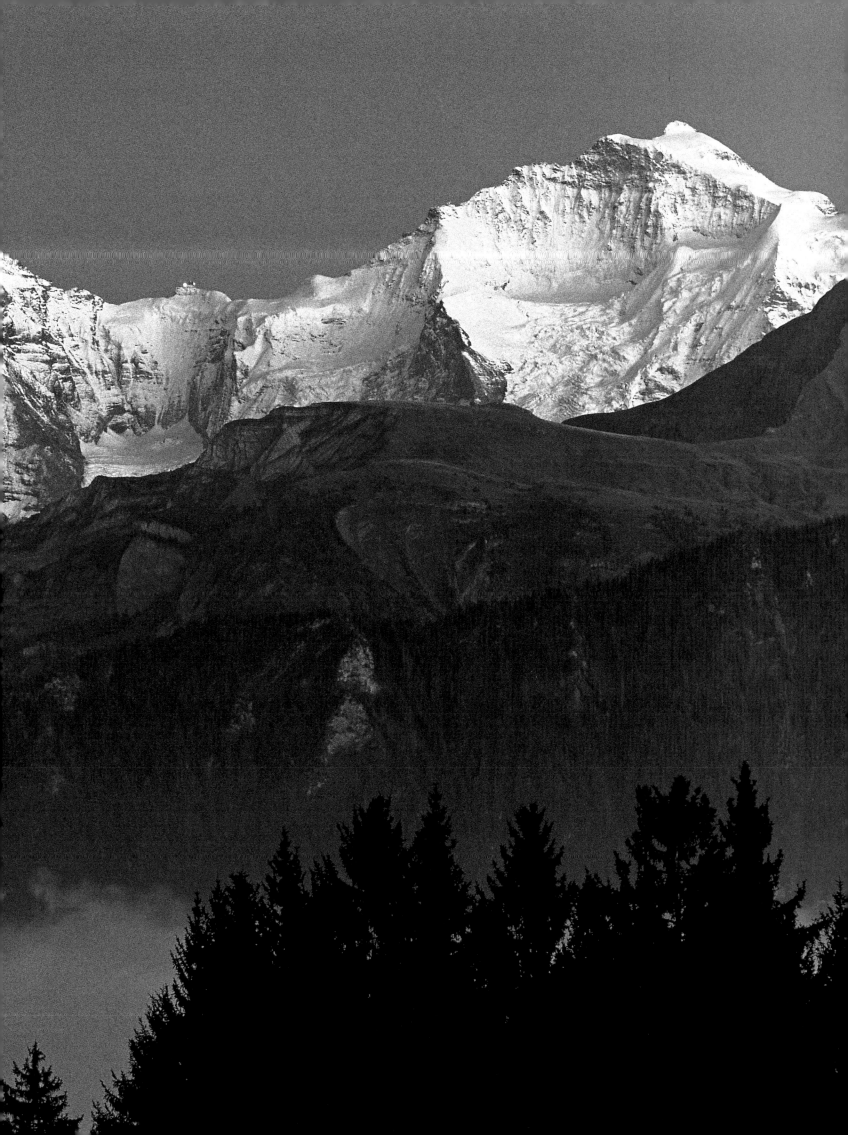

SAVOIR VIVRE
IN FRENCH SWITZERLAND

The heart of French Switzerland beats most passionately on Lac Léman or Lake Geneva, where stylish towns such as Montreux (shown here), Geneva and Lausanne, wide expanses of lush vineyards and historic villages and castles line its sparkling shores.

Savoir vivre
in French Switzerland

Where is Switzerland most Swiss? In the Bernese Oberland, where happy cows safely graze lush pastures beneath snow-capped peaks? In the mountains of Valais, where the Matterhorn marks the map like the national emblem of Switzerland? In the cellars of those infamous Zürich banks? With so much Swissness concentrated on the Lake Lucerne area alone, what indeed remains?

One region remains and a not inconsiderable one at that: the bit of Switzerland that speaks French. In the cantons of Jura, Neuchâtel, Fribourg, Vaud and Valais, all in the west and southwest of the country, the three major geographical elements which make up Switzerland are united: the Jura, the Swiss Mittelland and, of course, the Alps.

Bonjour or Grüezi? The Rösti Divide

The geographical borders may be clear cut; the invisible linguistic boundary between the French and German-speaking parts of the country definitely isn't. To this very day its zigzags outline the division between the ancient settlements of the West Germanic Burgundians and the East Germanic Alemanni. It pays no attention whatsoever to the political administrative partitions of the 21st century, winding its way willy-nilly through the cantons of Bern, Fribourg and Valais. The Swiss, with tongues firmly in cheeks, call it the Rösti Divide. This verbal gulf begins south of Basel near Laufen, tracing the chain of the Jura Mountains before crisscrossing Bienne/Biel, then follows the valley

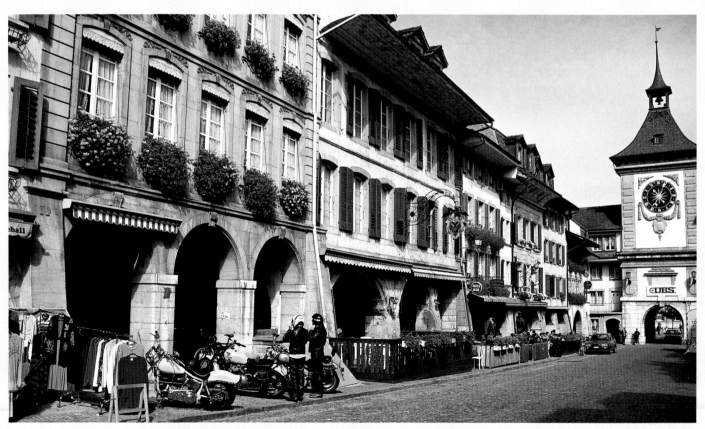

Morat on the lake of the same name in the canton of Fribourg is like Bern in miniature. With its old town from the 15th to 18th centuries, enclosed by a battlemented wall, the former Zähringer stronghold is one of the most beautiful historic legacies of urban Switzerland.

of the Saane/Sarine in the canton of Fribourg before entering Valais between the chic tourist resorts of Gstaad and Montreux. Between French-speaking Sion and German-speaking Brig it takes a sharp turn south and comes to a halt at the Italian border in the middle of the Alps.

Yet the Rösti Divide is more than just a semantic perimeter: It marks a distinctive difference between the mentalities of the *Suisse romande* and the German-speaking majority of the country. In matters of foreign policy French Switzerland shows itself much more pro-European and less isolationist than its German cousins. It's thus hardly surprising that the small city of Geneva, which provided French reformer Jean Calvin with a place of refuge, is now the seat of numerous international institutions of renown, among them the United Nations and the International Red Cross.

along its main street create an historic yet homely atmosphere. It seems incredible that such beauty was once the scene of terrible battle, when in 1476 the Confederates gave the troops of Charles the Bold such a thrashing that the water of the lake turned red with blood.

Neuchâtel, the capital of the canton of the same name, is even nobler with its countless aristocratic palaces and patrician dwellings. Here it's the yellow sandstone of the buildings which creates a sense of warmth, enveloping the town in a golden glow. Neuchâtel is also a lively university town, its young populace infusing it with a joyous and decidedly French *savoir vivre*. The produce of the lake shores is merrily imbibed at the town's many bistros and restaurants – and indeed elsewhere in Switzerland; Chasselat and Pinot noir grapes make some of the best wines in the country.

The charm of Switzerland: the lakes

It's the lakes which give French Switzerland much of its charm. Blossoming orchards, fields of succulent vegetables and undulating vineyards smother the shores of the extensive Seenland or lake district in the west, where Lake Bienne, Lake Neuchâtel and Lake Morat line up in neat Swiss fashion, linked to one another by a network of canals. The yield of local produce is almost Mediterranean in scale. The rural landscape is punctuated by the sizeable elevation of Mount Vully, from whose highest point there are marvellous views of the lakes and the nearby Jura in the west, with the entire chain of the Bernese and Fribourg Alps visible to the east on a clear day.

The warmth this part of Switzerland effuses is also tangible in its towns and cities. Bilingual Morat/Murten is tantamount to a giant open-air museum; its intact town walls, complete with battlements, towers and gates, and the arcades

Unforgettably glorious: Lake Geneva

The beauty of Lake Geneva is legendary; even in Switzerland, which is by no means short of impressive attractions, Lac Léman is particularly rich in feasts for the eye, nose and palette.

Time seems to have stood still in St-Ursanne. France is palpably close in the medieval streets on the Doubs, centred around the splendid Romanesque abbey.

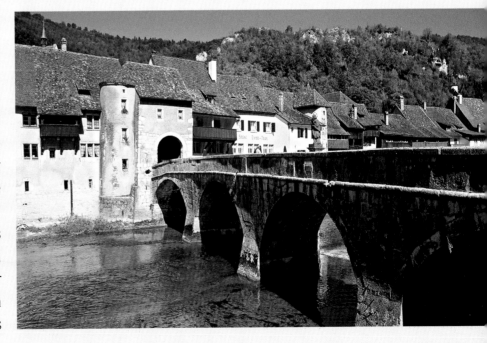

It attracts a noble and worldly clientele – and brings a pained smile to the faces of the locals when it's referred to by its German designation of "Genfer See". Tucked in between the Jura in the west, the Vaud Alps in the north and the French Savoy Alps in the south, the lake curves from east to west like a giant scythe, 72 kilometres (45 miles) long and up to 14 kilometres (9 miles) wide. Its great depth makes it the largest (or perhaps fullest) inland lake in Europe, its fascinating blue derived from the clear mountain waters of the Rhône which enters the lake south of Montreux from Valais and exits through the middle of Geneva on its journey to the Mediterranean with speed and spirit. About 60% of the lake is on Swiss soil, with the rest part of France. If you travel the northern shores, you will pass through one picturesque wine village after another, interspersed by elegant tourist strongholds which smack vibrantly of the Belle Époque. One such venue is Montreux, whose sub-tropical vegetation along the

lakeside promenade and yearly jazz festival are as famous as its Château Chillon, the most visited historic site in Switzerland whose moated fortifications afford fantastic vistas of the glittering lake. To the west the delightful old town of Vevey peters out into the luscious vineyards of the Lavaux. Lausanne, famous as the seat of the International Olympic Committee, is unforgettably glorious, with its ancient town perched high up on the steep slopes of the lake shore. The castles in the peaceful little towns of Morges and Rolle are visible for miles from the lake. The medieval flair of Nyon marks the transition from the Grand Lac to the Petit Lac, where ever grander country houses, villas and lakeside promenades tastefully pave the way to Geneva.

Between vines and glaciers: Valais

It rises near the Rhône Glacier at Dammastock and flows into the eastern end of Lake Geneva, separating the southern face of the Bernese Alps from the Alps of Valais along an enormous valley some three kilometres wide: the River Rhône, the main artery of German-speaking Oberwallis or Upper Valais and the French Bas-Valais or Lower Valais. As if wine and culture were the privilege of the French, the western reaches of Valais, which hit the linguistic boundary at Leuk/Loèche, is one exuberant garden, where fruit, vegetables and vines positively thrive. The little towns of Sierre and Sion embellish this agricultural paradise with an architectural and cultural history which is no less lush and manifold.

With around 600 millimetres of rain and snow and over 2,000 hours of sunshine a year the Rhône Valley, embedded amongst great rocky massifs, has a steppe climate, allowing vines to survive up to heights of 1,150 metres (3,770 feet) and giving Switzerland the highest vineyards in Europe. Approximately 40 percent of Switzer-

The highest-lying Arolla pine forest in Europe is at the south end of the Aletsch Glacier in the canton of Valais. Some of the Swiss pines which grow here are over a thousand years old.

land's wine comes from Valais, where Chasselat or Gutedel, Pinot noir and Sylvaner and also many local grapes (including Himbertscha, Ermitage and Amigne) are bottled.

The gentle scenery of the Rhône Valley changes dramatically when you enter one of the many narrow side valleys which take you up to the giddy crags of the mountains. These culminate in some of the most famous winter sports resorts in the Alps; Zermatt and Saas Fee, Crans-Montana and Verbier are household names for skiers and mountaineers alike. The magnificent backdrop of the Valais Alps is formed by over 30 mountains over 4,000 metres (13,000 feet) high , among them the legendary Matterhorn (4,478 metres/14,692 feet) and the Dufourspitze (4,634 metres/15,204 feet) on Monte Rosa, the highest peak in Switzerland. The lofty Bettmeralp and Riederalp, with their barns and houses browned by lashings of tar and sunshine, provide a fascinating bird's-eye view of life in the Rhône Valley. Tucked away at the back of the Aletsch Glacier, the attraction of these two particular Alps is heightened by the fact that they are only accessible by cable car...

Rugged natural beauty in the "poorhouse of Helvetica": the Jura

Peace and solitude in the midst of a rugged landscape of limestone peaks, wide plateaux, steep valleys and enchanted lakes: these are the trademarks of the canton of Jura, untypical of the orderly chocolate-box images Switzerland usually conjures up. The Jura hugs the French border from Geneva almost to the Rhine and has fantastic views of the Swiss Alps from its highest elevations. Political, cultural and tourist interest in Switzerland has more or less bypassed this part of the country – and has thus made it something of an unknown entity within the Confederation. However, the exception makes the rule; it is here, on the edge of the can-

tons of Jura and Neuchâtel, or "the poorhouse of Helvetica", as it was sometimes called, that the heart of the Swiss clockmaking and precision mechanics industry beats the strongest.

The largely unfertile land, winter temperatures of up to –40 °C and a weak infrastructure forced people to work at home for the Geneva clockmaking industry from the 17th century onwards. The small town of La Chaux-de-Fonds and neighbouring Le Locle are places of pilgrimage for clock and watch collectors from all over the world – provided they have healthy (Swiss?!) bank accounts. The history of the recording of time since the Egyptians is now the focus of the international clock museum in La Chaux-de-Fonds, the quality and quantity of whose exhibits is absolutely unique.

Over the past few years the isolation and expansiveness of the Jura Mountains, split into the jagged precipices of the Folded Jura, the Swiss Plateau and in the north the Tabular Jura, has increasingly fuelled the interest of hikers and cyclists. One of the most impressive natural spectacles of the Jura is the Creux du Van. The semicircular corrie, up to 500 metres (1,640 feet) deep, is breathtaking; the Areuse spring north of St-Sulpice and the gorge of the same river are no less so.

Over 30 mountains over 4,000 m (13,000 ft) high make up the Valais Alps, one of them being Monte Rosa. At exactly 4,634 m (15,204 ft) its Dufourspitze is the highest mountain in Switzerland. Beyond it lies Italy.

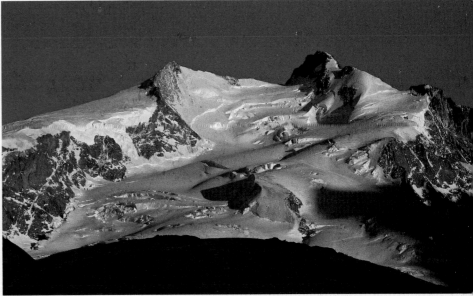

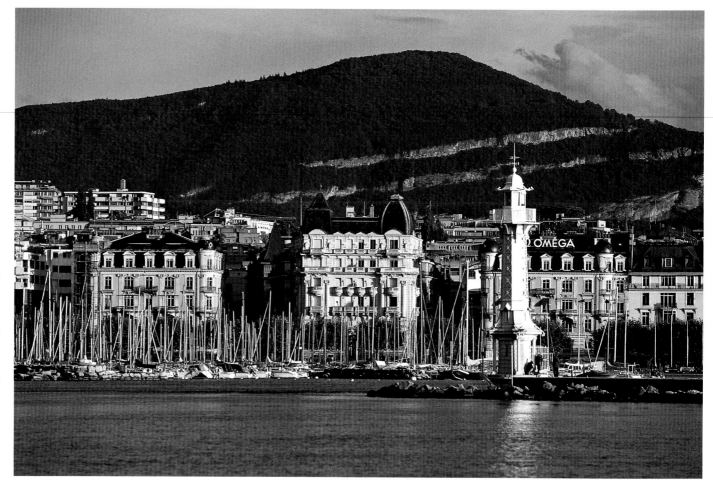

Entrance to Geneva harbour. The international metropolis in the French-speaking part of Switzerland forms a perfect union with the lake which stretches out from here in a generous arc 74 km (46 miles) long. The boats moored here regularly skipper holidaymakers across the glittering waters.

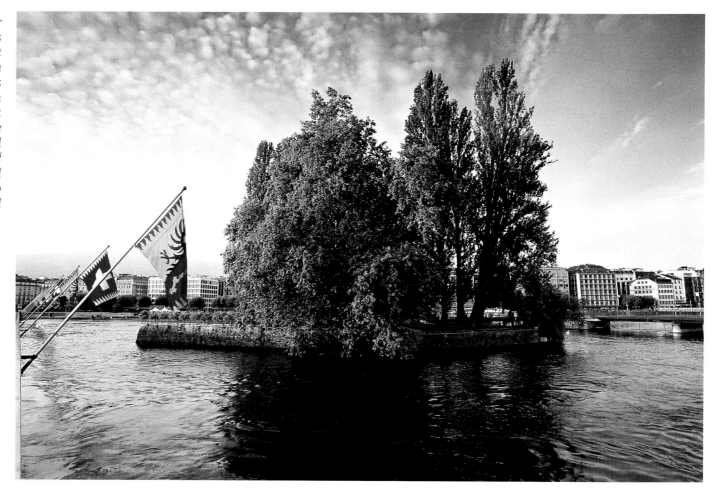

Swiss philosopher Jean-Jacques Rousseau couldn't have wished for a finer place for his memorial: on an island in the heart of the city, where the thoughtful blue expanses of Lake Geneva spill energetically into the narrow channel of the River Rhône.

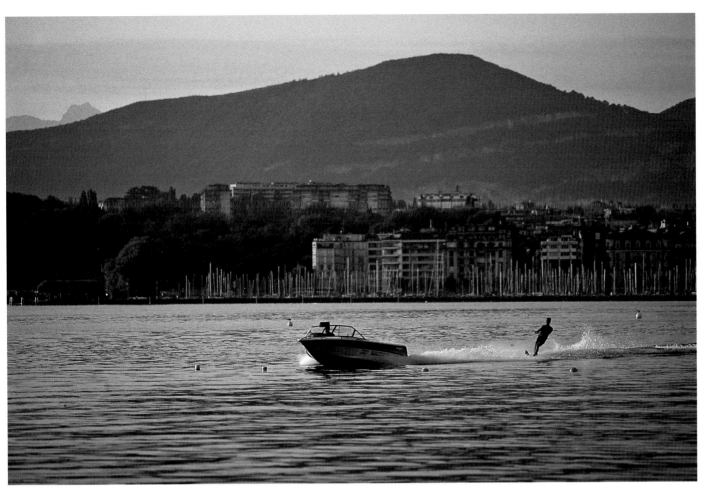

No-one will dispute
that Lake Geneva
is a playground of
the rich and famous;
here, one doesn't
traverse the lake on
a pedalo, one water
skis! Nevertheless,
despite its airs and
graces the Swiss-
French lake has
plenty for everyone,
whatever the size of
their wallet...

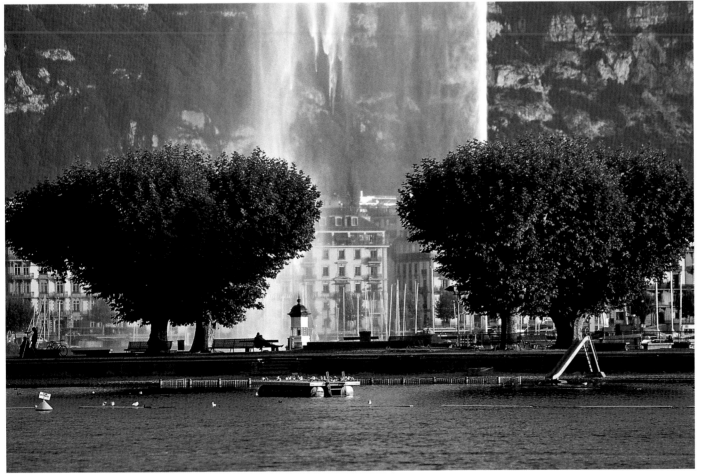

Geneva's impressive
landmark is without
doubt the Jet d'eau
fountain which spurts
seven metric tons of
water 140 m (460 ft)
up into the air.
Depending on the
wind direction the
spray can travel as
far as the city centre!

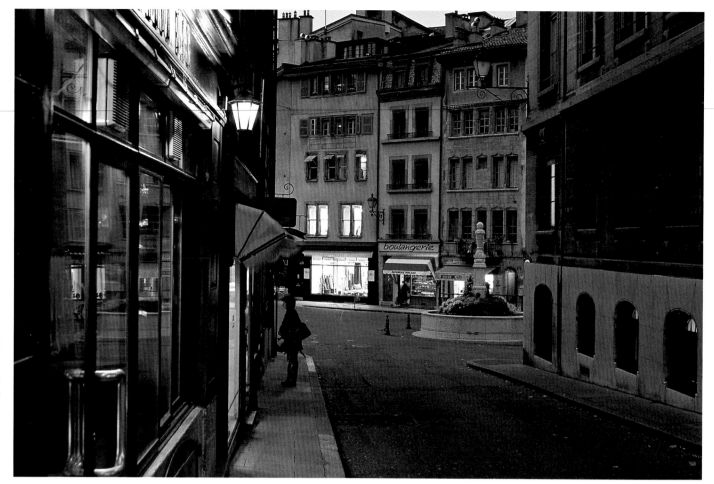

In the evening and at night Old Geneva is suffused with a warm, friendly light. It seems hard to imagine that this romantic setting is the domain of the international world of diplomacy and politics. Maybe it's this which makes Geneva so appealing to its 178,000 residents.

Chic boutiques and fancy restaurants jostle for space on the narrow streets of Geneva's old town. Fast-food outlets and chain stores are visibly absent from the mercantile ensemble.

Right page: The highest point of Old Geneva is marked by the cathedral or Temple de Saint-Pierre. The church is probably the most interesting historic building in the city which despite – or perhaps because of – its Calvinist austerity has a fantastic atmosphere

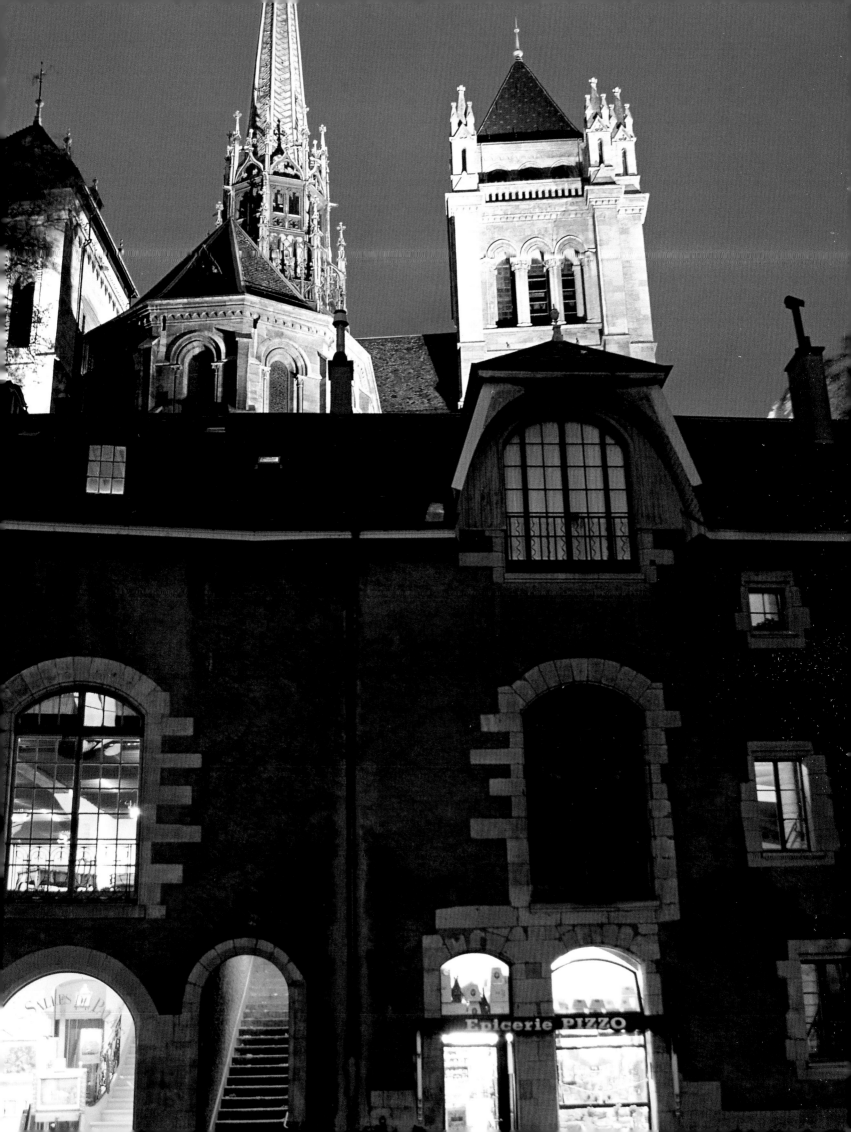

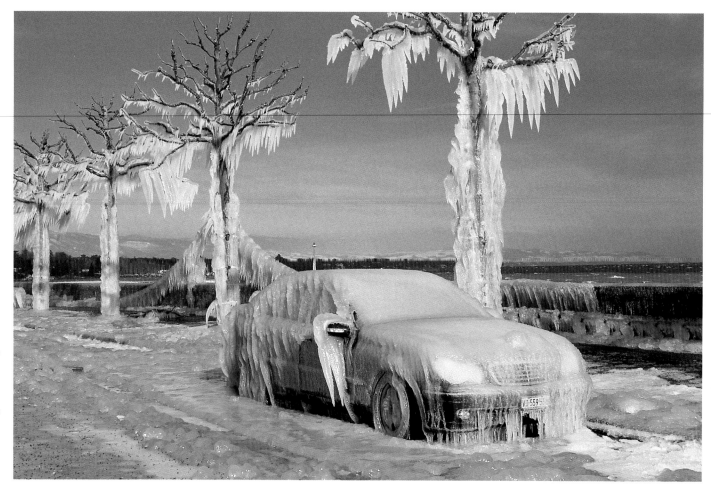

The drama of winter on Lake Geneva. Snow and ice storms have turned the lakeside promenade of Versoix into a frosty work of art. The mild summer winds seem light years away now.

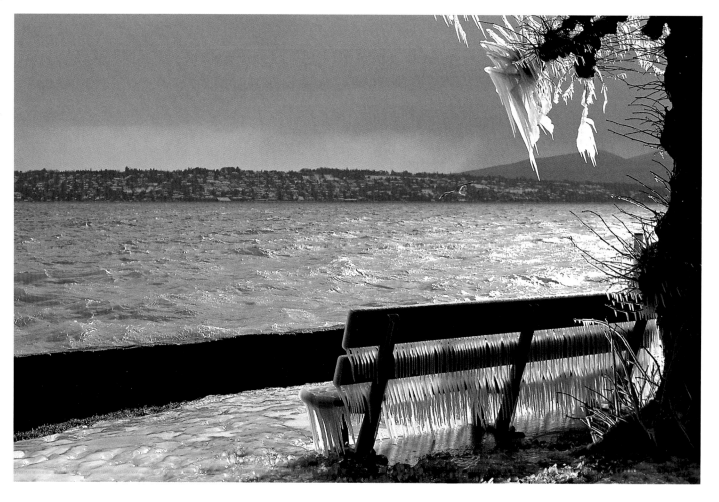

In the cold months of the year you can almost feel that Lake Geneva is fed by the glacial waters of the Rhône. The turquoise grey of the water mirrors the icy hues of the hibernal sky.

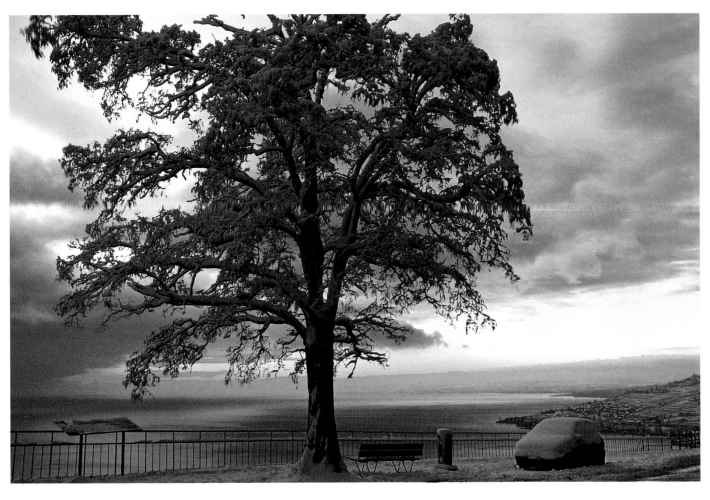

Near Epesses on the northeastern shores of Lake Geneva. Looking towards Geneva the lake seems to grow incredibly wide, providing a dramatic counterpoint to the narrow ridges and jagged summits of the Alps.

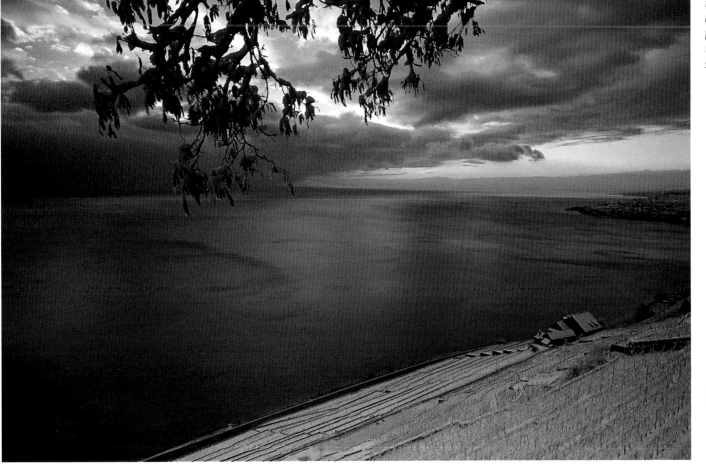

Page 34/35: Offshore from the little town of Rolle on Lake Geneva is the Ile de la Harpe. An obelisk on the island records the services of one General de la Harpe from Rolle, who in 1798 was partly responsible for Vaud gaining independence from Bern.

One of the most magnificent of the many castles on Lake Geneva is Morges, founded by the house of Savoy in 1286. It now houses the Vaud military museum which features a multitude of historic weapons and a huge collection of tin soldiers.

Right:
The 13th-century castle of Rolle dominates the lake front, its towers bathed in the soft light of the morning sun.

Far right:
For over 250 years, from 1536 to 1798, the castle at Nyon was the seat of the landvogts of Bern. The mighty fortress overlooks the medieval town which was once the Roman fort of Noviodonum governed by none other than Julius Caesar.

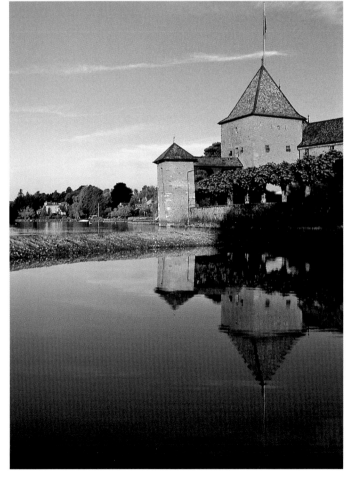

The northern shores of Lake Geneva are lined with castles, with Vufflens perhaps one of the more idiosyncratic examples. The impressive edifice, modelled on the castles of Piedmont, was constructed between 1395 and 1430 and is now under private ownership.

Just a few steps away from the hectic bustle of our 21st-century lives Castle Rolle seems to recapture some of the quiet of days gone by. The calm waters of Lake Geneva only heighten its sense of history and serenity.

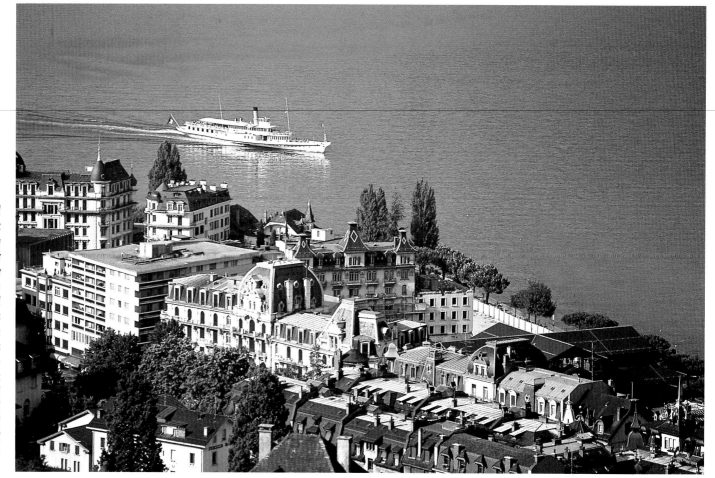

The location and climate of Montreux are absolutely unique – even for the superlative Lake Geneva. The jewel in the crown of the Vaud riviera, Montreux's history as a top-notch tourist hotspot dates back to the 19th century. Numerous villas, well-tended lakeside parks and a lovingly restored paddle steamer all add to the flair of this delightful little town.

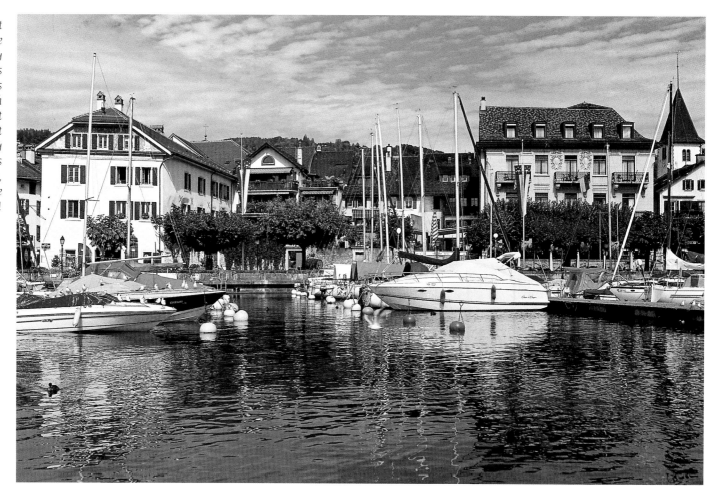

One of the most relaxing ways to see Lake Geneva is by boat. Many of its towns and villages have a marina, such as the one here at Lutry. Sailing is not always a leisurely affair, however; winds can suddenly change, calling for expertise and strong nerves!

The depths of Lake
Geneva are filled with
pike, perch and trout.
The humble char is
also resident here.

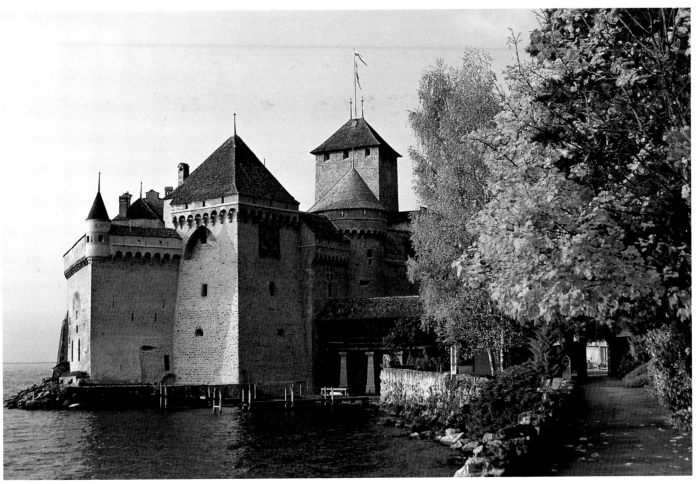

It's the most
frequently visited
historic building in
Switzerland and was
the epitome of the
Swiss castle for the
writers and artists of
the Romantic period:
Château de Chillon.
At the time of
its founding in the
10th century it
was anything but
romantic, its
dungeons full of
political rebels
incarcerated in the
most appalling
conditions.

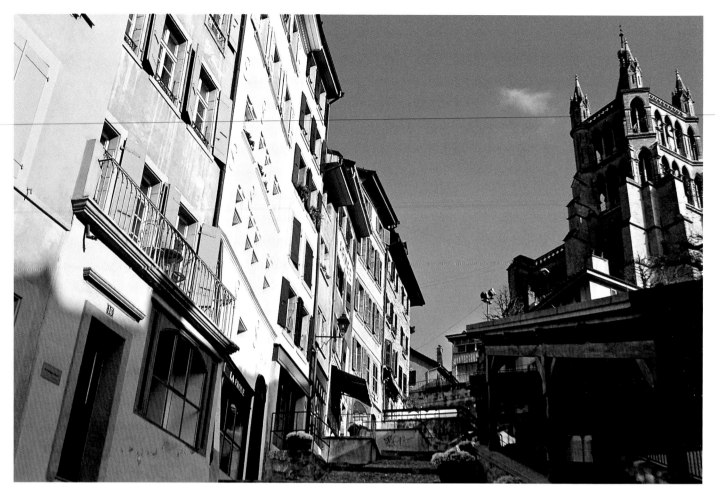

High up above Old Lausanne stands the early Gothic cathedral of Notre-Dame, accessed via flights of steep steps and narrow streets. Consecrated by Pope Gregory X in 1275, the church turned Protestant during the Reformation.

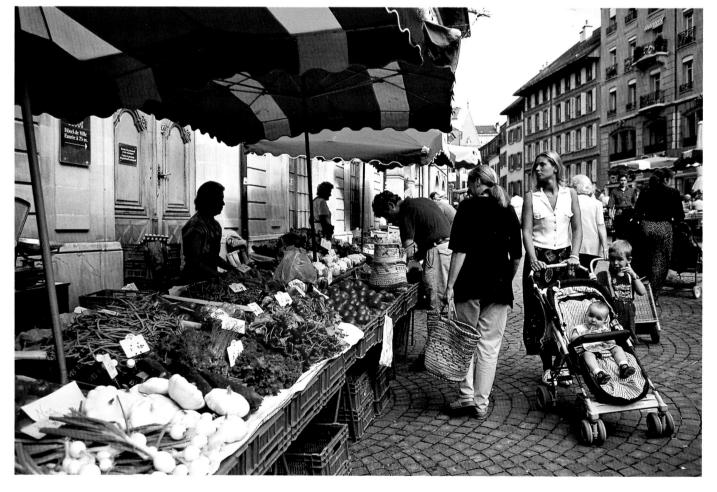

With around 130,000 inhabitants Lausanne is one of the largest cities in Switzerland. Its fervent Swiss industriousness is diluted by a good dose of French joie de vivre and laissez faire. Perhaps it's precisely this melange which lends the Vaud metropolis its indisputable allure.

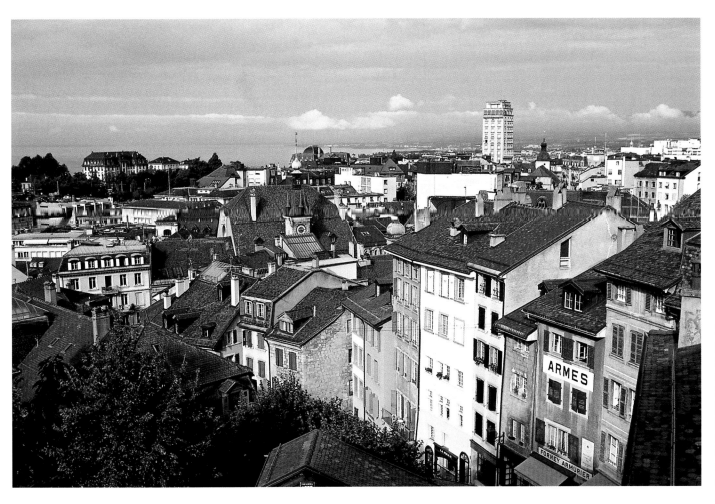

Lausanne's topography is unusual yet fascinating: a difference of 300 m (984 ft) separates the flat shores of Ouchy from the elevation of the Signal de Sauvabelin, with the city sloping steeply between them.

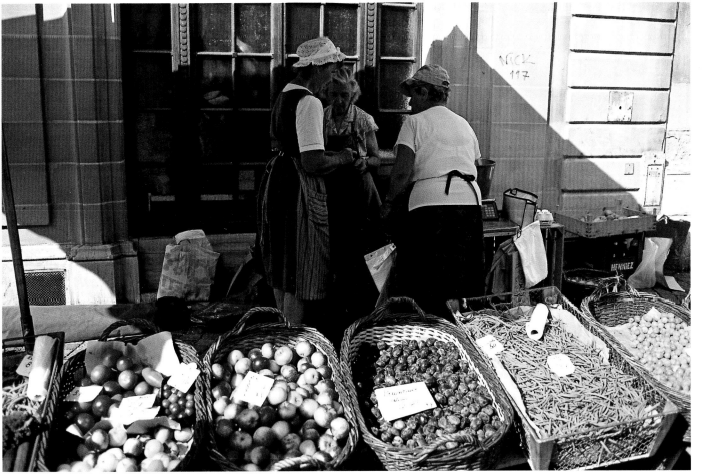

Lausanne's proximity to France and Italy is almost tangible, its markets stocked with a colourful array of fresh Mediterranean fruit and vegetables sold at affordable prices. The selection is rounded off by apples, pears and nuts grown locally.

Page 42/43: The passage of time seems to have side-stepped Gruyères.The little town,known as Greyerz in German, perches on a hill in the valley between the Moléson and the Dent du Chamois.

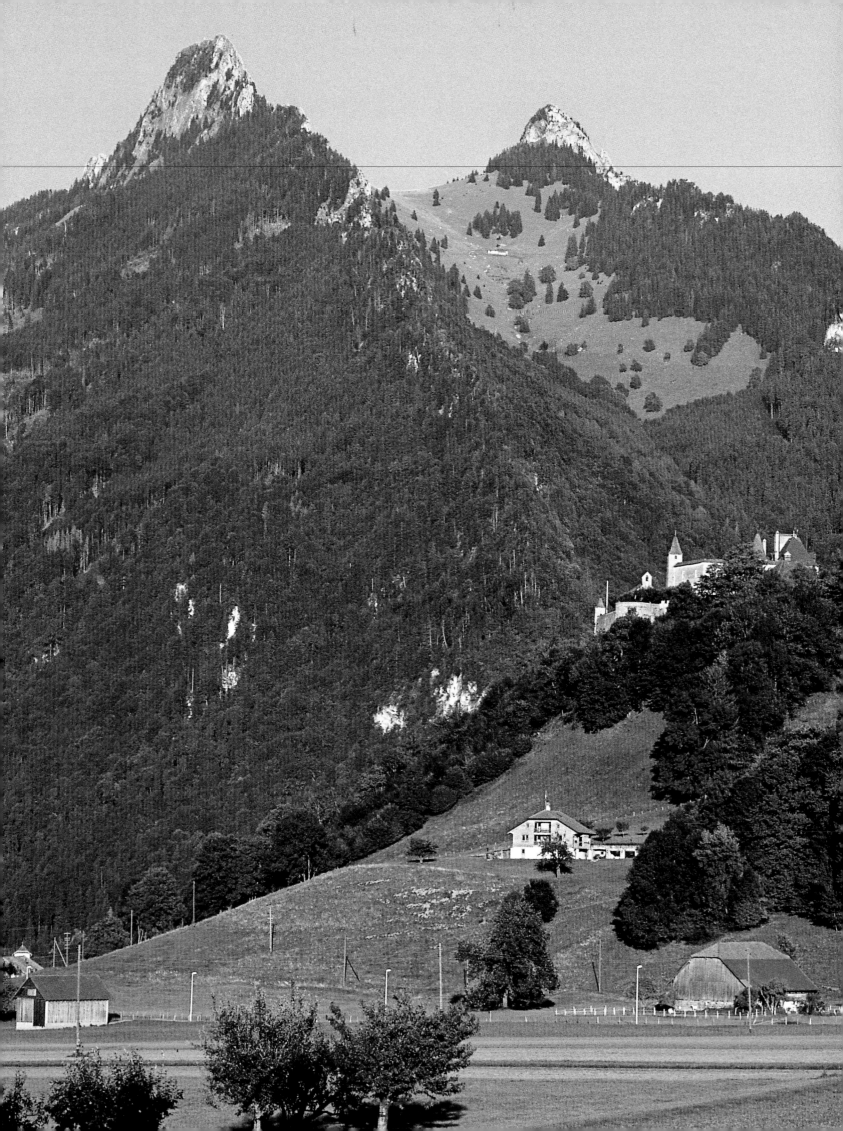

From the town wall walk you can look out across the idyllic medieval centre of Morat to Lake Morat and Mont Vully beyond it. The victory of the Confederates over the troops of Charles the Bold of Burgundy in 1476 give Morat a very special historic and almost patriotic air.

The atmosphere in Neuchâtel is both relaxed and cheery. Sandwiched between the hills of the Jura and the elongated Lake Neuchâtel, the town is an architectural tapestry of 18th century patrician dwellings, neoclassical edifices and Renaissance palaces. The old town lounges in the shadows of the stately castle which dates back to the 12th century.

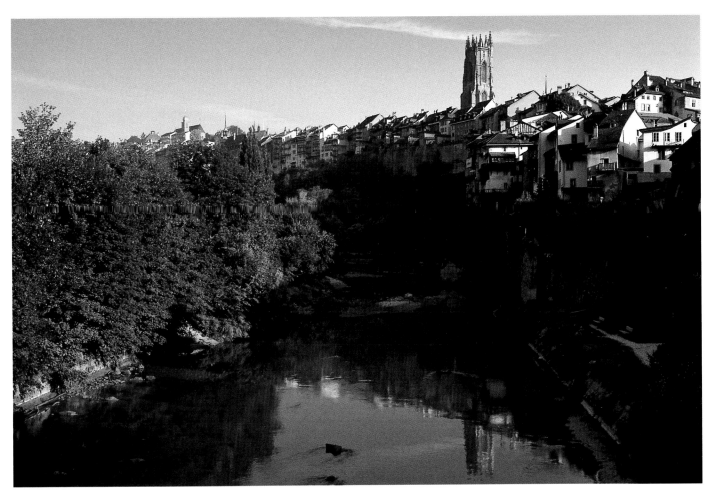

Although Switzerland is by no means short on history, Fribourg really excels in it. Its medieval visage is absolutely fascinating; over 200 Gothic buildings alone elbow each other for space on the slopes above the River Sarine. The tallest of them all is the cathedral St-Nicolas, its steeple slender, majestic – and unfinished.

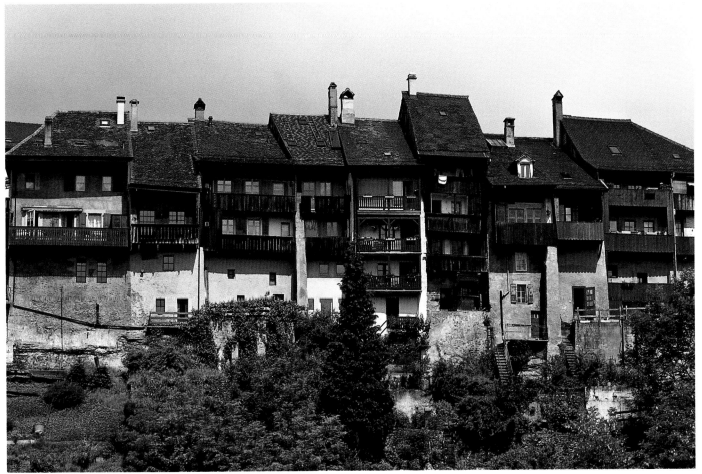

Moudon, the old Roman settlement of Minnodunum south of Yverdon, also has strong medieval leanings. It no longer has its castle or town walls, however.

45

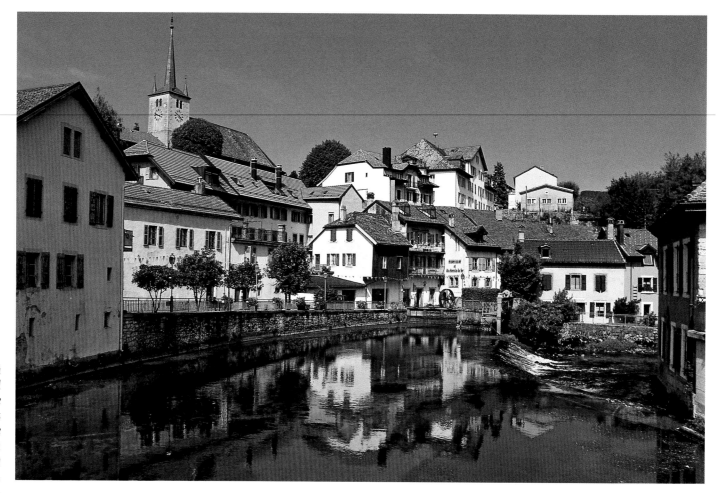

Close to the French border in the Vaud Jura is the pretty little town of Vallorbe. Its major attractions are the railway museum and the nearby dripstone caves.

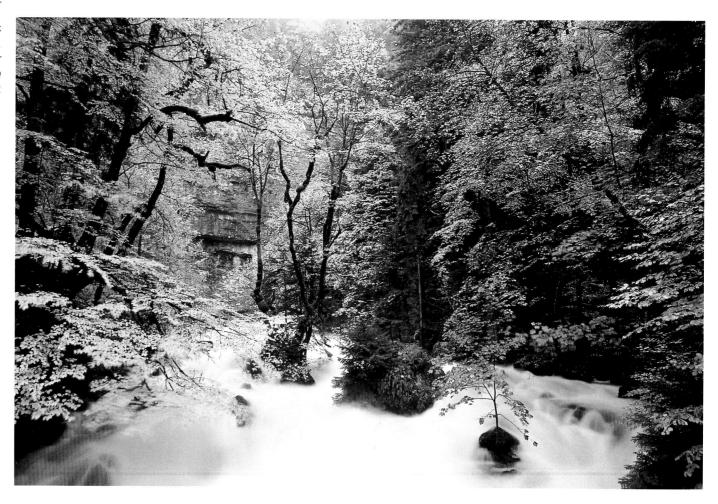

The River Orbe rises up above Vallorbe. From here the river begins its journey to the lakes of West Switzerland.

One of Switzerland's major sacred buildings, the church of St-Pierre et St-Paul, is the pride and joy of the beautifully situated town of Romainmôtier. The abbey was once part of the Cluniac priory dissolved in 1537.

On the Jurahöhenweg or Jura trail. Over the past few years the Swiss Jura has become one of the country's most popular hiking areas despite – or perhaps because of – its isolated location. Here you really can escape the everyday trials of life in the big smoke.

Page 48/49:
The semicircular basin of the Creux du Van is 500 m (1,640 ft) down. The impressive walls of limestone, from the top of which there are breathtakingly spectacular views, are one of the most beautiful natural beauty spots in West Switzerland.

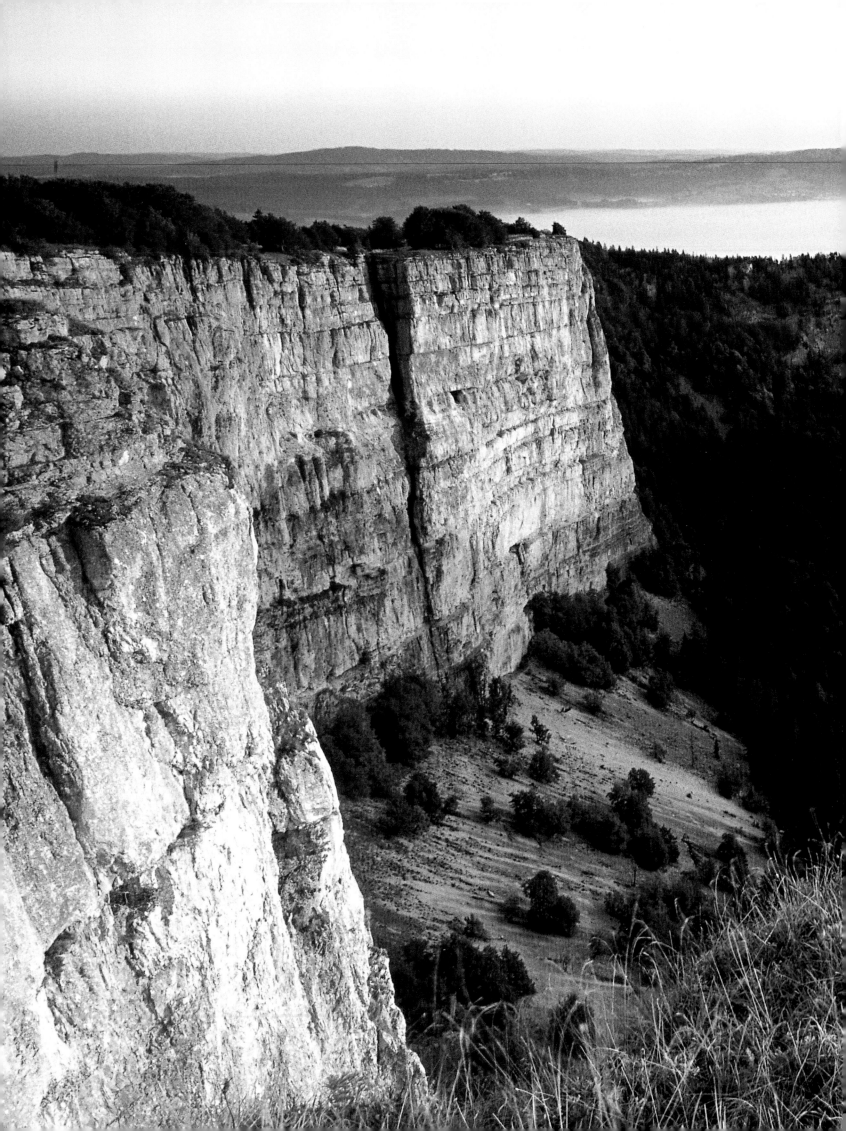

The climb up from the Creux du Van basin to the summit of the Soliat (1,463 m/4,800 ft) takes several hours. Once up on the plateau, the going is easier. The signposting of the trails is, like every-where in Switzerland, absolutely exemplary.

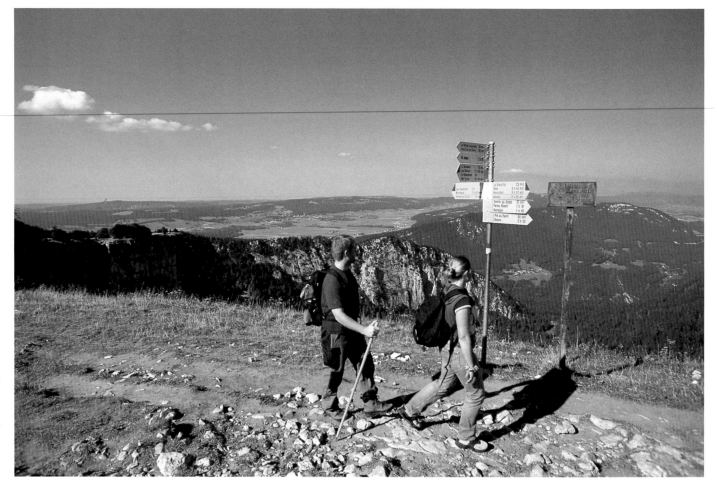

In the Gorges de l'Areuse. The narrow Jurassic ravine between Noiraigue and Boudry has been carved out by the waters of the River Areuse.

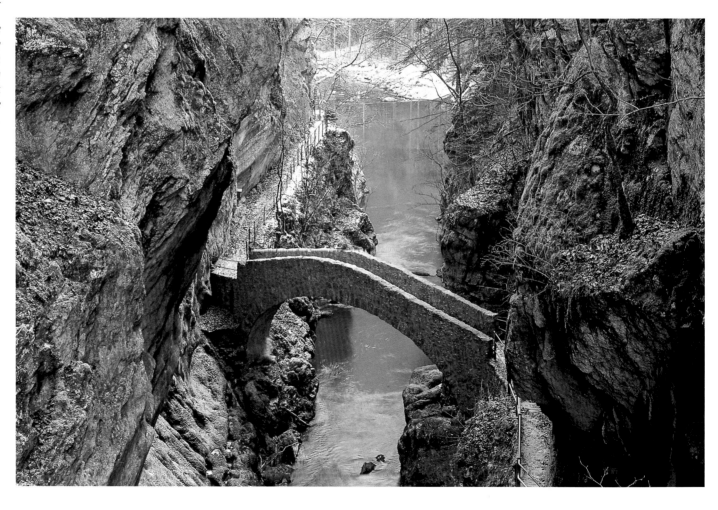

In winter the lonely Lac des Taillères area not far from the French border is one of the coldest in Switzerland. Frozen solid, the idyllic lake is perfect for skating on.

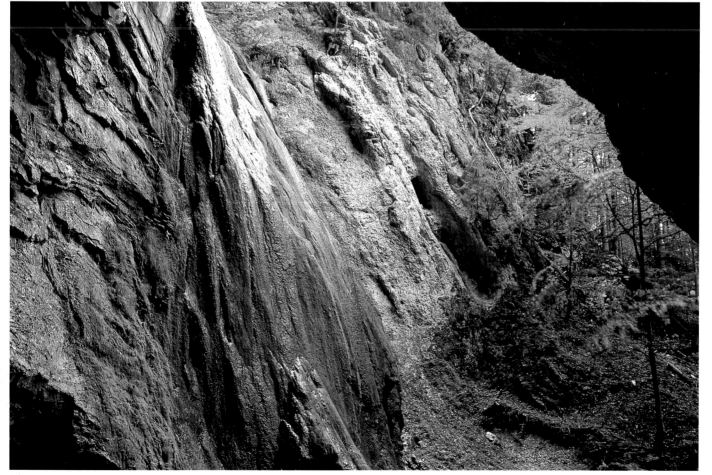

The Cascade de Môtiers. The waterfall is one of the many delights of the Val de Travers.

Page 52/53: The icy masses of the Aletsch Glacier curve down in a wide arc from the Jungfrau Massif to the valley of the Rhône in the canton of Valais. This natural wonder is 23 km (14 miles) long and has a surface area of 85 square km (33 square miles), making it the largest glacier in Central Europe. The Jungfrau-Aletsch-Bietschhorn region is a UNESCO World Heritage Site.

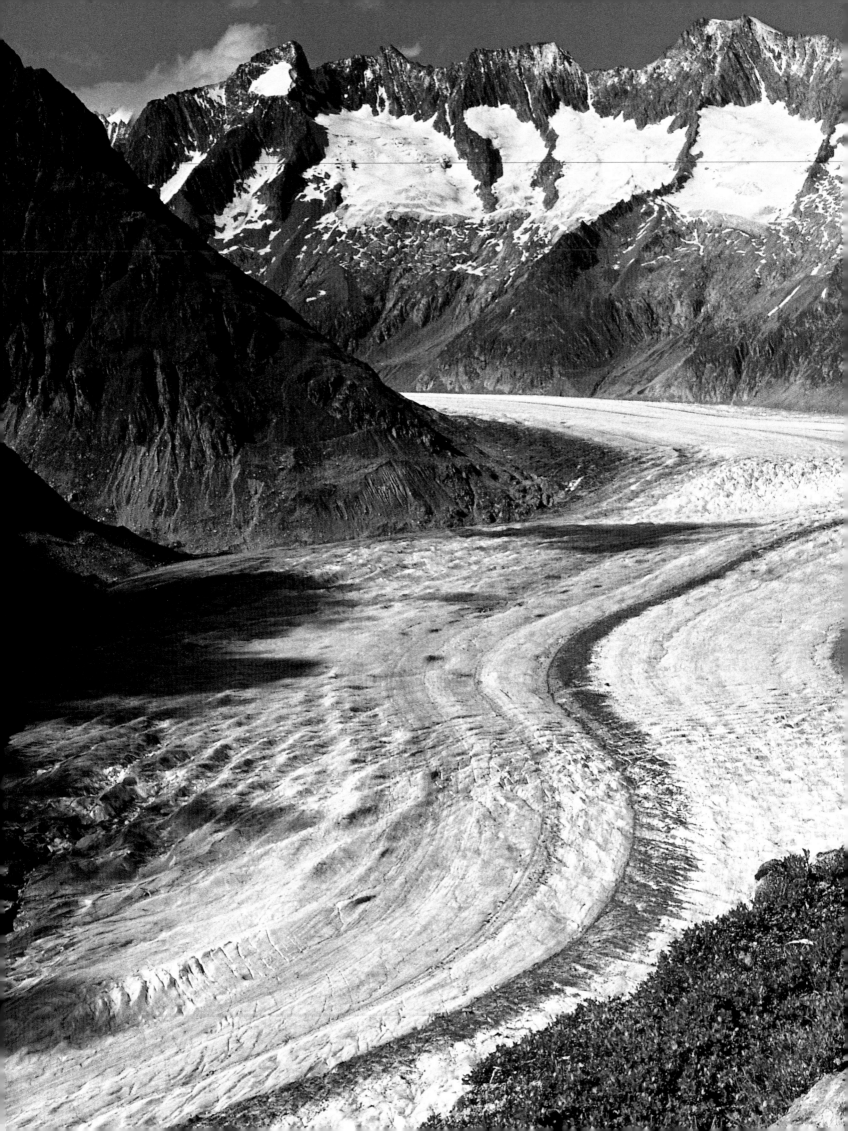

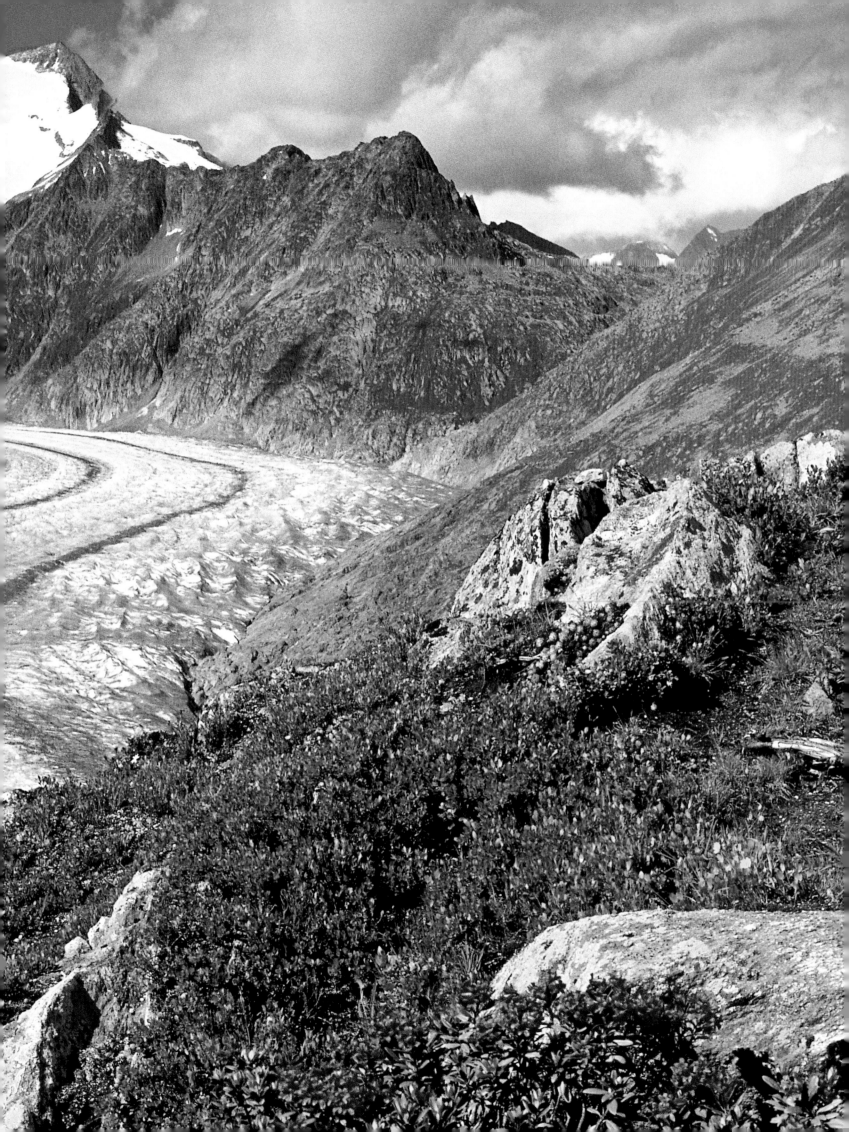

Each spring local farmers set off with their animals on a 'tour' of the Alps known as "Vieh-auftrieb" in Swiss German. About 300,000 bovines – and also a good number of sheep and goats – are taken to pastures green and tasty where they spend the warm summer months.

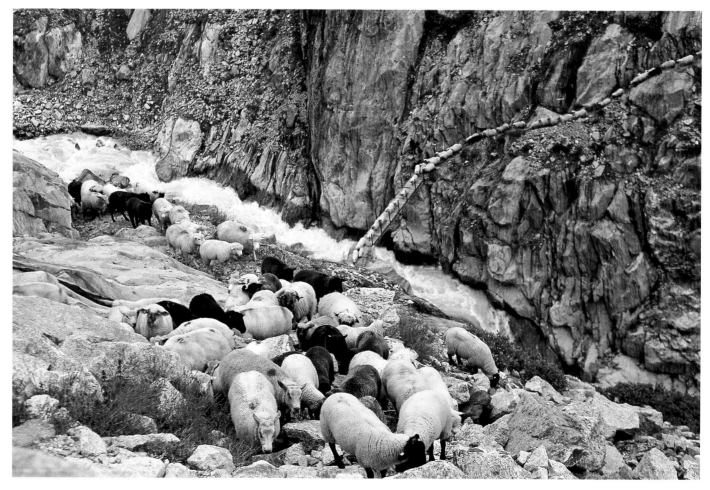

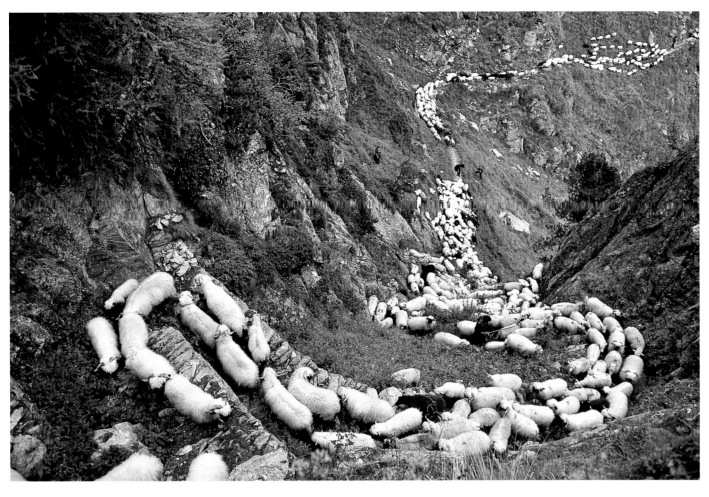

For most of Switzerland's Alpine farmers the yearly herding of livestock up and down the mountains is a vital part of their culture and not – as many see it – an event staged for the tourists. This procession on Aletschbord (Valais) takes place with winter rapidly approaching.

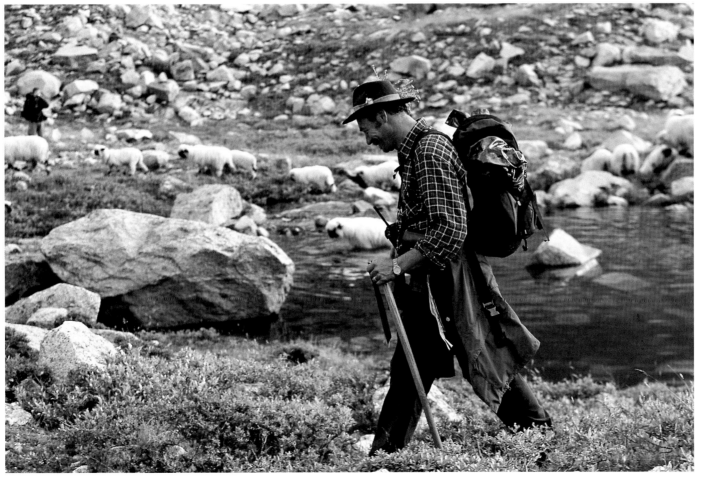

Many villages lie dotted about the valley floor and slopes of the German-speaking Goms. The upper section of the Rhône Valley between Gletsch and Fiesch, slightly off the beaten track, is a sleepy little place. In Niederwald, now little more than a hamlet, famous hotelier César Ritz first saw the light of day.

The chapel in the little village of Biel. Unlike this exterior, many of the churches of the Goms are elaborate baroque affairs.

56

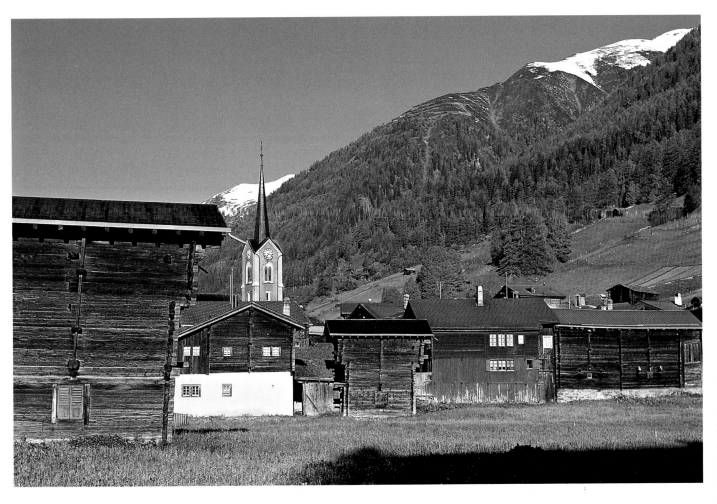

Unusually, in
Ulrichen the barns
and stables for the
farm animals have
been built well away
from the houses,
many of which are
extremely old.

The centre of the
Goms area is Ernen,
1,200 m (3,937 ft)
up on a terrace above
the valley. Richly
decorated houses from
the 16th century
indicate how impor-
tant Ernen once was
as a trading post en
route to the major
Alpine passes.

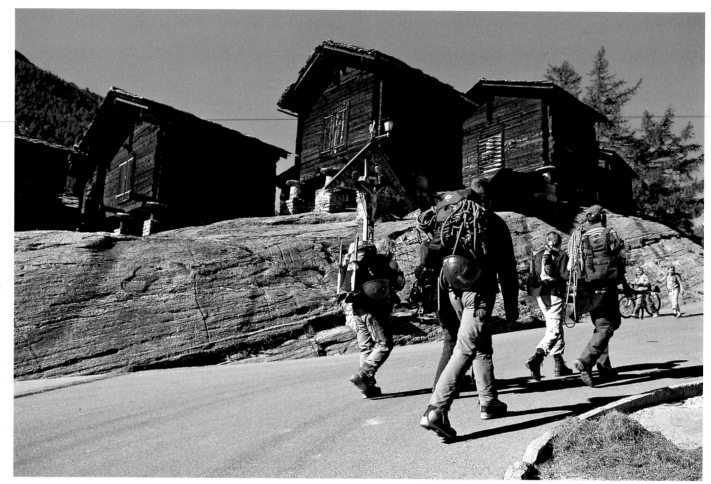

At the upper end of the Saas Valley in Valais lies Saas Fee, spectacularly enclosed by mountains which top the 4,000-metre mark. In winter the little town is packed with bronzed skiers; in summer avid hikers tramp happily through the traffic-free streets.

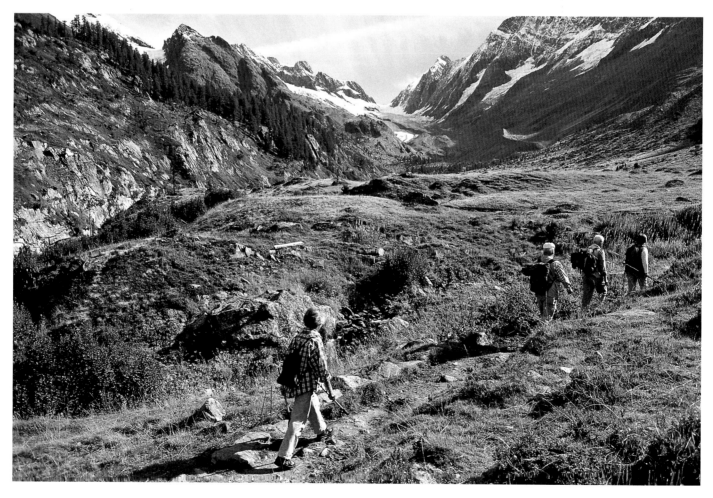

At the south end of the Lötschberg Tunnel the Lötschental begins its slow but steady climb up to the glacial peaks of the Jungfrau region. The Trogtal in the canton of Valais, rich in tradition, offers some fantastic hiking, with trails leading high up into the mountains.

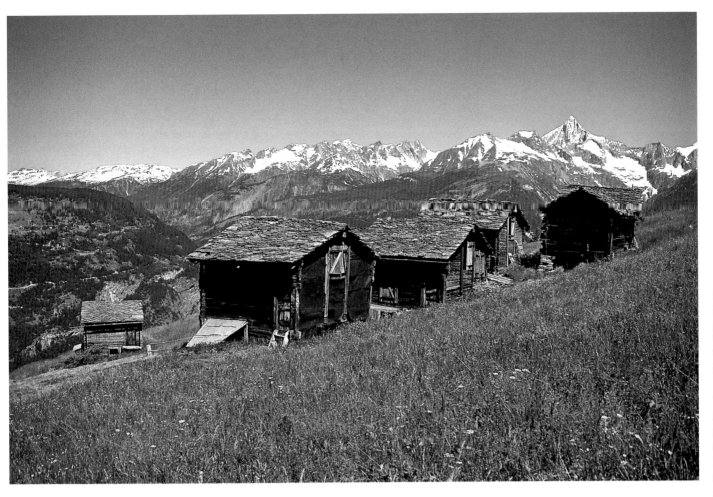

It may seem incredible but it's true: here near Visperterminen in Valais grapes thrive at a height of 1,150 m (3,770 ft)! The vines tended by the old village yield quantities of delicious Gutedel and Pinot noir, among other varieties.

Valais, and especially the Rhône Valley, has some of the lowest levels of rainfall in Switzerland. If sheltered from the wind, you can enjoy the warmth of the sun even at high altitudes – but don't forget to liberally apply your sun cream!

Page 60/61: View from the Stellisee of the Matterhorn. The exposed pyramid (4,478 m/14,692 ft) is probably the most famous summit in the whole of Switzerland. The high land between the valleys of Valais and the Italian border is riddled with splendid hiking trails, many of which take in some magnificent panoramas.

59

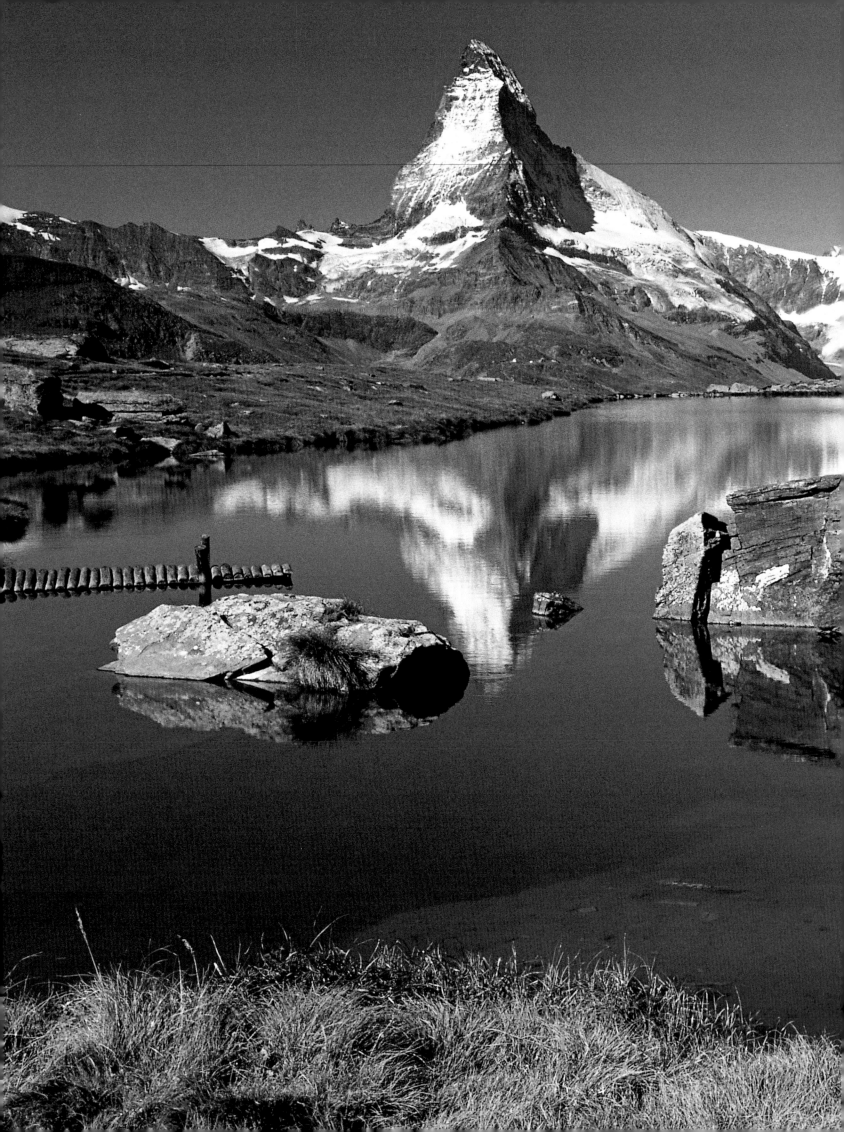

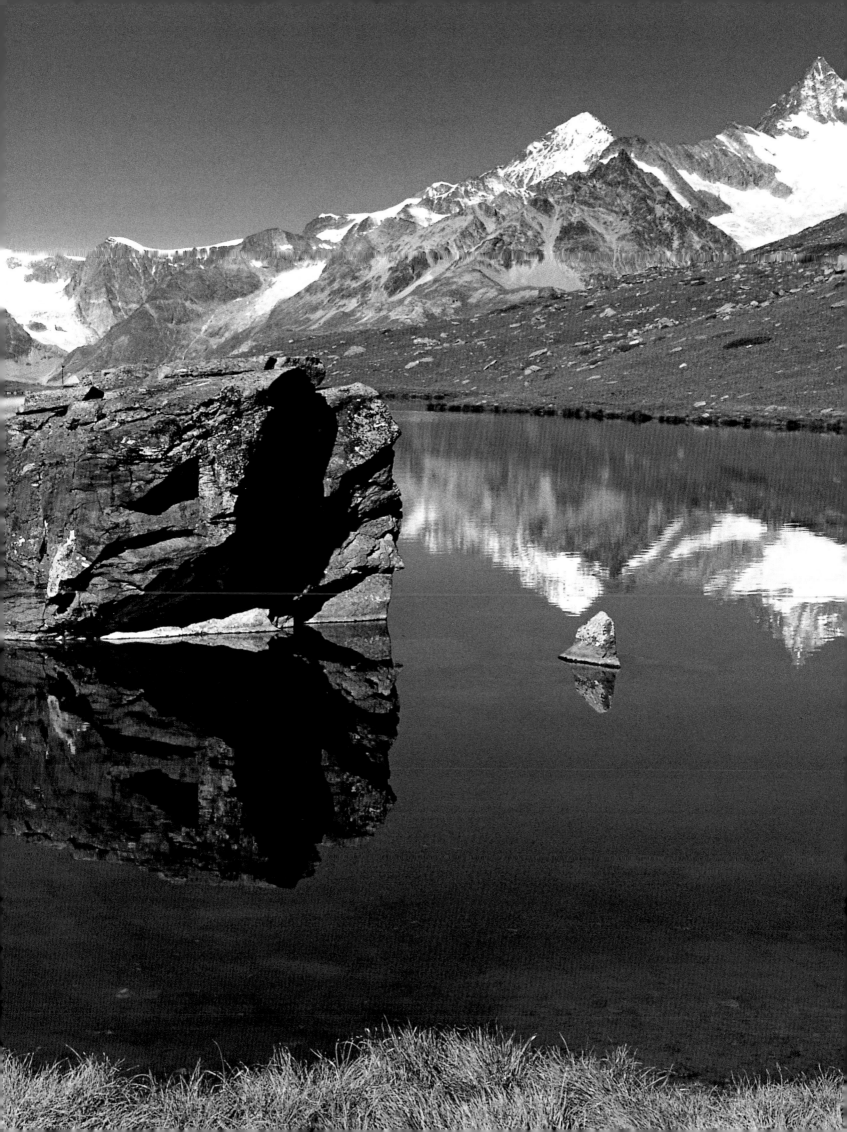

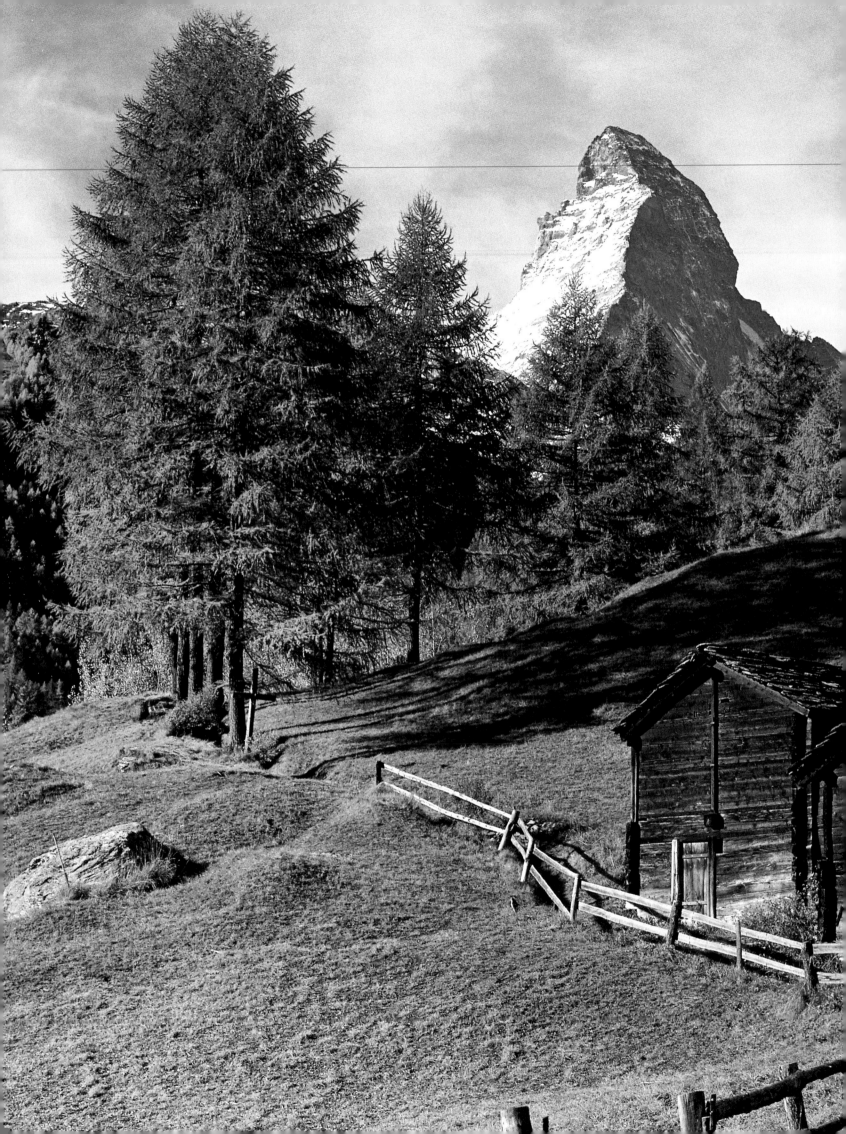

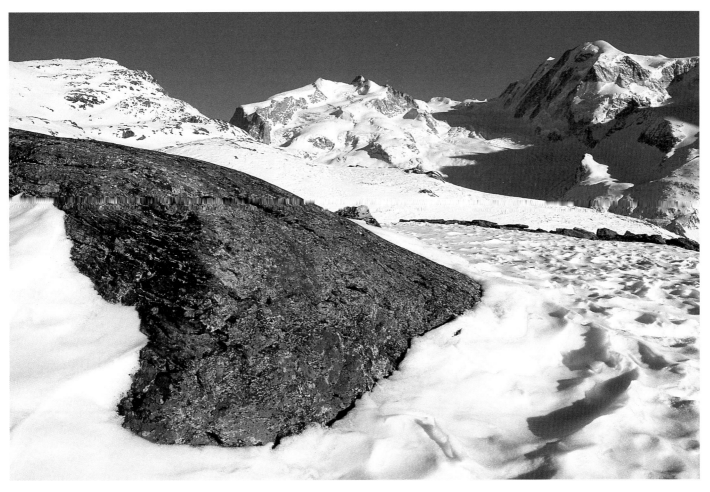

Left page:
Like a painting by Segantini: on an Alpine pasture near Zermatt.

Left:
You can travel across the Gorner Glacier to the top of the Gornergrat on Europe's highest rack railway. The glacier feeds the Mattervispa which tumbles down to the Rhône.

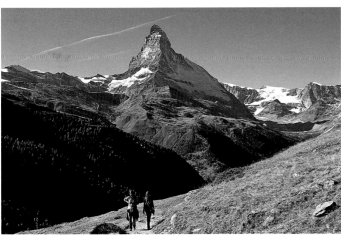

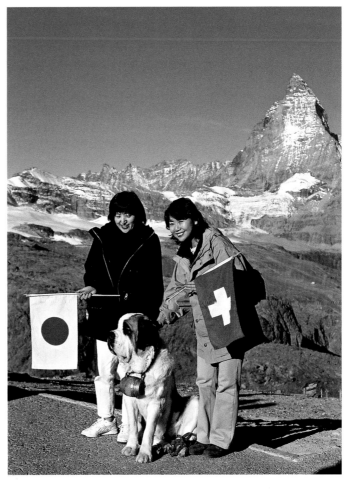

Top far left:
Smile, please! That's the Matterhorn behind you!

Bottom far left:
Lots of hiking trails zigzag through the mountains up above Zermatt, most of which have a single goal: the Matterhorn.

Left:
Swiss-Japanese friendship near the Matterhorn. For over 100 years now people from all over the world have come together at Switzerland's top Alp, engaging in the cosmopolitan spirit of this snowy wonder in the heart of Europe.

Luxury hotels and snow-capped peaks: Switzerland, the cradle of tourism

Its location in the middle of Europe, its spectacular passes across the great divide of the Alps, its astounding beauty and diversity: these are the ingredients the Swiss have used to turn their little country into a top destination for travellers over the past few hundred years. Touring Switzerland today, you are treated cordially and kindly by your hosts who appear self-assured and experienced in their dealing with "foreigners". This seems somewhat remarkable when you consider how restrictive and insular Swiss immigration policy can be, especially in the German-speaking parts of the country.

Up until the Romantic period foreign travel was synonymous with the steady transit between the north and south of the Continent. In time this changed; paths and tracks through valleys and across mountains were carefully maintained by the local populace, guest

Far right:
This rather severe black-and-white illustration captures the zeitgeist of the troublesome decade between 1930 and 1940.

Middle:
Generations of tourists have travelled Switzerland over the past 150 years. The Swiss have advertised their Alpine domain for just as long, with this not so politically correct poster from days gone by praising the delights of driving your car through the mountains.

Right:
The electrified railway line running along Lake Geneva was a big selling point for visitors in the 1920s.

indomitable summits were a national concern and often seen as demonstrations of great loyalty to one's mother country.

The British and the Belle Époque

During the 19th century it was chiefly the British who indulged their passion for travel, with Switzerland soon becoming one of their favourite destinations. Mountaineers from the British Isles wrote Alpine history. Among them were Charles Hudson, who climbed the Dufourspitze with his entourage in 1855, and Edward Whymper, who ten years later was the first person to conquer the Matterhorn, the Alpine icon of Switzerland. Not only wealthy individuals found their way into the Alps; organised groups from England have become inextricably linked with the name Thomas Cook. Tourism in

houses, hospices and even monasteries began taking in paying guests. Travel for travel's sake – a privilege of the nobility and later the educated classes – became popular in the 18th and 19th centuries. Switzerland was a composite part of the Grand Tour, traversed by the young elite of Central Europe on their way to the cultural strongholds of Italy. Swiss philosophers such as Jean-Jacques Rousseau and poets likes Albrecht von Haller discovered the Alps in their raw, unadulterated natural beauty, a dramatic spectacle staged for their personal enjoyment. First ascents to

Europe positively boomed in the years 1880 to 1914, cut short by the event of the First World War. In Switzerland rapid development in industry and travel technology during this period and the increasing prosperity of the upper classes fuelled the race for the best new travel experience. Piece by piece railway track was laid up mountainsides, where new hotels on lofty peaks provided more or less suitable accommodation for their well-heeled clientele. The entire country was in the grip of railway fever, making it very easy for hotel owners and rail companies to

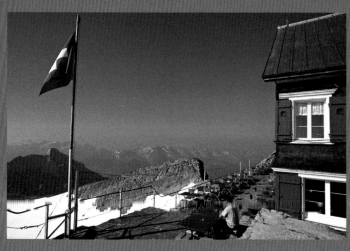

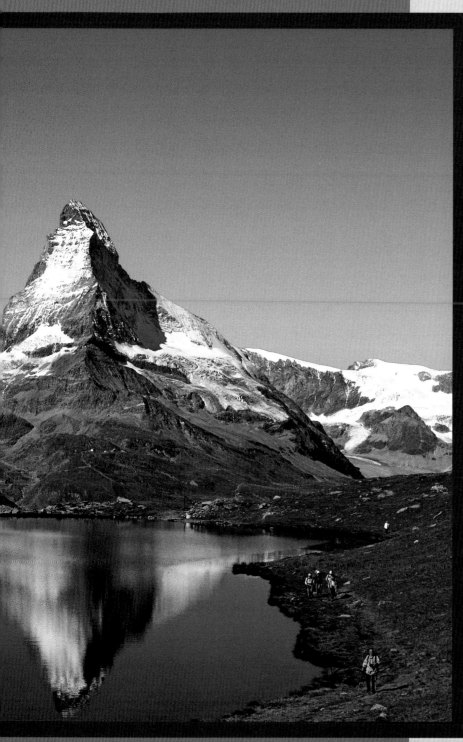

come by the necessary capital from banks all too eager to finance such innovative undertakings. The Brünig was vanquished by the railway in 1889, the Pilatus a year later and the Rothorn in Brienz and Visp to Zermatt in 1891. During the 19th century railway engineers inching their way forwards from Scheidegg got as far as the Eiger Glacier. 14 years later in 1912 the Jungfraubahn steamed into the highest station in Europe, 3,454 metres (11,332 feet) above sea level.

The queen of Switzerland's viewpoints in the 19th century, the 1,800 metres (5,900 feet) of the Rigi near Lucerne, was accessed by no less than two rack railways between 1868 and 1878. In his Switzerland from 1891 Baedeker describes the merry throng up on the plateau: "The Kulm is busy throughout the day, especially in the evenings and mornings. Before sunset everybody assembles up on the summit. An alphorn sounds the retreat of the sun and pleads for its reward. Then the crowds gradually disperse and the dinner table exerts its magnetism."

The pull of the lakes

In tune with the development of the railway life on Switzerland's lakes also began to change. Ever larger fleets of often luxurious steamers presented their passengers with the full beauty of the lakeside strands and fantastic vistas of the surrounding mountains. A few steps away from the landing stages a bevy of stylish hotels awaited. Whether in Montreux or Geneva, on Lake Lucerne or on the lakes of Thun and Brienz in the Bernese Oberland, the setup was the same. One of the most popular attractions of Lake Brienz were the frothing Giesbach Falls, illuminated in the 19th century, next to which one of the most sumptuous hotels of the Belle Époque invites you to travel back in time. Other magnificent establishments erected at the turn of the 19th century are Badrutt's Palace in St Moritz, the Victoria in Interlaken and the Hôtel de la Paix in Geneva.

Switzerland's impressive collection of paddle steamers has also survived the passage of time. It's a great pleasure indeed to sit in a class salon over a slap-up lunch, feeling the pistons propelling you gently across the water past one mighty peak after another. The Belle Époque lives on – and, if only for a few hours, all of us can have a part of it.

Left:
Since the dawn of modern travel and the 'invention' of the nature holiday the Aletschwald between the Aletsch Glacier and Rhône Valley, the highest Swiss pine forest in Europe, has been targeted by keen hikers.

Left:
The demand of Belle Époque travellers to be able to view the beauty of the Alps from their very summits prompted a veritable boom in mountain railway engineering. From the Säntis in the canton of St Gallen there are marvellous views of Lake Constance and also the Urner, Glarus, Grison and Vorarlberg Alps.

Page 66/67:
On the Riffelsee (Valais). On a fine day the modest mountain lake beneath the tip of the Gornergrat presents visitors with a particularly glorious spectacle: a reflection of the Matterhorn.

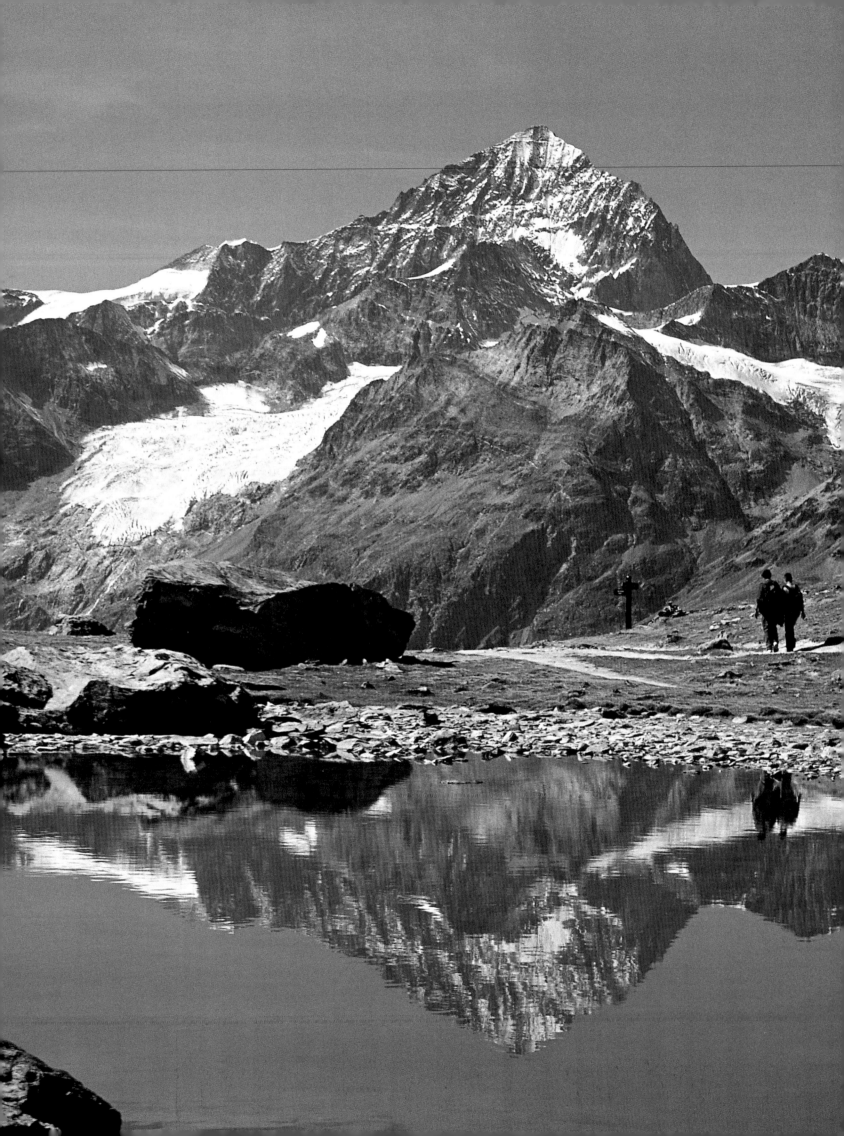

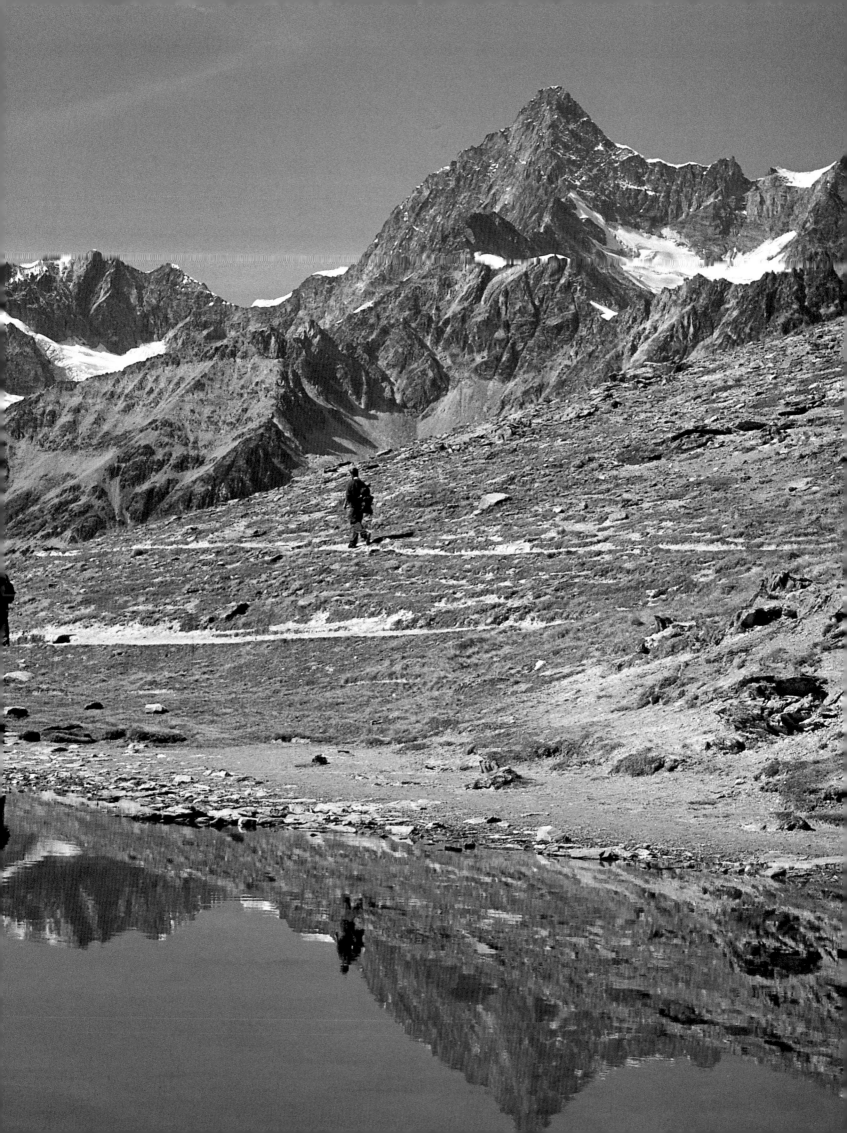

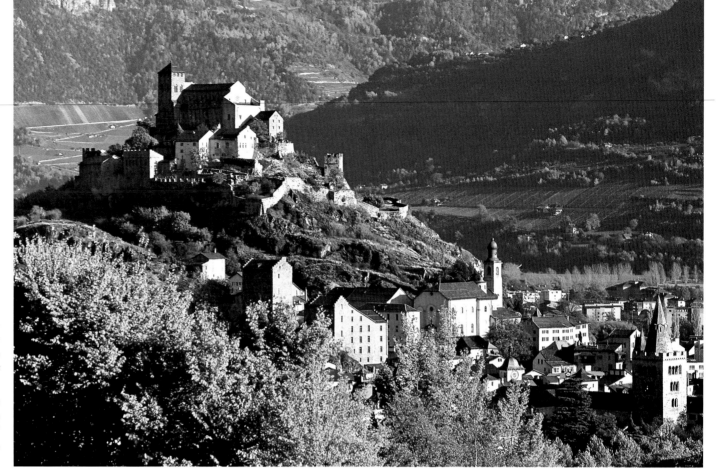

At French-speaking Sion in the valley of the Rhône the fortified churches of Valeria and Tourbillon still smack of the former might of the bishops who resided here until well into the 18th century.

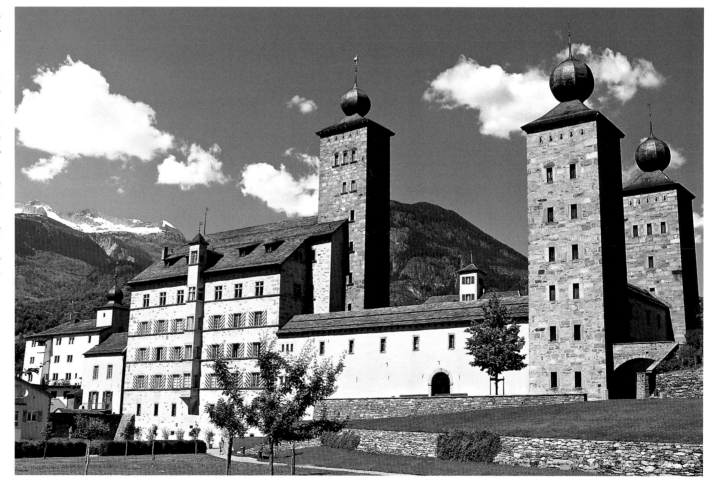

The grand castle of the Stockalper dynasty dominates the city of Brig, best known to rail passengers as the main junction between Valais, Italy and the Bernese Oberland. Kaspar Stockalper von Thurm, under whose aegis the palace was built, lived from 1609 to 1691. The "king of the Simplon" amassed a huge fortune constructing mountain passes, hospices and mines.

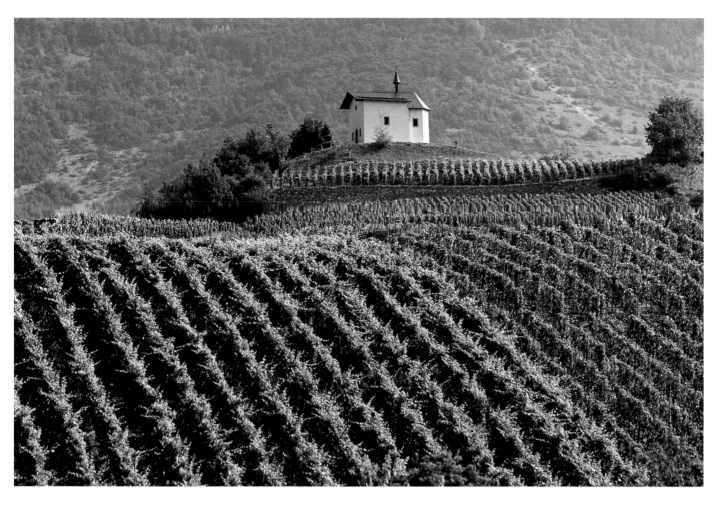

Nowhere else in Switzerland is as much wine grown as in Valais. The extremely dry valley of the Rhône and good soil provide perfect conditions for the cultivation of Silvaner, Chasselas and Pinto noir grapes. In Sierre and Salgesch (shown here) museums of viniculture tell the story of wine made on the Rhône.

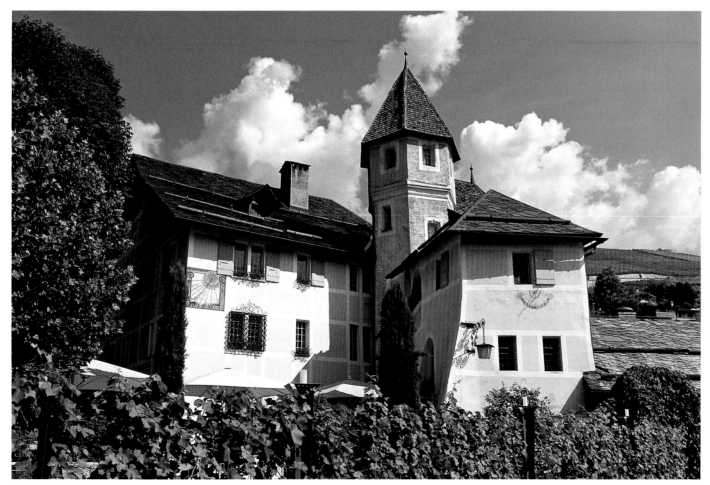

Château de Villa in Sierre dates back to the 16th century and now houses the Valais museum of vines and viniculture. Valais's number one wine village is also famous for its museum dedicated to German poet Rilke who lived in Muzot Castle here towards the end of his life.

69

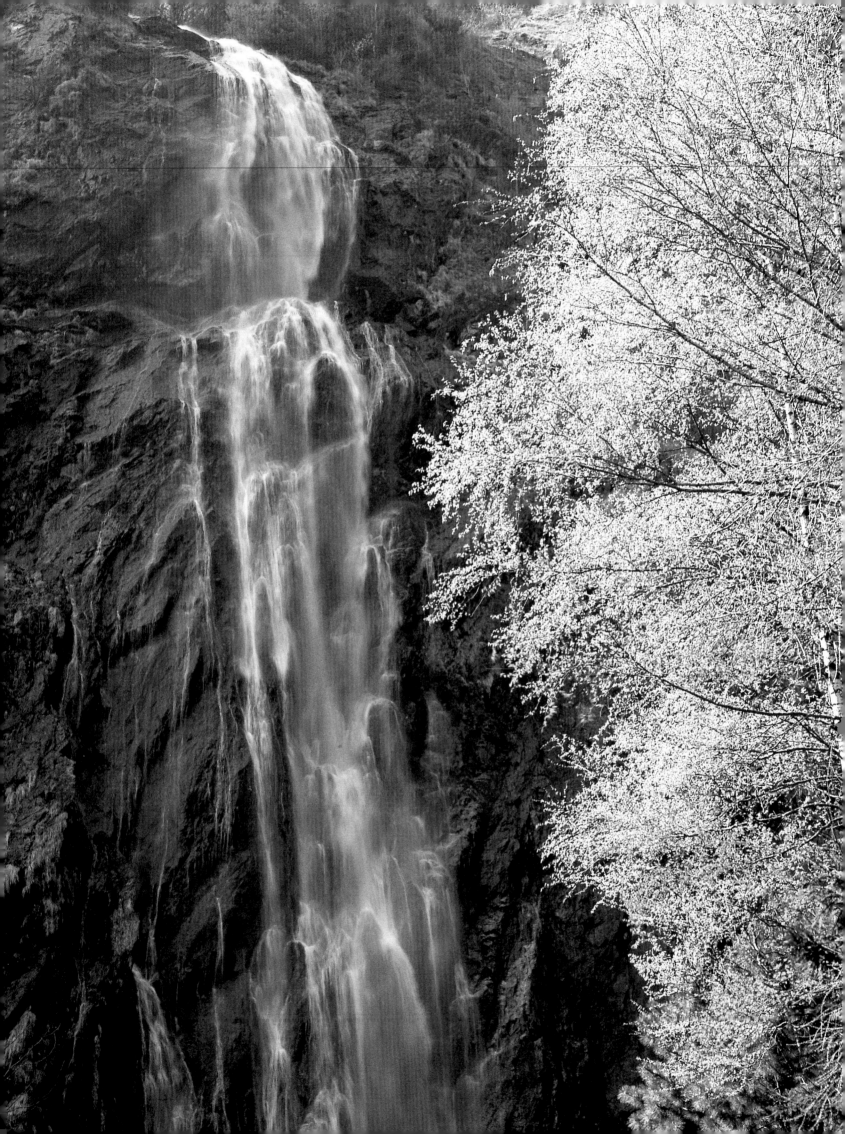

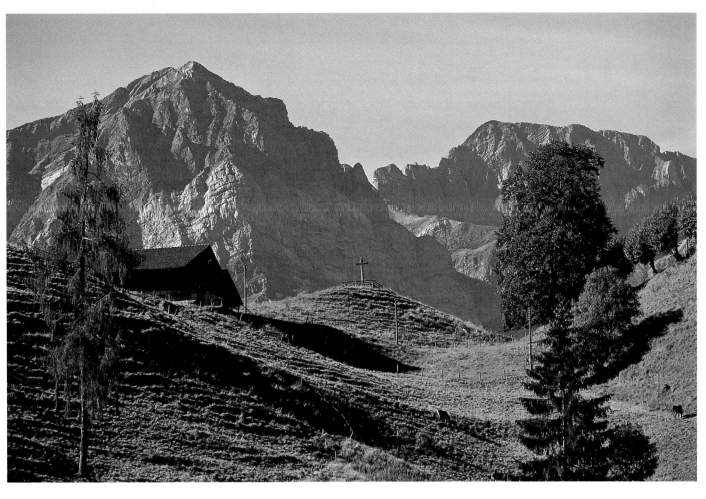

Left page:
Lac de Salanfe south of the Dents du Midi feeds the waterfall at Pissevache. This romantic little spot north of Martigny is one of the lesser known beauties of Switzerland.

High up in the Val d'Illiez, which cuts off from the Rhône Valley at Monthey, is Champéry. From the popular little village there are plenty of forays out into the surrounding mountains, with views like this one the perfect reward for a few hours' exertion.

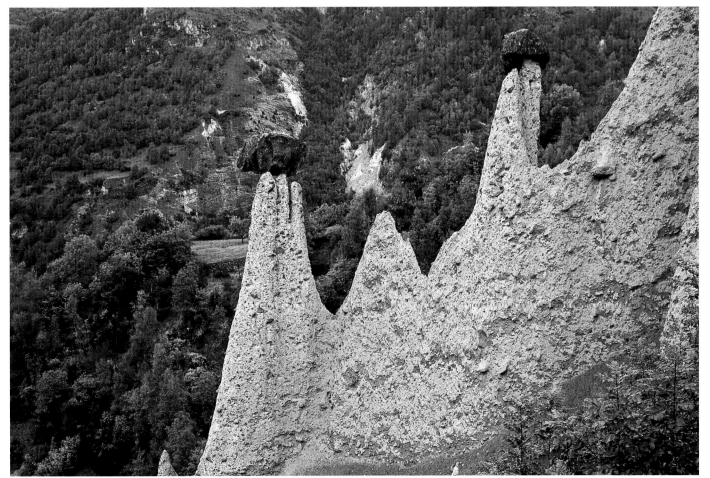

The pyramids in the Val d'Hérens are among Switzerland's more unusual natural phenomena. The rocks, topped by stone boulders, have withstood the elements for tens of thousands of years, a lasting remnant of the moraines of the last ice age.

THE CONFEDERATION HEARTLANDS: GERMAN-SPEAKING SWITZERLAND

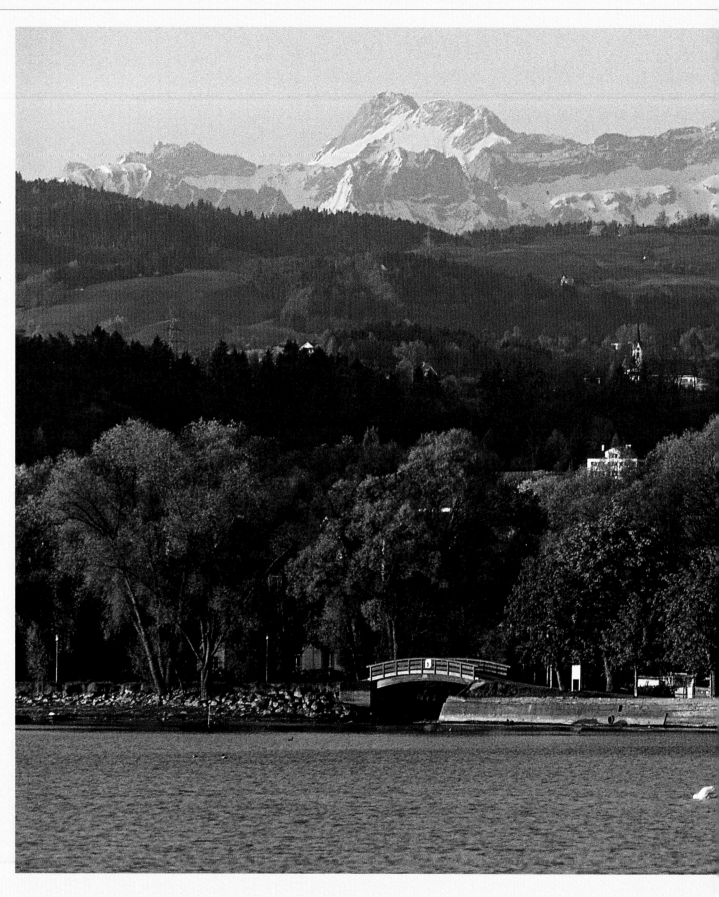

Wherever you are on Lake Constance, on a clear day the Alpstein Massif looms large on the horizon (here beyond the shores of Arbon).

THE CONFEDERATION HEARTLANDS: GERMAN-SPEAKING SWITZERLAND

This is the highest it gets; the most elevated station in Europe (3,454 m / 11,332 ft) is just a few steps away from the viewing platform of the Jungfraujoch in the Bernese Oberland. Here on top of the world the mood is decidedly cosmopolitan; people from all corners of the globe gaze in wonder at the magnificent vistas which unfold before them, with Germany to the north and the icy band of the Aletsch Glacier to the south both clearly visible on a good day.

Swiss by name and Swiss by nature... Tucked in between Lake Lucerne and the south end of Lake Zürich in the middle of the country, the canton of Schwyz with its provincial capital of the same name clearly indicates where the heart of the Confederation beats most fervently. Tiny Schwyz (Swiss German for "Switzerland") is one of 18 German-speaking cantons which have a marked linguistic majority; about three quarters of the Swiss population speak Swiss German in all its various permutations.

From Basel upstream to Lake Constance are the cantons of Basel, Aargau, Zürich, Schaffhausen, Thurgau and St Gallen. Despite the many idyllic spots, the rolling hills surrounding medieval towns and villages and the industrial agglomerations of Basel and Zürich are a far cry from the cliché of the imposing and impressive Swiss Alps. Basel enjoys something of a special status, hugging a bend in the River Rhine between Switzerland, Germany and France. Where Geneva acts as a gateway to the world with its many international institutions and Zürich as a hotline to the financial strongholds of the globe with its banking conglomerate, Basel is a centre of production and hub of world trade. Today it's one of the mainstays of the chemical industry in Europe – yet also has one of the most beautiful old towns in the entire Alemannic region. Gliding serenely over the Rhine on one of the four historic cable ferries, the pace of modern life is somewhat slowed – at least for a brief while. Basel also owes much of its international flair to its diverse and ambitious arts scene which finds expression in inspiring museums and galleries and in the yearly Art Basel exhibition.

Zürich and Lake Zürich

Cities built on the shores of a lake have a very special atmosphere – and Switzerland is not short of examples. One of the most successful combinations of urban life and lakeside idyll is found in Zürich and its aquatic expanses. The busiest and richest town in the country is the only real metropolis in Switzerland – with all its pros and cons. It has nevertheless remained relatively compact, with a great sense of cheer and nonchalance clearly tangible along the shores of the lake and the banks of the River Limmat which divides the city up into its business sector and cultural *Szene*. The city's general intellectual receptiveness somewhat takes the edge off the often over-flaunted affluence of many of its burghers; its cultural prowess is in-

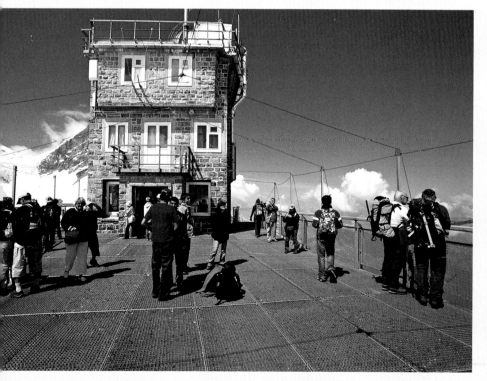

fluential far beyond the regional and national boundaries.

The orderliness of Zürich seems to smartly sweep as far as Lake Constance; driving through the vineyards and orchards of the Thurgau you find an organised landscape of tidy villages full of neat half-timbered houses and carefully tended vines. Along the shores of the Swabian Sea, as Lake Constance is often called, tight-knit villages and towns jostle for space, the attraction of building on the water's edge irresistible to Swiss, Germans and Austrians alike. A glorious transition from the sparkling waters of the lake to the giddy summits of the mountains is formed by the canton of St Gallen with its administrative inclusions; like a Russian doll St Gallen houses the two half-cantons of the picturesque Appenzell: Ausserrhoden and Innerrhoden. From the surprisingly steep slopes of the Alpine foothills you can gaze out in wonder at the many panoramas of Lake Constance and beyond. With each kilometre nearer to the Rhine plateau, which forms the national boundary to Austria and Liechtenstein in the east, the mountains become more Alpine. From the Hoher Kasten, for example, 1,795 metres (5,889 feet) above sea level, you can see as far as the Allgäu in Germany, the Tyrolean Alps and Graubunden or The Grisons. These peripheral peaks in the northeast of Switzerland are largely unknown, dominated by the huge massif of the Säntis. This mighty wall of rock, whose summit has been turned into a miniature theme park, positively commands the surrounding countryside; in the red glow of the setting sun, Säntis Mountain is akin to an ancient place of worship. Opposite the Säntis the tips of the Churfirsten Group puncture the sky like a set of jagged teeth. They make up the south end of the Toggenburg area, whose gently undulating hills with their isolated farmsteads are like the Swiss Alps in soft focus.

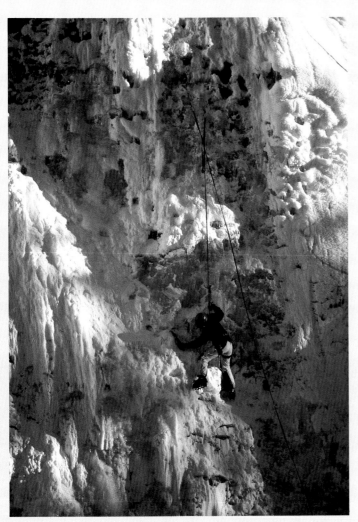

Lake Lucerne, the heart of Old Switzerland

We could say that no other place in the tiny country of Switzerland is as far away from foreign territory as the area around Lake Lucerne. This charming expanse of water between Lucerne and Altdorf is not only the geographical but also the historic heart of Old Switzerland. OK, so we may argue about the amount of truth to Schiller's William Tell legend; the Oath of Allegiance sworn by the confederates of Uri, Schwyz and Unterwalden in 1291 is a fact. One of the country's most beautiful cities, Lucerne, owes much of its prosperity to its early joining of the Confederation; situated at the outlet of the River Reuss it was the first in Switzerland to belong to the defensive alliance of Confeder-

Left:
This sport may not be everybody's cup of tea but climbing frozen waterfalls is increasingly becoming the discipline of choice for many adventurous souls. East Switzerland provides the low temperatures required, such as here in the Weisstannental which runs from Sargans to the Glarus Alps.

Bottom right:
Good wood and a
steady hand are
crucial to makers of
musical instruments:
here a craftsman at
work in Mels in the
canton of St Gallen.

Bottom:
Switzerland is one of
the most modern
countries in the world
– yet it upholds its
ancient customs and
traditions with an
enthusiasm barely
matched anywhere
else in Europe.
Masks worn at the
many parades which
take place throughout
the year are often
carved by hand, such
as here in Berschis.

ates from 1332 onwards. During the 19th century Lucerne became a centre of early international tourism which left it with some wonderful attractions still operating today; the paddle steamer still chugs merrily out to sea, visible from the viewing points up on Pilatus, Rigi and Bürgenstock. The first, Lucerne's local mountain, can be "climbed" using the steepest rack railway in the world. The view from the top – providing there's no fog – is nothing less than grand; the lake, Lucerne and the Alps make up an impressive and pleasing ensemble.

The gateway to Central Switzerland in the south is the canton of Uri with its capital of Altdorf. The canton wedges itself in between the Glarus and Bernese Alps, with the mighty Gotthard Massif to one end.

The full beauty of the Alps: the Bernese Oberland

Coming from the north through the Aare Valley, they suddenly appear, a few kilometres beyond Bern and their shape and colour become more distinct; stacked like a deck of tattered cards, the mountain chain of the Bernese Alps looms large on the horizon, its meadows emerald green, its rocky cliffs as dark as the night, its peaks glistening with everlasting snow and ice. Where Central Switzerland transmutes into a high Alpine region Lake Thun offers a peaceful counterpoint, its glacial waters crystal clear and warm enough for swimmers in the summer, its marinas full of sailing boats gently straining at their moorings. From the northern shore you can see the pyramid of the Niesen, 2,300 metres

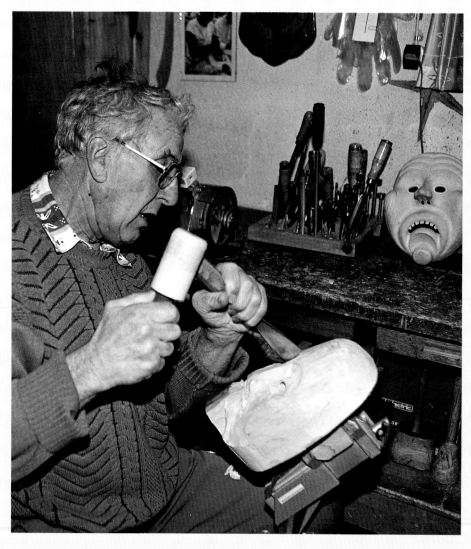

(7,546 feet) tall, which Swiss artist Paul Klee so memorably portrayed. Beneath it Spiez, idyllically situated in a bay of the lake, is where the German national football team were based during the World Cup of 1954; the "spirit of Spiez" they developed here was said to greatly contribute to their sporting success (they won). Meandering through the vineyards of Spiez down to the castle and along the lakeside to the neighbouring little town of Faulensee the entire beauty of the Lake Thun region opens up before you.

Perhaps the most relaxing way to travel the mountain giants, some of them still glaciated, is to take a trip across the lake from Thun to Interlaken and board the trim carriages of the Bernese Oberlandbahn. The signs on the trains list destinations which have been the epitome of Alpine travel for over a hundred years; in the trains bound for Lauterbrunnen and Grindelwald, the traffic-free villages of Wengen and Mürren and at Kleine Scheidegg you can meet people from all over the world. The imposing backdrop of the Eiger, Mönch and Jungfrau doesn't only hold great appeal for hikers and mountaineers. Indian film producers making their wonderfully kitsch Bollywood movies for the folks back home, admen out to promote chocolate and train buffs from Great Britain and the USA on the lookout for the ultimate photographic motif are just some of the characters who make up the great melting pot of visitors to the depths of the Bernese Oberland. In the train on its way up to the highest station in Europe, the Jungfraujoch at 3,454 metres (11,332 feet), Japanese ladies in patent leather shoes sit next to Australian and Russian Alpinists armed with ropes, picks and rucksacks for tours of the slopes and glaciers. The mood is merry, friendly and heavy with expectation.

People say that the people in the canton of Bern are rather reflective and inflexible, some-thing each visitor will have to find out for themselves. A certain down-to-earth approach to life is, however, evident in the vernacular architecture. The trademark of the Bernese Oberland are its gnarled, dark brown wooden houses, often covered in carvings, with window boxes of vibrant flowers adding a vital splash of colour. Their history and the lives of those who once inhabited them is explained in exemplary fashion at the Swiss museum of rural culture on the Ballenberg up above Brienz at the east end of Lake Brienz. Here, 60 hectares (150 acres) of Alpine scenery provide space for over 90 old farms and houses which make up a very lively village ensemble, manned and inhabited nearly all year round. The technology of the Alps is just as fascinating – technology?! Yes! The nearby Rothornbahn boasts a unique form of travel, an ancient rack steam railway which puffs all the way up to the summit at 2,252 metres (7,388 feet). Straddling the canton boundaries of Bern, Lucerne and Obwalden, from the top of the mountain there are magnificent views of the entire chain of the Alps and the northern Alpine foreland.

In rural parts of the country many traditional trades are still practised by hand. Distilling is one of them; here aromatic spirits are made from local most, cherries and plums.

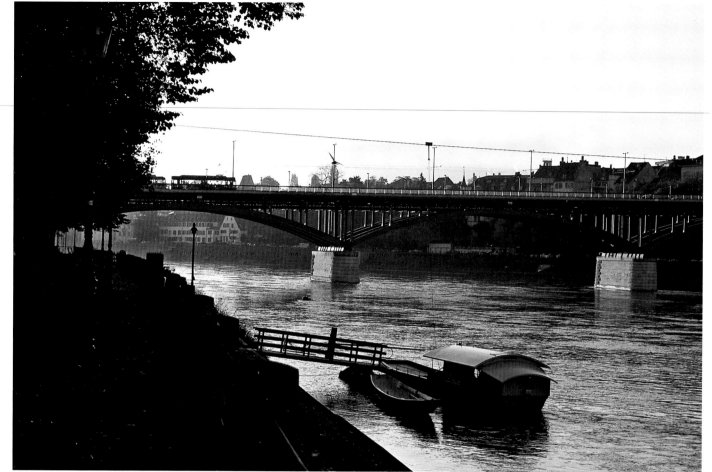

Basel, the north-westernmost city in Switzerland, and the River Rhine are one. There are lots of idyllic spots to be found where the Rhine meanders through France, Germany and Switzerland – despite the relative proximity of several major chemical works.

Basel is where many cruises of the River Rhine depart and terminate. Some of the more comfortable riverboats sail north up the river all the way to Rotterdam in The Netherlands. Most of Switzerland's lake shipping companies are also based in Basel.

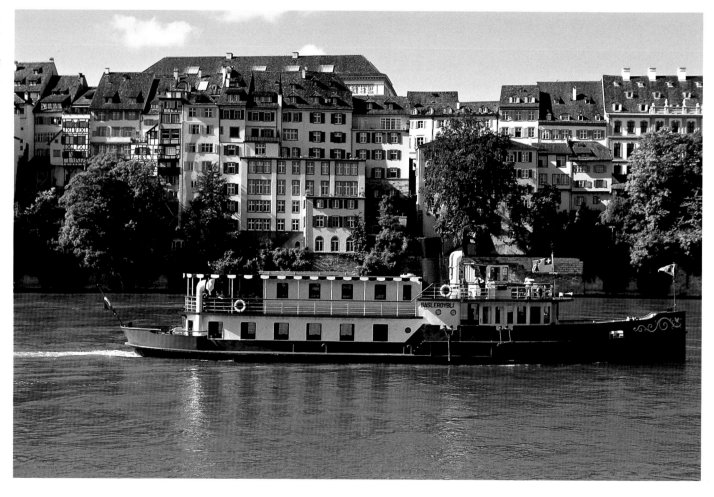

A major river such as the Rhine greatly boosts the quality of life in any city. As only a handful of freighters pass through Basel, the river can safely be used for a number of sporting events.

One of the best ways of crossing the Rhine is on one of the half-open barges operated as a ferry, all of which are chain operated and driven only by the river current. The ferryman or woman is always pleased to engage in a pleasant exchange or provide passengers with snippets of interesting information.

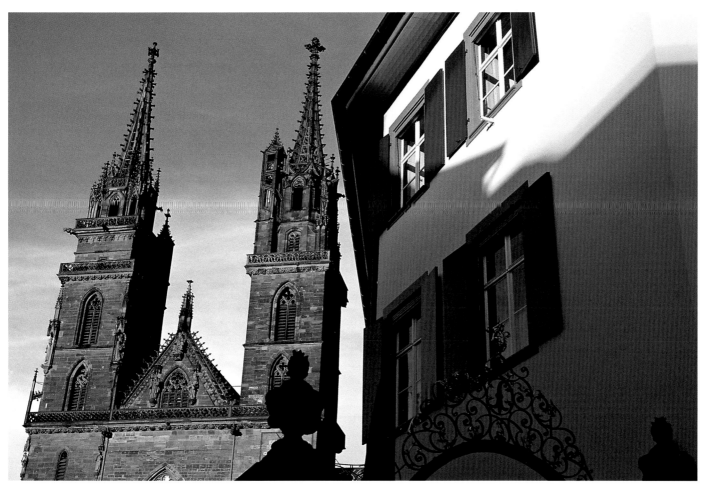

Up on a hill in the old town is Basel's minster which originated in the 9th century. Its colourful roof, and particularly the red sandstone from the Vosges, lend the church a great warmth. The Galluspforte on the transept is Switzerland's chief Romanesque building sculpture.

Left page:
Berlin isn't the only place with a red town hall. The prestigious edifice in the city of Basel was gradually assembled over the course of four hundred years, namely between 1504 and 1904. The ornamental facade goes back to the 17th century.

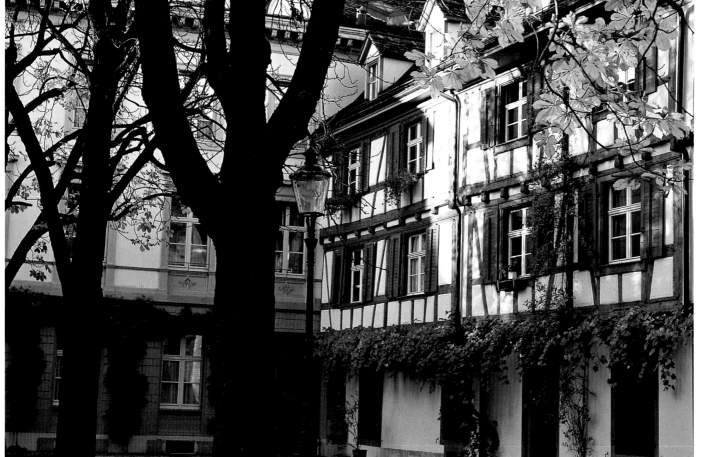

Half-timbered houses line the city side of Münsterplatz outside the cathedral, creating a friendly and pleasing atmosphere.

A successful union:
art and architecture in Switzerland

A t last!" we could cry. At last many famous Swiss artists have found a suitable home within their homeland. At last they have been given an honourable place at a number of exciting museums, whose architecture, interior design and transparency lend the work of Alberto Giacometti or Paul Klee a lightness not immediately associated with Switzerland.

In the past few years art and architecture have entered into a number of successful unions here. These marriages have not only drawn attention to the aesthetic common bond which enjoins them but also served to heighten awareness of art itself. One such recipient of increased public attention is Ferdinand Hodler, for example, the most famous Swiss painter of the 19th century. Born into a poor family in Bern, he began his artistic career at the Musée Rath in Geneva at the age of just 20. An expressive, colourful manner of painting and monumental motifs characterise the work of the learned decorator who moved with the times – from Realism to Naturalism to Symbolism before the turn of the 19th century. No large, self-respecting museum in Switzerland would be without at least one painting by Hodler, made an honorary citizen of Geneva in the year of his death 1918.

The wonderful mechanical sculptures of Jean Tinguely (1925–1991) clatter, bang and drone merrily in the centre of Basel. At the behest of Tinguely's native city star Ticino architect Mario Botta created a suitable modern setting for the sculptures in 1996 in Solitudepark on the banks of the Rhine

opposite the old town. Children and adults alike have great fun bringing Tinguely's perfectly conceived, anarchic, magical world of machines to life simply by pressing a big red button. His contemporaries, among them his wife Niki de Saint Phalle, Yves Klein and Bernhard Luginbühl, have also found a home in the Botta building.

Making waves in the Alpine foreland: the Paul Klee Centre

The Paul Klee Centre on the edge of Bern is like an exotic spaceship landed in the midst of lush Alpine pastures. Opened in 2005, the museum is perhaps the most spectacular in Switzerland. The three domes of steel and glass are not just a museum; they are more a landscaped sculpture with an artistic content, the focus of which is the person, life and work of the multifaceted artist Paul Klee (1879–1940). The building, designed by major Italian architect Renzo Piano, has provided the canton with an important cultural venue; fine art, music, theatre and dance, literature and art mediation are all instrumental in illuminating the ca. 4,000 works by the painter, drawer and graphic artist on display at the Bern centre. This thus owns about 40% of Klee's creative legacy; nowhere else in the world can boast such an extensive collection by just one world-famous artist.

Incorporating elements of Jugendstil, Expressionism and Surrealism into his work Klee found his characteristic style chiefly in his late period. Klee fell ill in 1935; after Hitler's rise to power his native Switzerland became a small place of refuge for the man who had long lived in the big wide world, teaching at the Bauhaus in Weimar and acting as professor at the academy in Düsseldorf. Looking at the exhibition is thus akin to a study of the troublesome history of Europe in the 20th century. Its countless angels are tragic yet beautiful symbols of what was for Paul Klee such a fatal period.

Center:
The Paul Klee Centre on Ostring in Bern is like a space ship which has landed with its nose in the grass. The art museum designed by star architect Renzo Piano holds about 40% of Klee's oeuvre, much of which used to be on show at a number of different locations.

They bang, clang and rattle like there's no tomorrow: the sculptures by Swiss artist Jean Tinguely, technical masterpieces fashioned with great wit and a huge sense of fun. The biggest collection of his work is to be found at the Museum Tinguely in Basel, built in 1996 by Mario Botta on the north bank of the Rhine.

Centres of the arts

Zürich, the economic and cultural pivot of Switzerland, is of course also a centre of the arts. Its Kunsthaus contains one of the most significant collections of art and sculpture in Europe. Nowhere else in Switzerland can so many works by sculptor Alberto Giacometti be admired under one roof. The late oeuvre of the painter's son from Stampa in Bergell in Graubünden has received world acclaim; his matchstick figures mounted on thick bases have made Giacometti famous all over the world.

Left:
This international bank in Basel is also the creation of the Mario Botta architectural bureau. His buildings are famous for their lightness in which the interplay of light and shape plays a major role.

The Kunsthaus also provides a good overview of Swiss art of the 18th and 19th centuries, including many works by JH Füssli, Arnold Böcklin and Giovanni Segantini (1858–1899). The latter focused his entire creative output on the Alps and the hard lives of the people living there. In 1908 the town of St Moritz thus erected a rather unusual museum in his honour, its exterior more reminiscent of a memorial than an exhibition hall.

The art scene in Basel is world famous, the quantity and quality of which speaks for itself. More surprising are the cultural gems you are likely to unearth out in the sticks, such as the Kunsthaus in Aarau, for example. Half way between Basel and Zürich, it houses an extensive and outstanding collection of Swiss painting, sculpture and graphics from the 18th century to the present day which would greatly honour any national gallery. Modern architecture in Aarau also pays homage to art; in 2003 the local art gallery moved into an ensemble designed by Swiss architects Herzog & de Meuron. The powerful sense of creativity of the new structure respectfully emphasises the art of old.

Nanas, brightly coloured, voluptuous female figures, are what made Niki de Saint Phalle famous. Here they adorn the Olympic Museum in Lausanne.

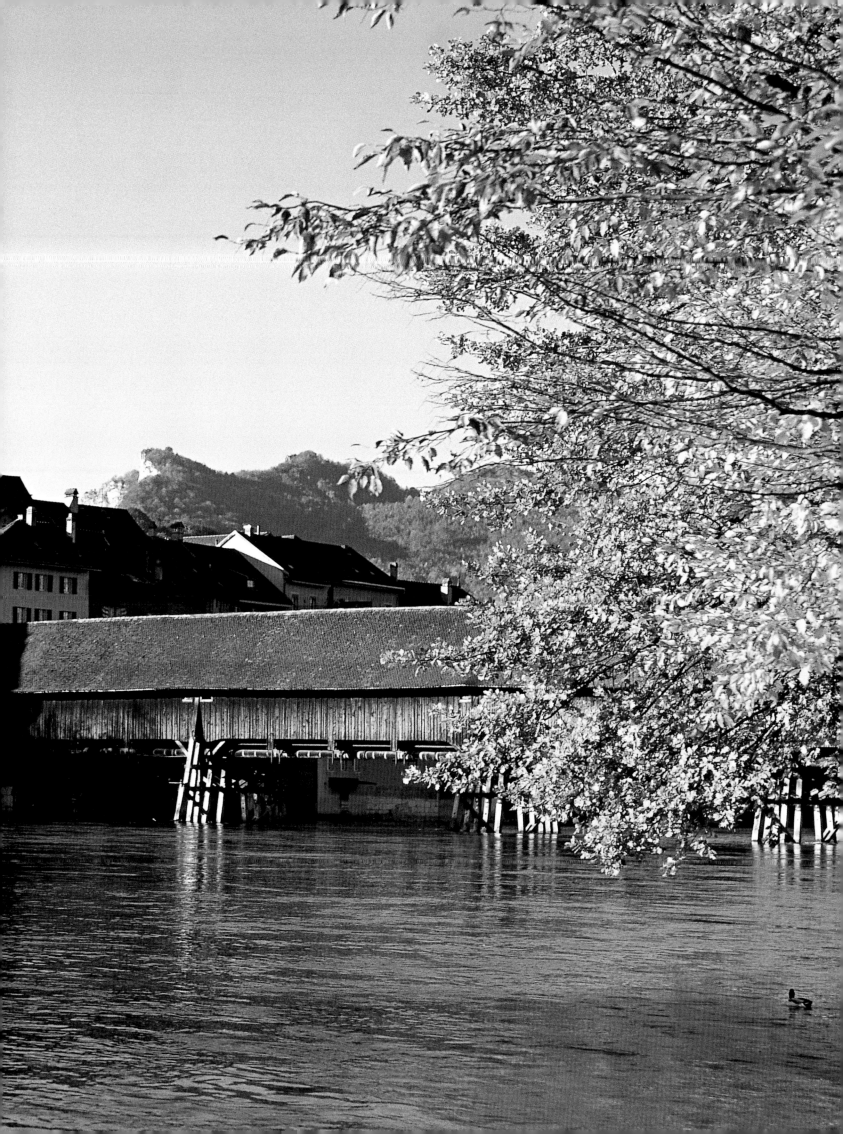

Page 84/85:
The River Aare runs through the middle of the little town of Olten in the canton of Solothurn. Its peaceful old centre seems far removed from our modern world – and light years away from the bustle and industry of Olten's major railway junction.

Just a few miles south of Basel the cathedral of Arlesheim is one of the most beautiful sacred Rococo buildings in the country. Built between 1679 and 1687 the church took on its present appearance during the 18th century when major work was done on it.

Part temple, part spaceship, the Goetheanum in Dornach is the world centre of anthroposophy. The concrete structure was erected between 1925 and 1929 from plans made by Rudolf Steiner after the first was destroyed by fire. The lack of right angles makes the building extremely unusual.

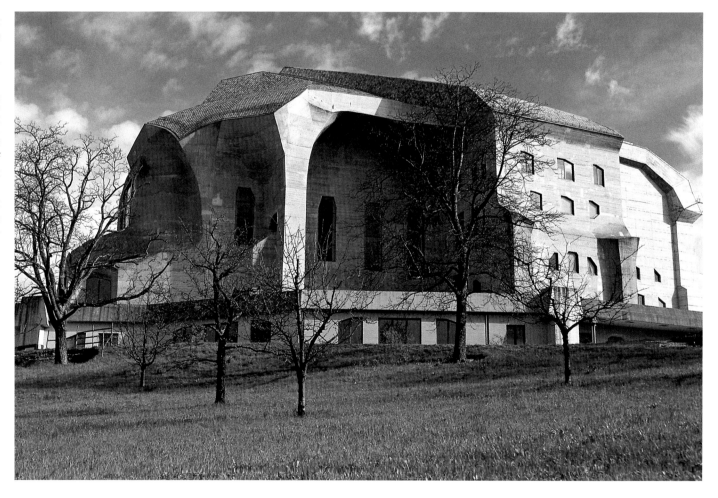

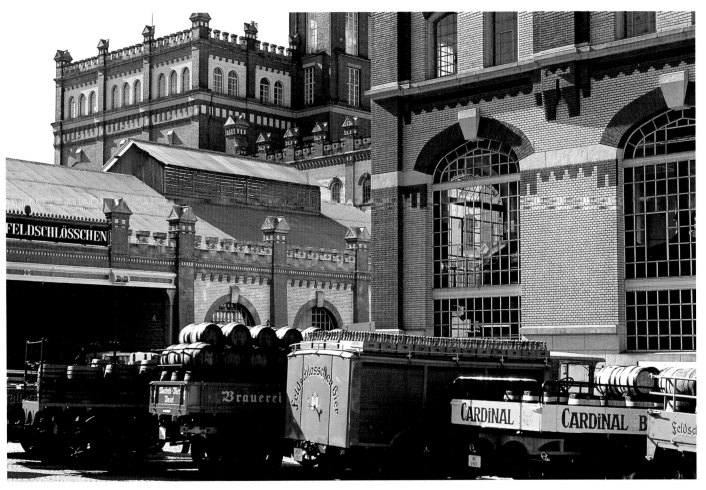

Zero Rhine kilometres not only marks the spot where the river becomes navigable but also where Rheinfelden can be found, established by the Zähringers. The town is famous the world over not just for its pretty town centre but also for having the biggest brewery in Switzerland, the Feldschlösschen-Brauerei.

The brewer hasn't got far to go for the ingredients he needs; the hop gardens are a mere stone's throw from Rheinfelden.

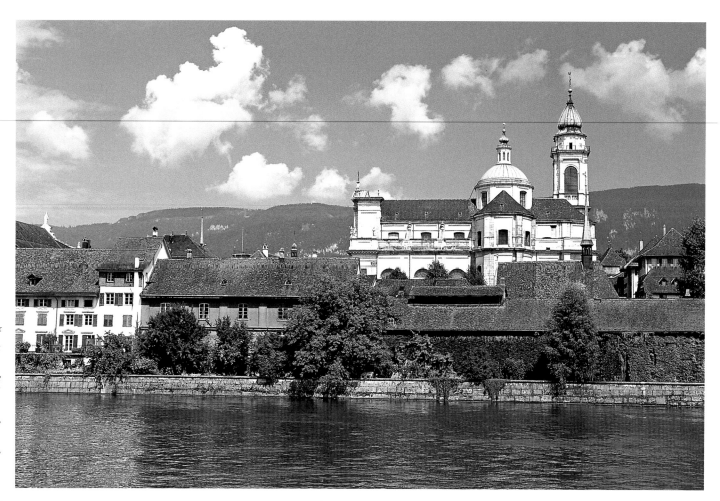

The cathedral of St Ursen dominates the town of Solothurn on the Aare. The many baroque and Renaissance buildings here give the capital of the canton at the foot of the Jura Mountains a distinctly French air.

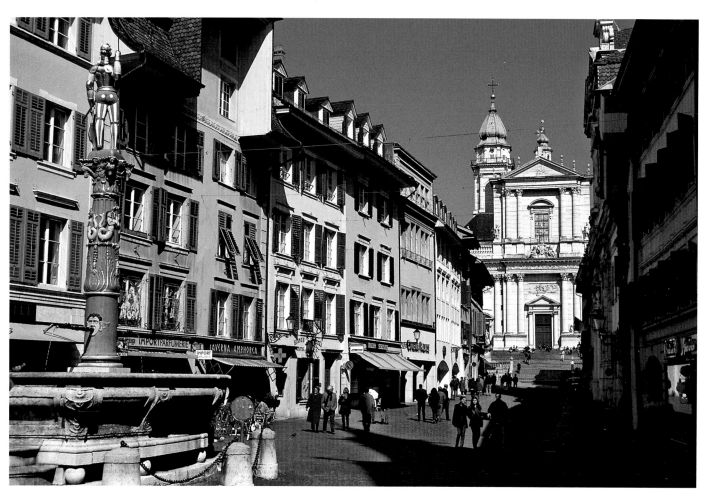

Old Solothurn has many churches and fountains; there are eleven of each! On the pedestrianised Hauptgasse the Mauritiusbrunnen and cathedral form a pleasing axis.

88

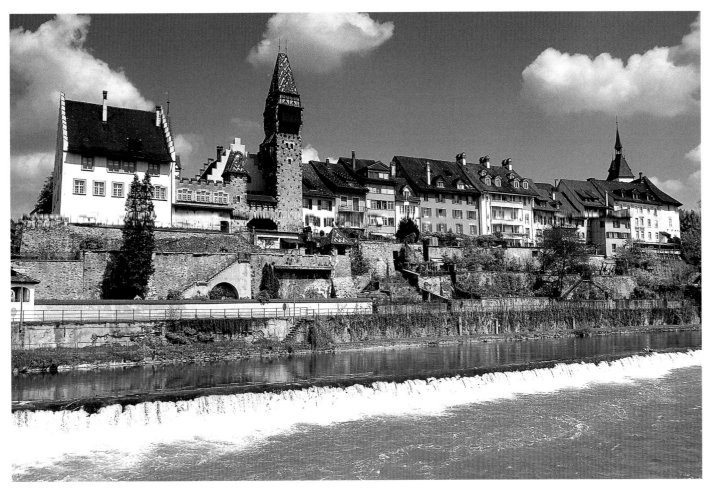

The Reuss River winds its way through Central Switzerland on its way north to the Aare and later the Rhine. The little town of Bremgarten in the canton of Aargau takes up a defensive position on the river bank.

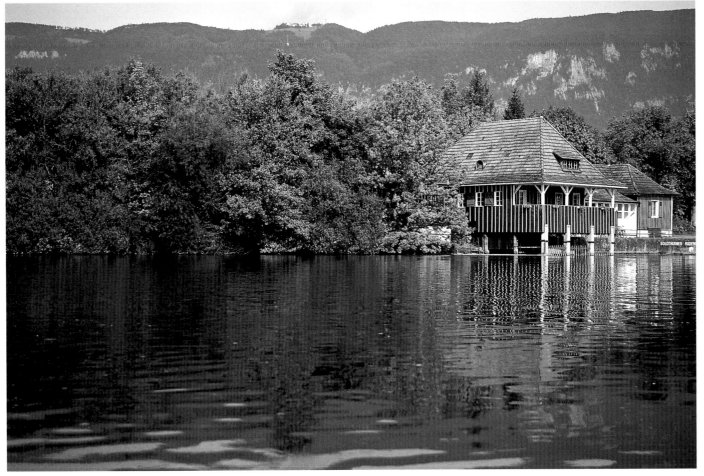

The Aare takes in vast amounts of water on its long journey from the glaciers between the Schreckhorn and Finsteraarhorn (canton of Bern). Although a long way from the Alps here near Solothurn its waters are still crystal clear.

89

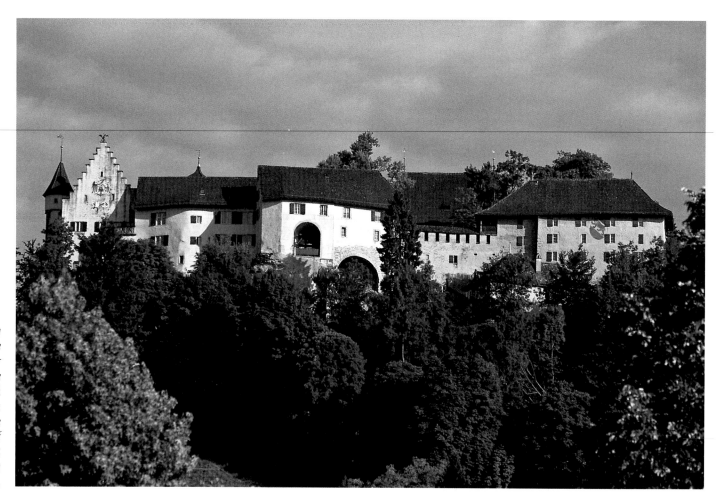

Schloss Lenzburg atop its sizeable castle mound is visible for miles around. The mighty complex high up above the town of the same name houses the canton of Aargau's historic museum, among other things.

At the north end of the Hallwiler See is the moated castle of Hallwil. Its serene beauty modestly echoes that of the lake district which stretches from Lucerne to Aarau. Less famous than Lucerne, Thun and Geneva, the local waters of the Sempacher, Baldegger and Hallwiler See have remained largely unspoilt.

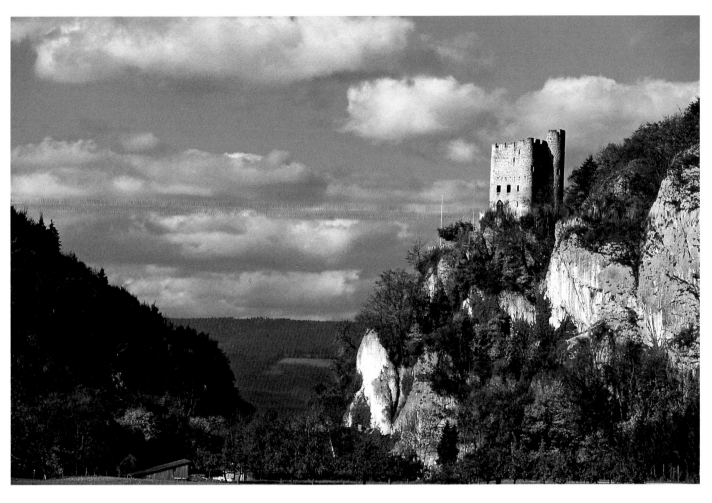

Up above the Lüssel in the limestone peaks of the Jura is Veste Thierstein near Büsserach. After centuries of decay it has now been restored and opened to the public. The fortress marks the spot where the canton of Solothurn practically borders on Basel.

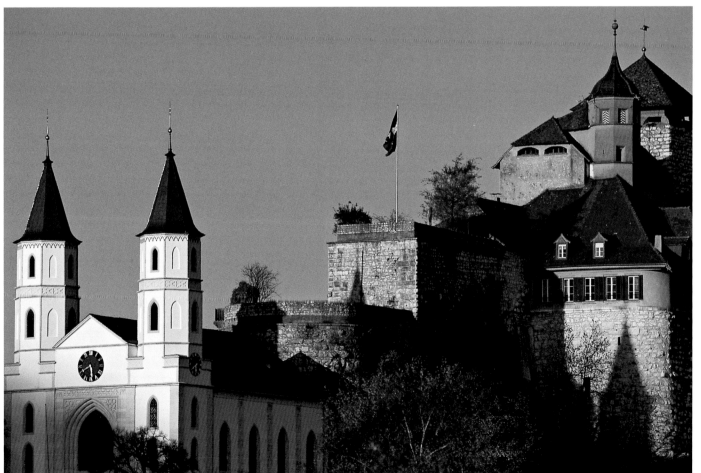

Where the landvogts of Bern once resided young people are now re-educated at a correctional facility. The impenetrable stronghold above Aarburg (canton of Solothrun) mirrors the medieval character of the little town at its feet.

Page 92/93: Schaffhausen in Switzerland is famous for having the mightiest waterfall on the Continent. Across a breadth of 150 m (492 ft) the Rhine crashes down a drop of up to 23 m (75 ft).

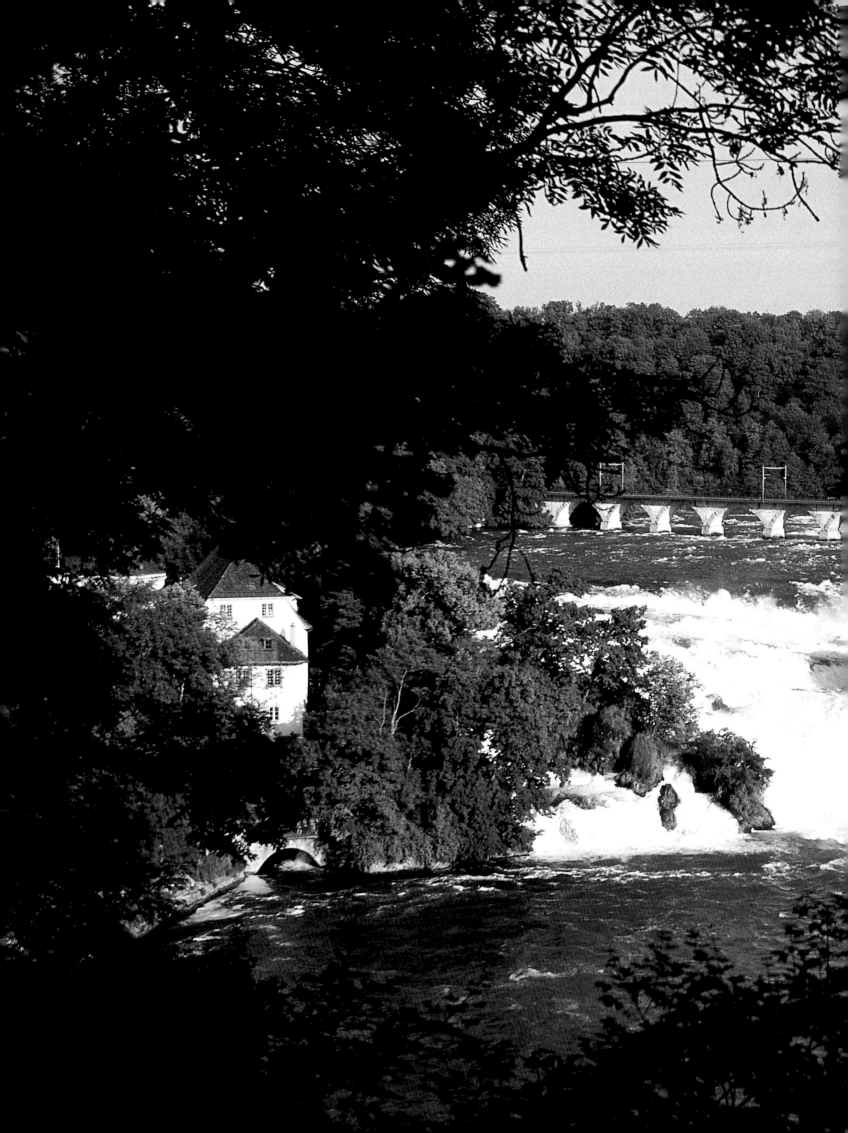

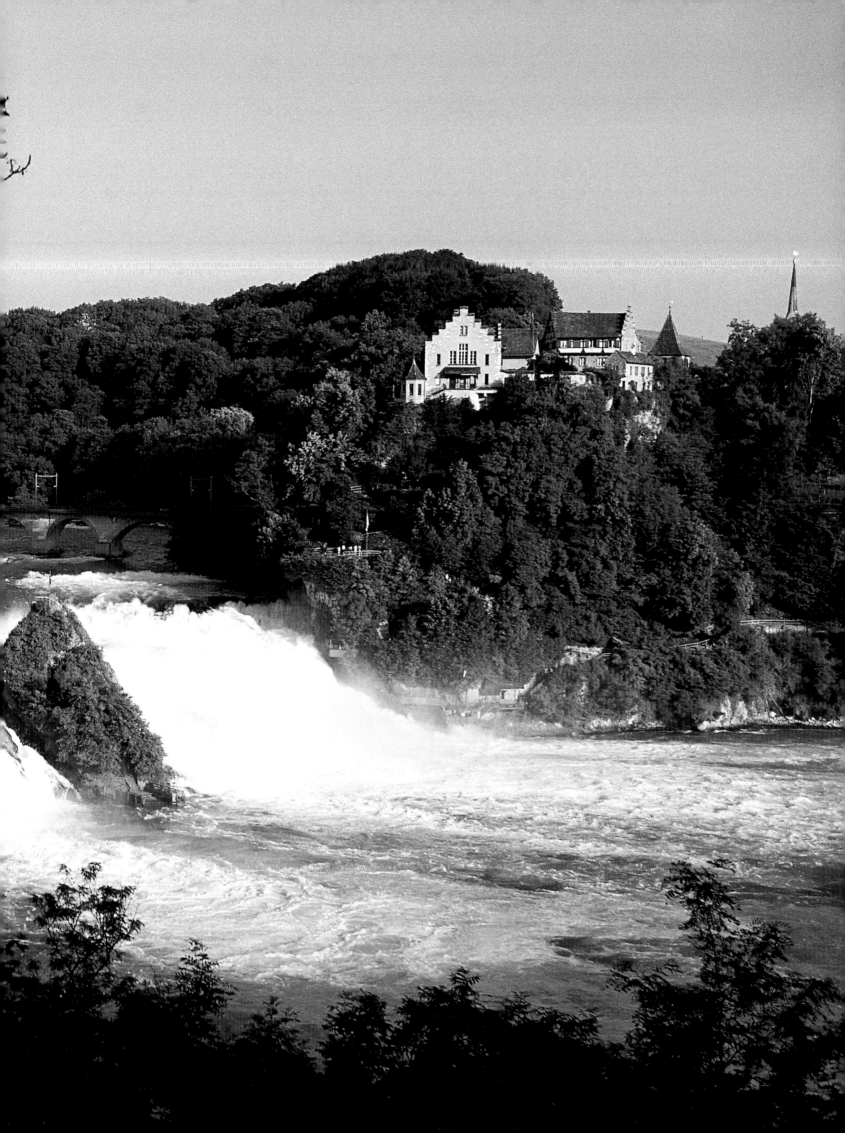

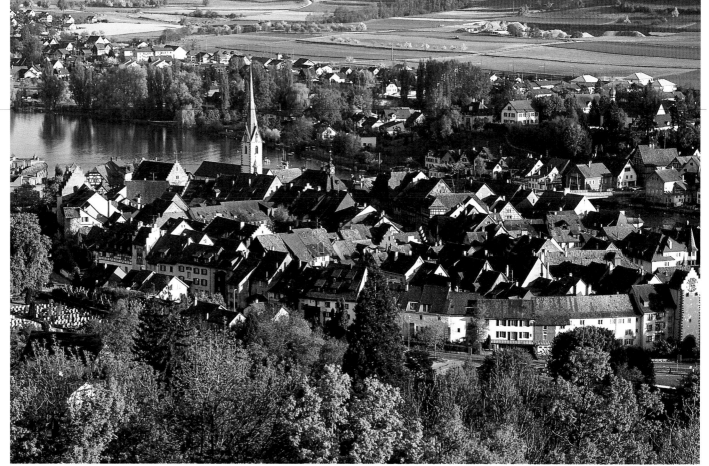

Like so many other towns on the German-Swiss border, seen from high up the little town of Stein is rather unassuming. Closer to it is an absolute gem, its medieval streets and houses forming a perfect and extremely pleasing ensemble.

Wonderful frescoed facades, oriels, town gates and half-timbering are what make Stein am Rhein the best preserved medieval town in German-speaking Switzerland. Its wealth of historic buildings is only comparable to that of Morat west of Bern, founded by the Zähringer dynasty.

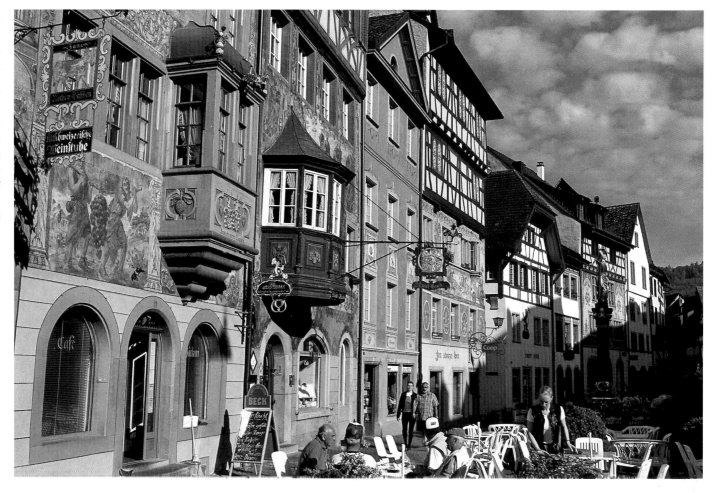

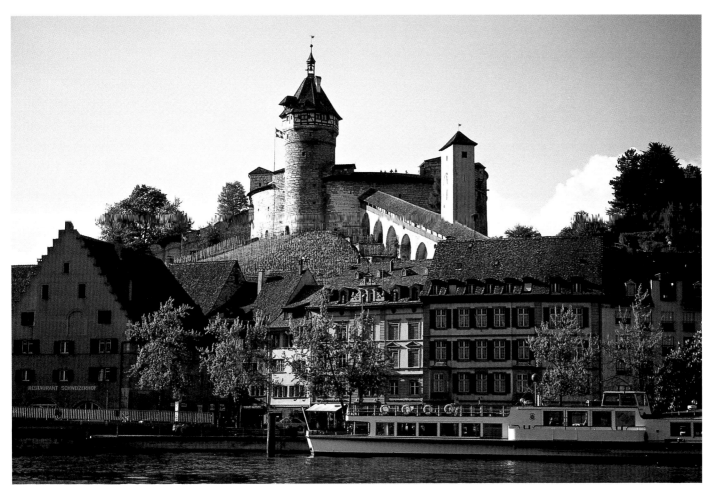

The strong walls, tall towers and battlements of Kastell Munot positivelky dominate the town of Schaffhausen. The vines creeping down its slopes are the most northerly in Switzerland. The canton of Schaffhausen is also the only one in the country to possess territories north of the River Rhine.

The island of Werd near Stein am Rhein. East of Stein the Rhine merges with the Untersee, a side arm of Lake Constance which relentlessly fills the famous river.

Arbona, "good earth", was the name the Celts gave to their settlement on the southern shores of Lake Constance. For centuries the production of canvas brought prosperity to the town, as did the Saurer factory in later years which manufactured Switzerland's famous long-nosed post office vans. Fans of classic cars can pay homage to the objects of their desire at the Saurer Oldtimer Museum.

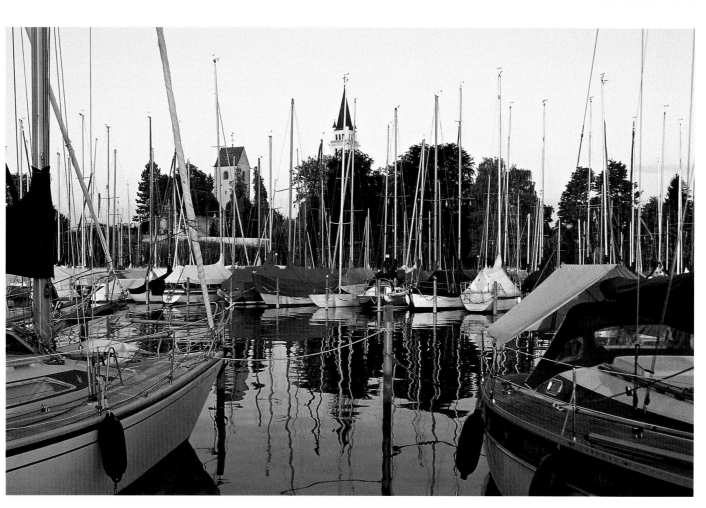

All of the towns on Lake Constance have their own marina. Like here in Romanshorn sailing and motor boats of all shapes and sizes await their owners at the quayside. When sudden thunderstorms rage across the lake in summer, the harbours are indispensable to skippers seeking protection from the elements.

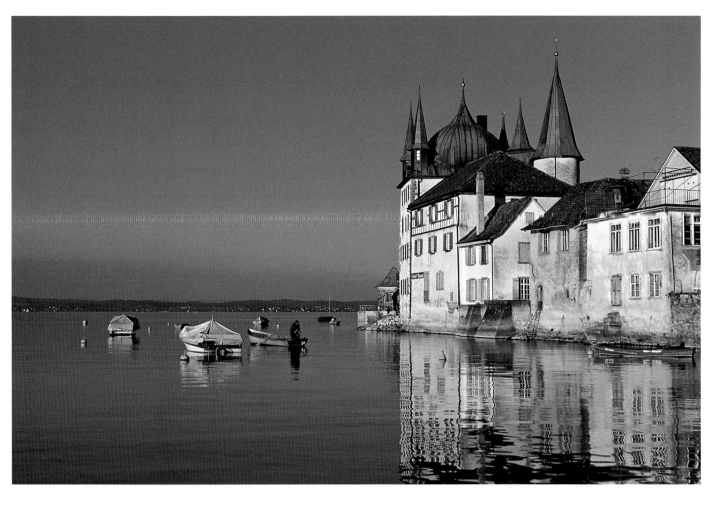

The small Schloss
Turmhof, built by
abbot of Reichenau
Diethelm von Castell
in c. 1320, is the
most significant
building in the town
of Steckborn. The
palace is on the
Untersee or lower lake
on Lake Constance.

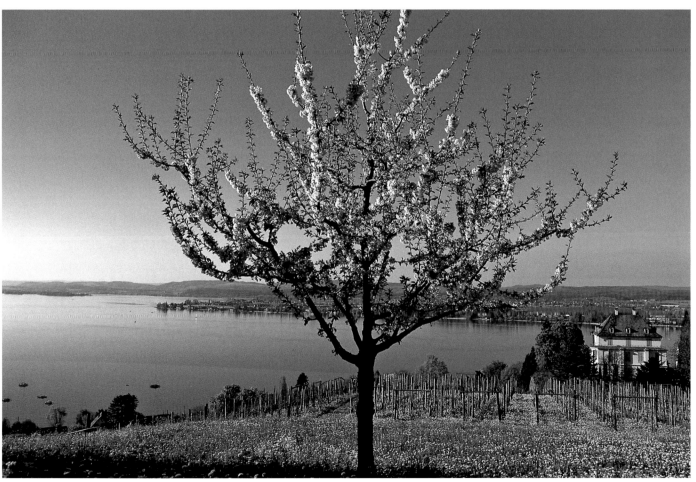

There are grandiose
views of Lake
Constance from
the elevations of
Schloss Arenenberg.
Beyond the island
of Reichenau lies
Germany. The castle,
now used for wed-
dings, was where
Napoleon III spent
much of his youth.

97

Off the beaten track, where the Old Rhine and Lake Constance become one, the beauty of the region is quietly palpable. On the far bank of the river lies Austria.

545 square km (210 square miles) in area and up to 250 m (820 ft) deep, Lake Constance is full of fish. Fishermen can make a good living off the stock of pike, houting and perch which thrive in its depths.

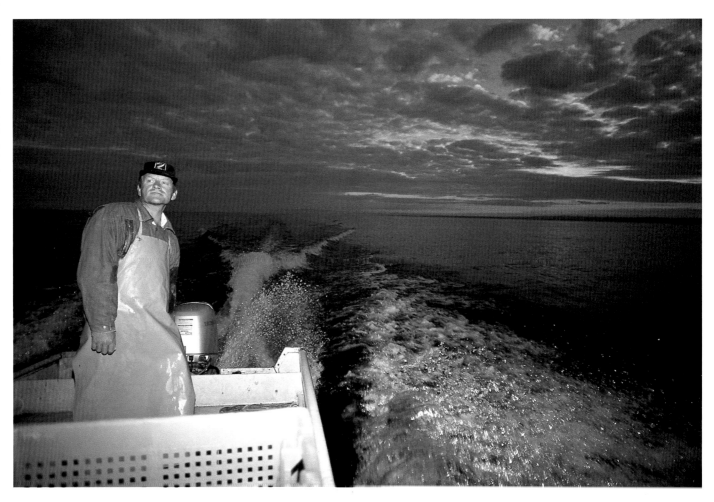

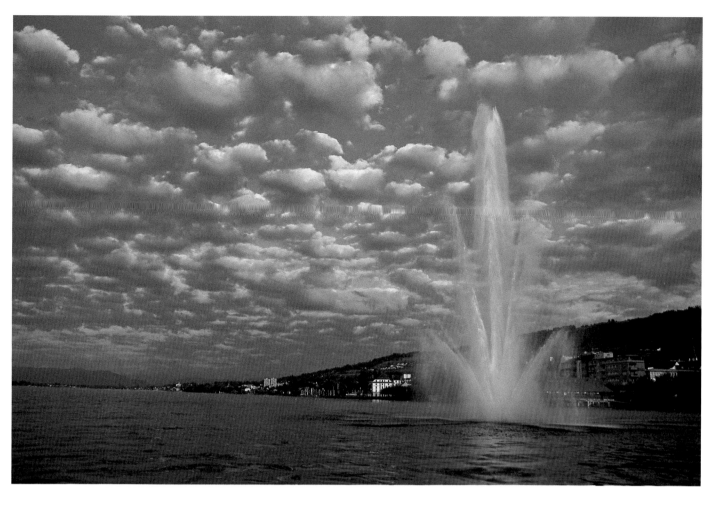

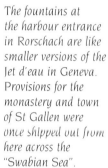

The fountains at the harbour entrance in Rorschach are like smaller versions of the Jet d'eau in Geneva. Provisions for the monastery and town of St Gallen were once shipped out from here across the "Swabian Sea".

Page 100/101: This baroque edifice houses one of the most valuable collections of books in Europe: the monastery library of St Gallen. Tucked into the southwest wing of the former Benedictine monastery, this cultural treasure-trove includes the oldest book in German from 790 and a manuscript of the "Nibelungenlied" or Song of the Nibelungs.

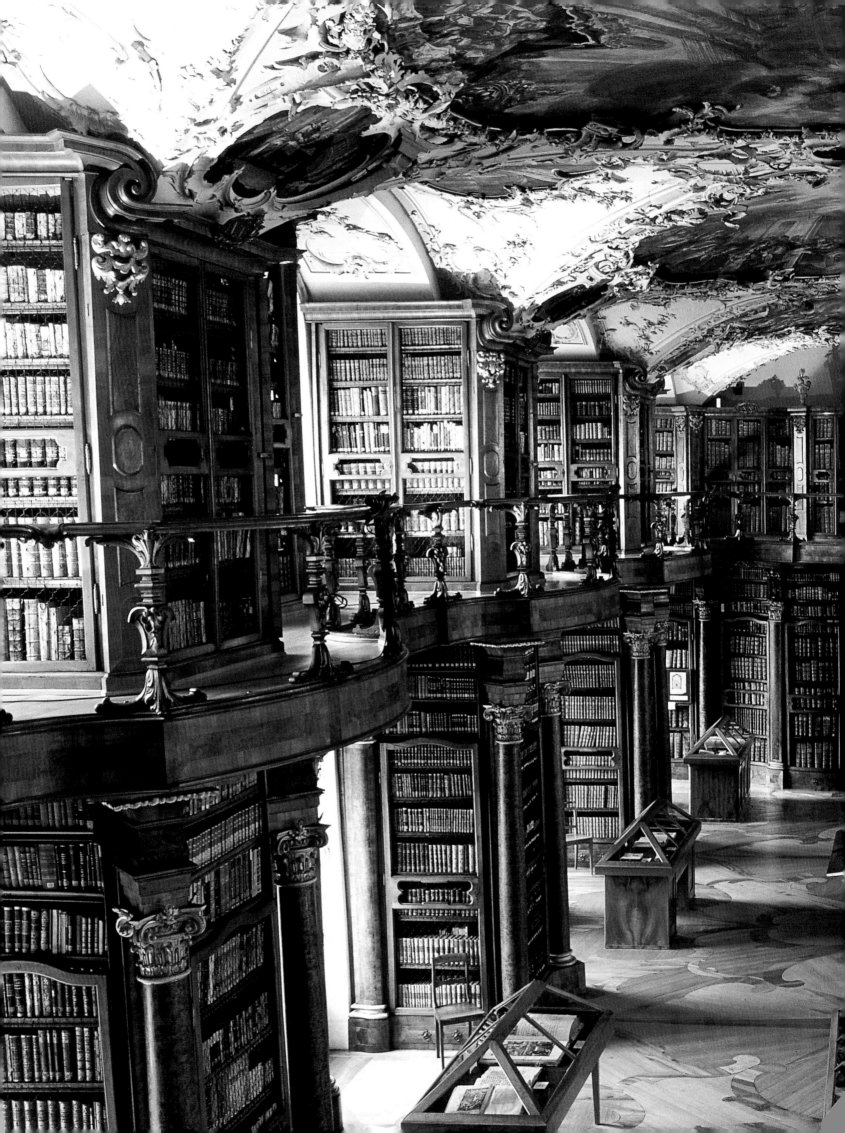

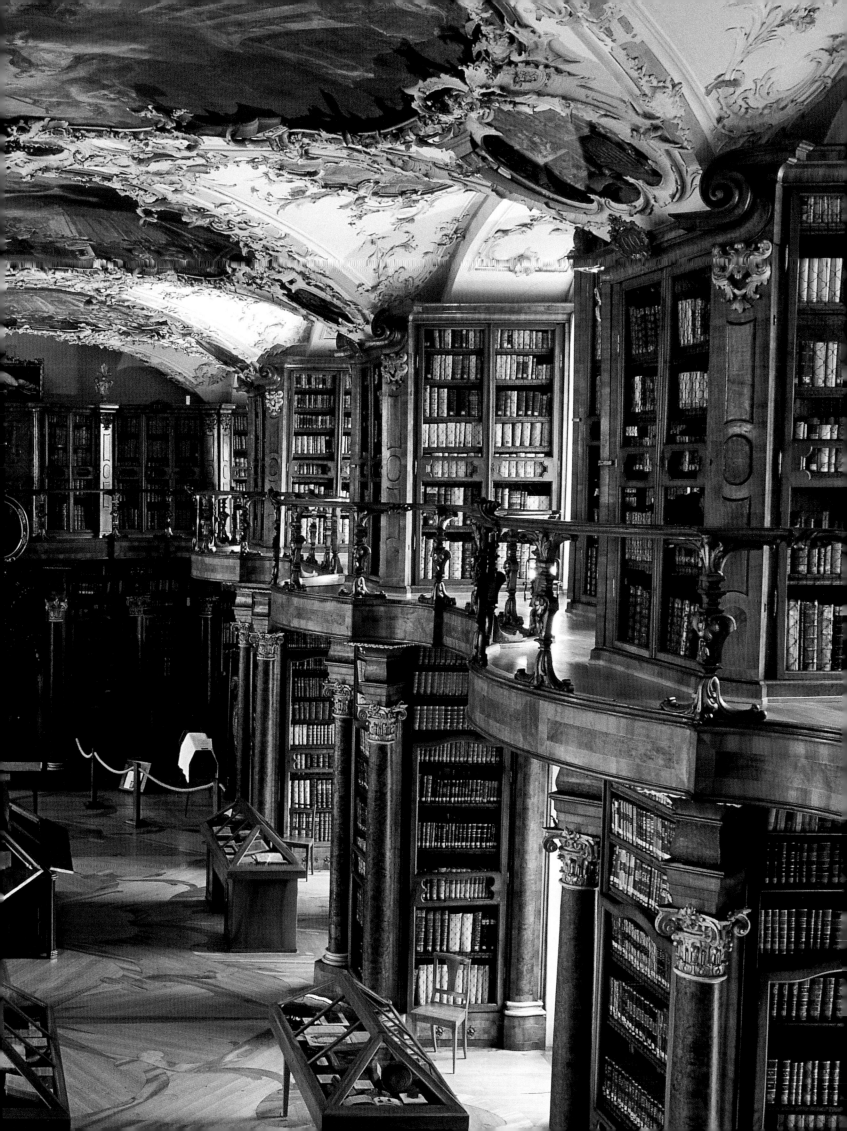

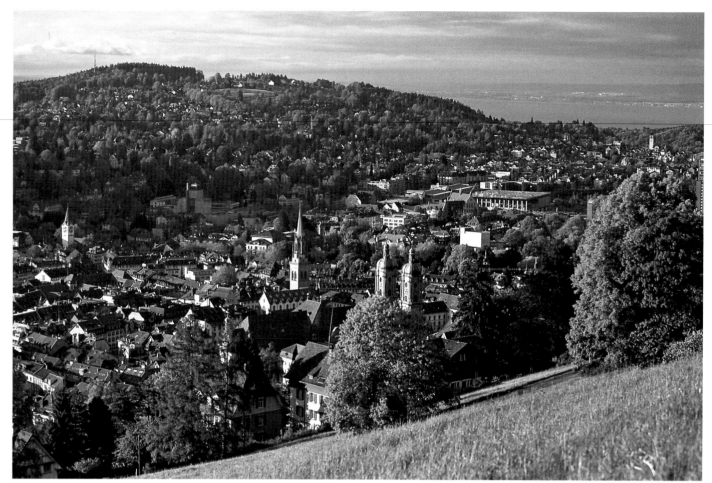

The undulating hinterland of Lake Constance has given St Gallen its unusual topographical layout: steep hills and ridges are predominant in the capital of the canton. St Gallen is the urban centre of East Switzerland. Its rich cultural heritage is undoubtedly best epitomised by the former Benedictineabbey with its monumental collegiate church and ornate library, now a UNESCO World Heritage Site.

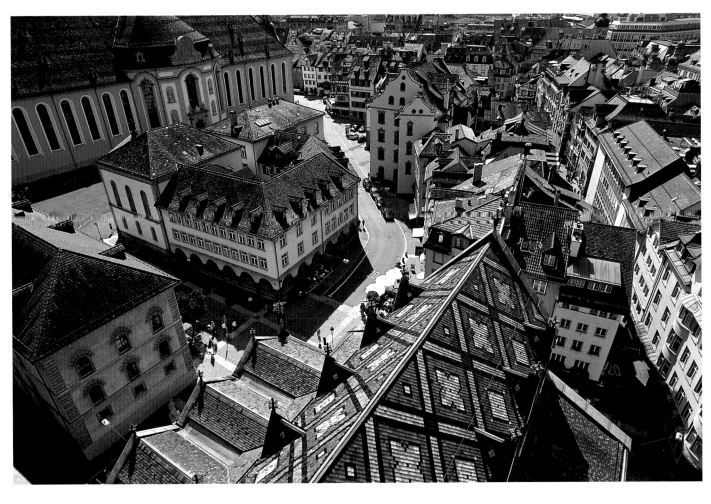

Like so many other Swiss towns St Gallen is also blessed with a picturesque and extremely lively historic centre.

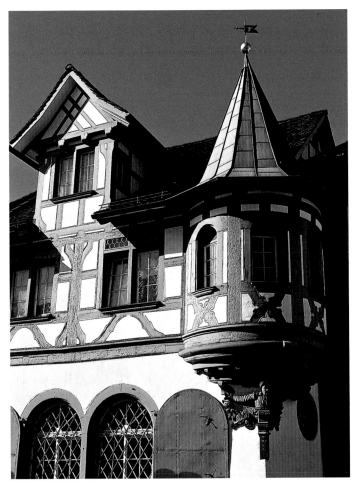

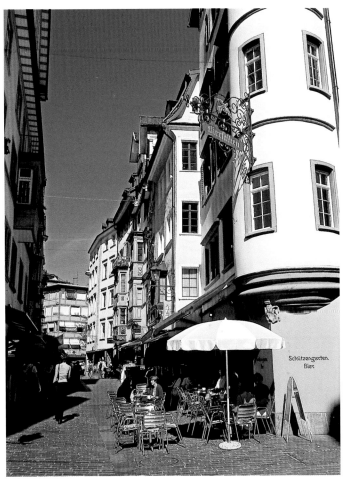

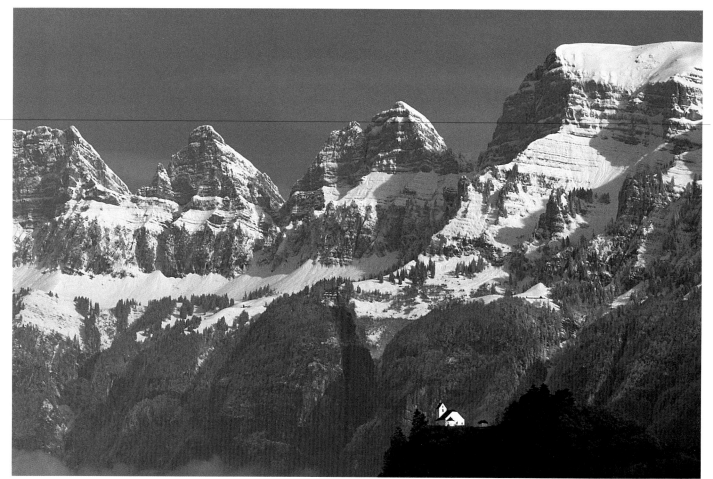

Like the teeth of a saw the Churfirsten Group puncture the sky above the Walensee in the canton of St Gallen. Beyond the lofty peaks in Toggenburg is one of the most scenic ski resorts in East Switzerland.

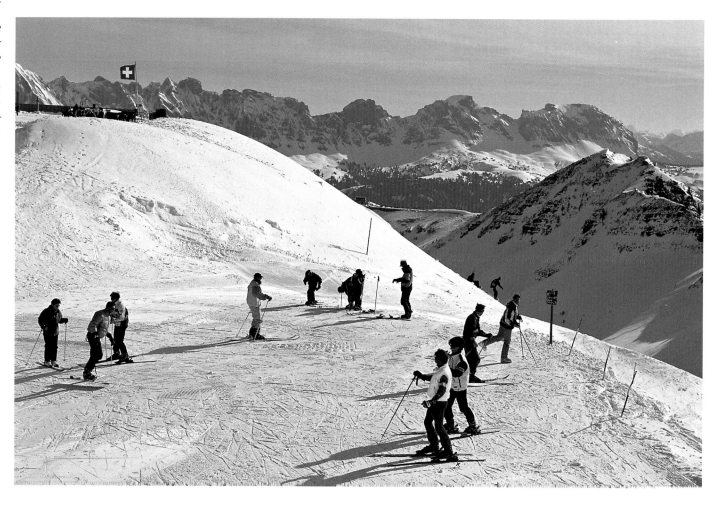

South of the Walensee, more or less opposite the Churfirsten Range, the Flums Mountains provide excellent skiing in the winter and good hiking in the summer.

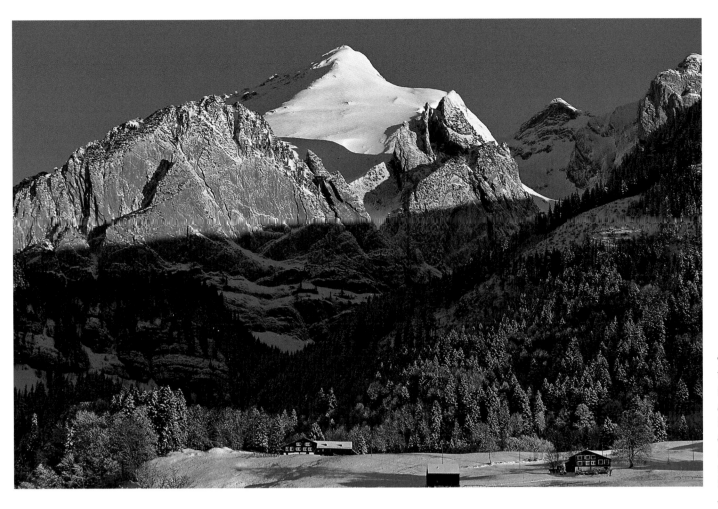

The Schafberg near Wildhaus is one of the most distinctive elevations in the Obertoggenburg area and immediately recognisable by the marked folds along its rock face.

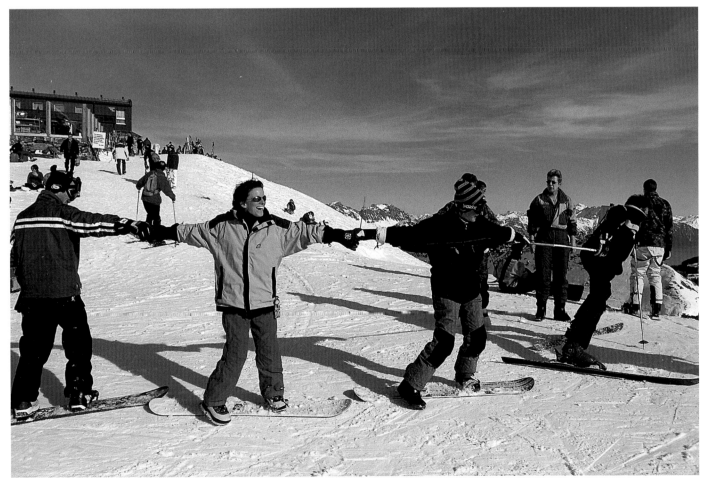

Having fun in the snow on the Flums Mountains. Their northern aspect promises good skiing conditions quite early on in the season.

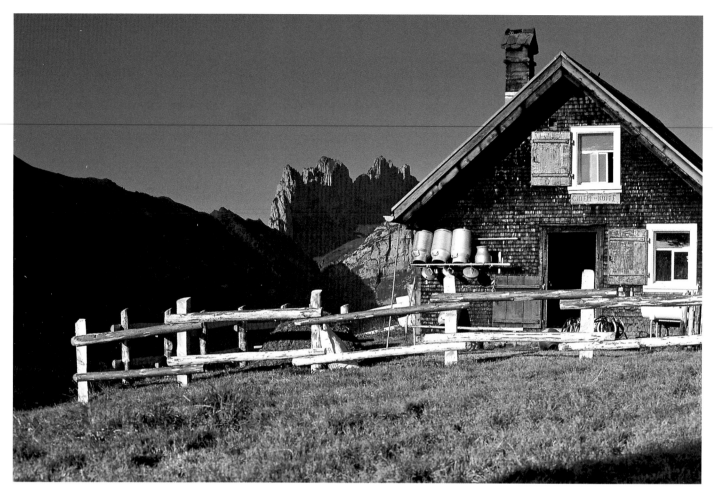

Just four percent of the Swiss population still works the land. The family-run holdings, most of which farm cattle, are crucial to the upkeep and preservation of the ancient cultural landscape.

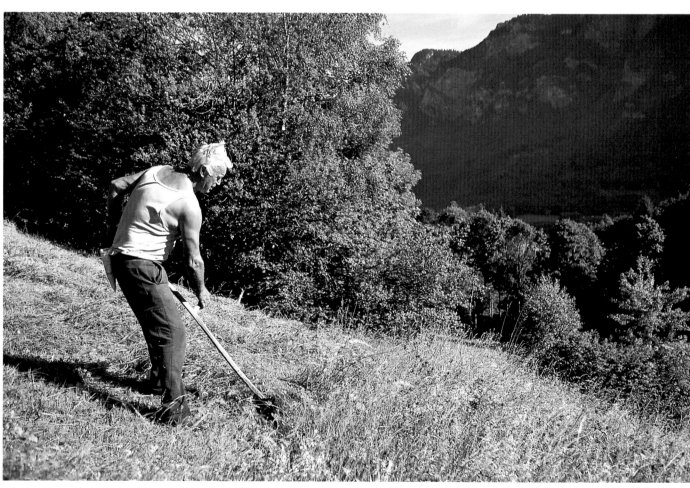

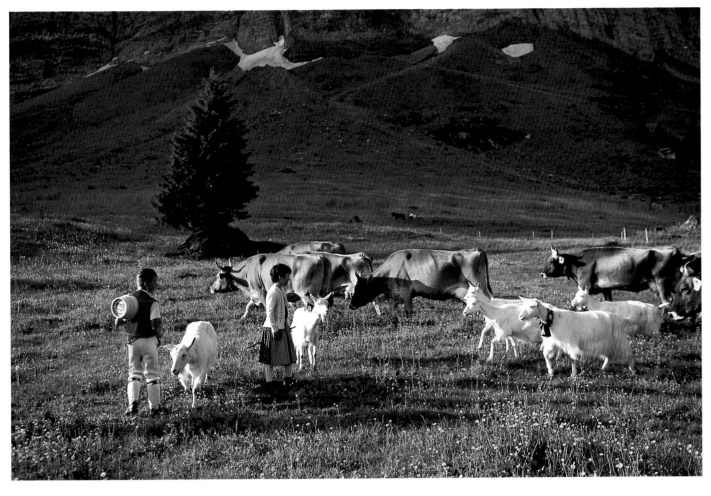

Farming the Alps
not only results in
top-quality cheese
and milk products
but also guarantees
the welfare of the
natural environment,
tested to its extremes
by the elements.
The running of the
small farms here is
expensive; 78 percent
of a farmer's income
is subsidised by
the state which allots
about eight
percent of its budget
to agriculture.

Cheese and other culinary delights

The secret lies in the meadows. Both in the foothills of Lake Constance or high up on mountain pastures, where Nature is at her purest the grass tastes best – if you're a cow, that is. More than practically anywhere else in Europe dairy produce positively monopolises the cuisine and eating habits of the Swiss. Whether cheese, chocolate, meat or sausage produced in Switzerland, you have to be exceptionally unlucky to come across a second-rate product; delicious, top-quality food is practically guaranteed.

Käse, formaggio, fromage: a miniature feast

The carefully engineered subsidy policy of the Bern government of course has a major role to play in shaping the Swiss diet. Over a thousand village dairies making the finest cheese with great expertise owe their mere existence to it. The best-known hard cheeses from such establishments include Appenzeller from East Switzerland, Gruyère from French Switzerland and of course Emmental. The epitome of Swiss cheese gets its characteristic holes from carbon dioxide gas which is formed during the ripening process and makes bubbles in the cheese which can't escape. If you like your cheese even harder, you could try Sbrinz which is primarily manufactured in Inner Switzerland. Muscles are required if you fancy a slice of "monk's head"; Tête-de-Moine is served in long curly slices scraped from the block with the round, specially developed *Girolle* knife. This speciality cheese comes from the bleak mountains of the Jura.

Cheese soups and cheesecake may be found on local menus in many regions; cheese fondue and raclette, both from West Switzerland, have become synonymous with Swiss cooking far beyond the national boundaries. If you prefer lighter, low-calorie dishes, then these are to be avoided; for lovers of good hearty fare fondue or raclette is an extremely tasty and communicative affair. Fondue consists of melted cheese in wine flavoured with pepper and kirsch and cooked in a clay casserole. Pieces of white or brown bread are dipped into the hot gooey liquid on a long fondue fork. *Gschwellti*, boiled potatoes, and half a raclette cheese are the main ingredients of raclette; the cheese is heated along its cut surface and the melted part scraped off and eaten with the potatoes. Favourite nibbles for both dishes are pickled silverskin onions and small gherkins.

Sausages, cockerel and whitefish

If you like savouries, then you'll find it hard to resist the vast assortment of Swiss sausage. Graubünden is particularly prolific in this department, from *Salzis*, a tiny salami made from pork and wild boar, Engadine sausage and *Beinwurst* to *Bündner Fleisch* or dried and cured beef. *Krautwurst* and liver sausage are a speciality of French Switzerland as are *Longeoles* from Geneva, pork sausages spiced with caraway and aniseed.

Mistkratzerli ("dung scratcher") and *Güggeli* ("cockerel") are just two of the terms you'll find roast chicken sold under in the north of Switzerland. It's not so difficult to guess where *Zürcher Gschnetzeltes*, strips of veal in a cream sauce, comes from (Zürich) and locating *Berner Platte*, a mixed pork platter served with large helpings of sauerkraut, is also not that tricky. A must when eating out in Switzerland are *Rösti*, crispy fried potatoes which have been boiled and grated before being thrown into the

Right and centre: Traditional cheese manufacture: within twelve hours of milking the milk is already being processed at the dairy. It's heated in the cheese vat and mixed with rennet and lactic acid bacteria. The curd is cut with a special wire slice called a cheese harp which siphons of the excess liquid or whey from the solid mass.

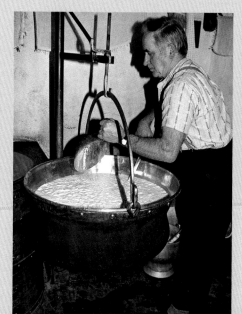

pan. They can even be enjoyed as a main course, although usually they act as the staple carbohydrate in German-speaking Switzerland, together with *Härdöpfelstock* or mashed potato. South of the main ridge of the Alps, in Ticino and Graubünden, polenta and risotto are fixed items on local menus. The close proximity to Italy is also evident in the variety of pasta on offer here; the ravioli served in indigenous restaurants is light years away from the stuff you used to get out a tin as a child.

If you're a connoisseur of fish, don't be put off by the great distance from the mountains to the sea. Switzerland's crystal clear waters are home to the finest fish which delight many *chefs d'haute cuisine*. Pike and small perch can be fished out of almost all of the large lakes; trout swims merrily in practically all of the country's mountain streams. And if whitefish and char are your thing, the hostelries of Lake Geneva and Lake Neuchâtel will be happy to still your appetite with some very tasty dishes indeed.

Death by chocolate

What Emmental has done for cheese, namely inextricably link its country of origin to the finished product, Toblerone has done for chocolate. Its triangular allusion to the Matterhorn requires no further comment. Even more mouth-watering are the delicacies produced with great love and attention to detail by countless private confectioner's. Champagne truffles, pralines and wafer-thin chocolate slices are designed to simply melt in your mouth. Fans of original Swiss chocolate advertised profusely in supermarkets and tourist shops should read the labels very carefully, however; due to the high price of powdered milk in Switzerland, many bars bear the words "Hergestellt in Deutschland" or "Fabriqué en France"...

Left:
Fondue is a typical Swiss cheese dish which consists primarily of melted cheese and is usually eaten in the cold winter months.

Page 110/111:
The snow-capped Alps under brilliant blue skies you find depicted on souvenir boxes of chocolates – maybe with an Edelweiß or two tucked in the corner – can be deceptive; their dangers are not to be underestimated, especially in bad weather. Here, the Alpstein Massif which divides the east of Switzerland from the Rhine Valley shows itself to be bleak and inhospitable.

Below:
Developed in 1908, it wasn't long before the decidedly triangular Toblerone bar with its famous logo became synonymous with Swiss chocolate. The name "Toberlone" is a fusion of the name of chocolate manufacturer Tobler and the Italian word for honey and almond nougat ("Torrone").

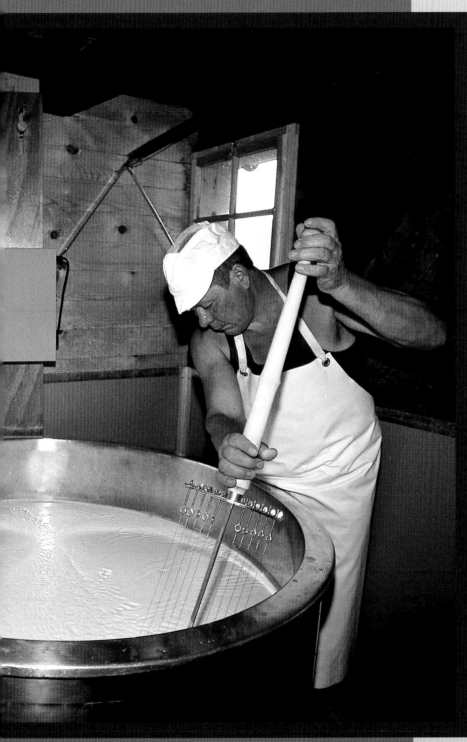

109

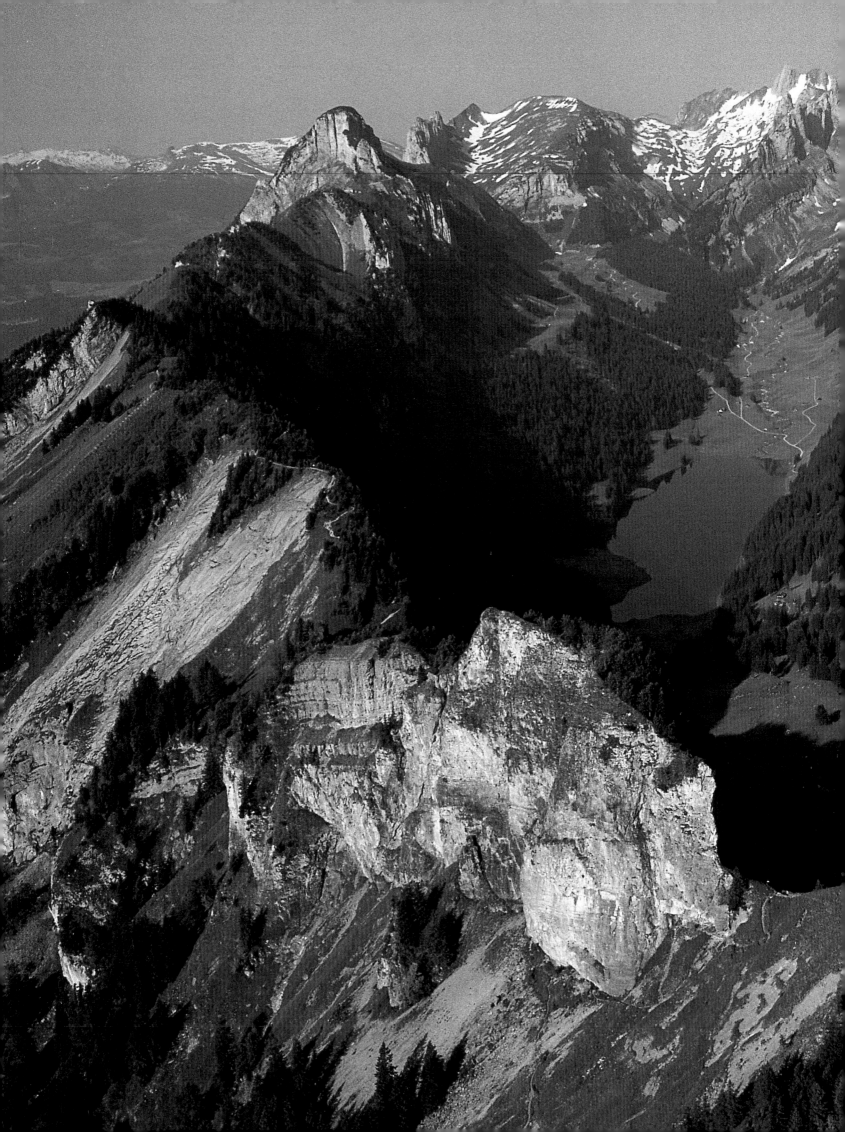

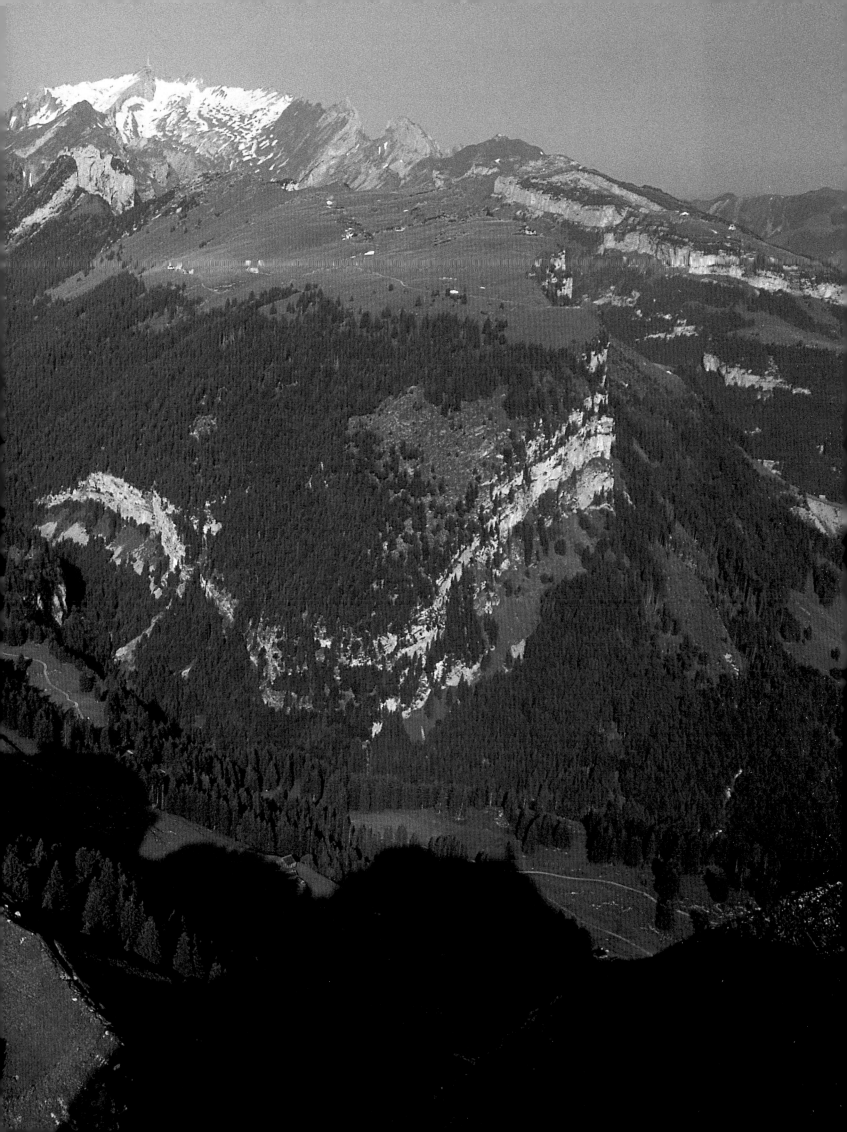

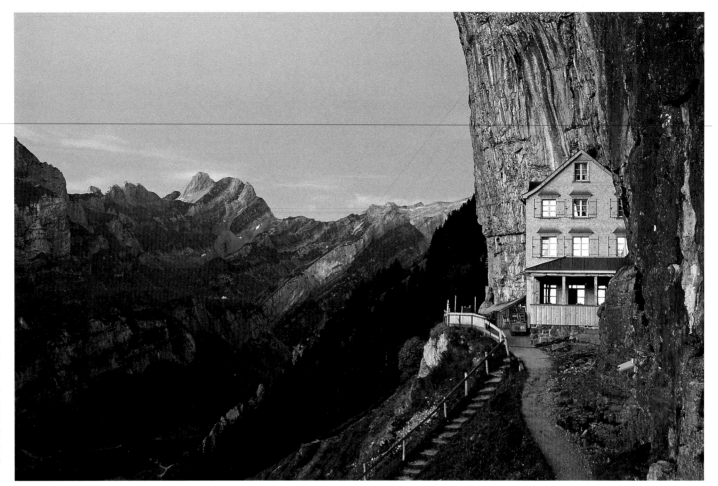

One of the most scenic mountain huts in Switzerland, Aescher-Wildkirchli, is far off the beaten Alpine track, squeezed under a rock ledge 1,454 m (4,770 ft) up above Ebenalp in the canton of Appenzell.

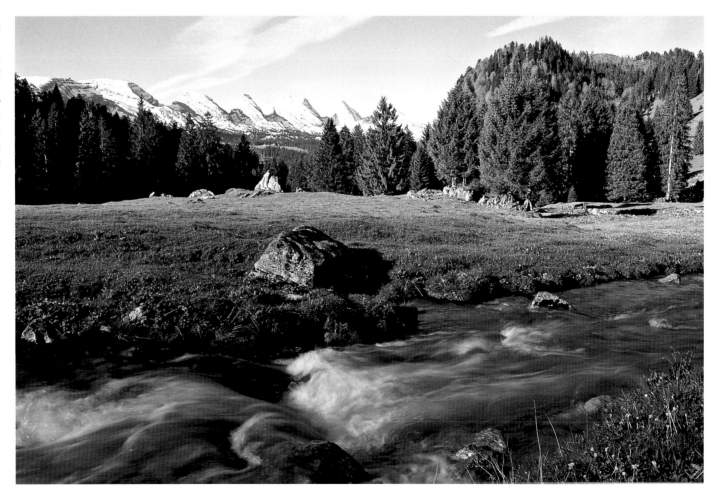

The tops of the Churfirsten Group peak out beyond the Thur Valley in the Obertoggenburg area. The River Thur travels more or less the whole of East Switzerland before flowing into the Rhine south of Schaffhausen.

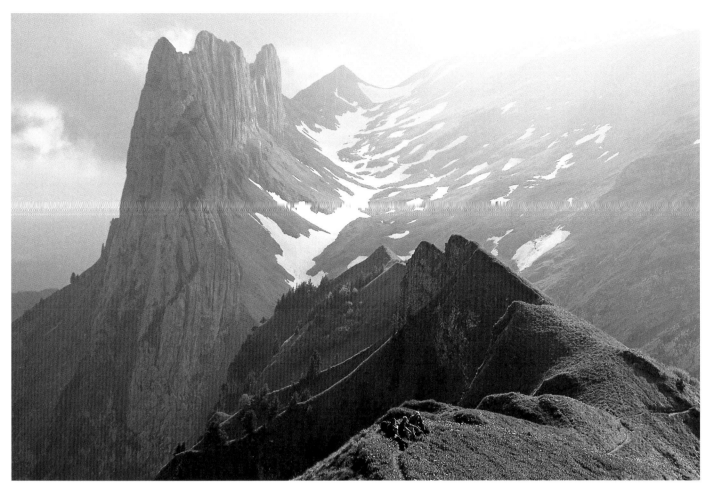

For hikers and climbers the eight summits of the Kreuzberge are one of the highlights of the Alpstein Massif in the canton of St Gallen. No less than 110 routes zigzag across the limestone mountains.

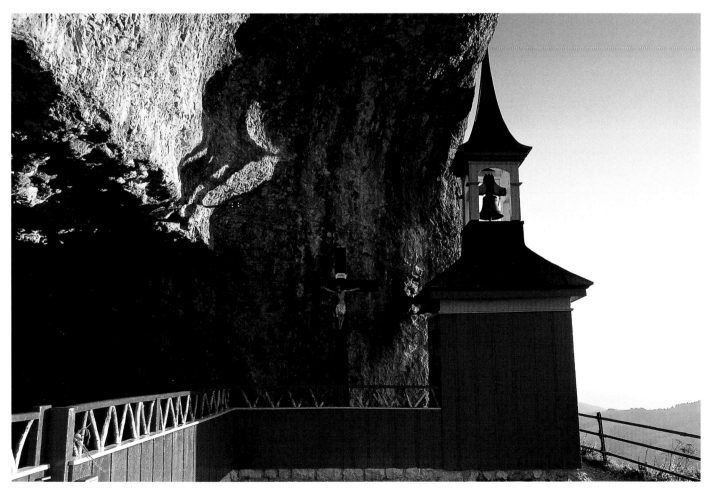

From the Aescher-Wildkirchli mountain hut there are wonderful views of the panoramic Alpstein Massif.

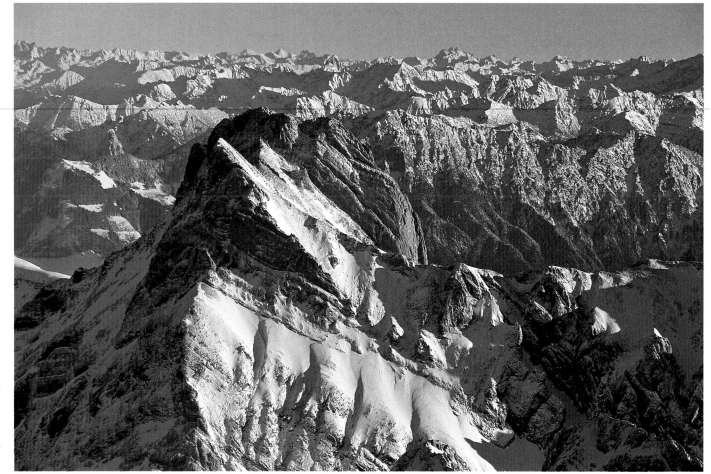

You can't get much higher than Säntis Mountain in East Switzerland, with the Churfirsten Group a close second at just under 2,500 m (8,202 ft). The view from the top is thus uncluttered – less so the summit itself which in the past few years has become something of a theme park, albeit one of taste and quality.

The summit of the Säntis is a good place from which to embark on hikes and climbing tours of the Alpstein Massif. Lisengrat, shown here, leads to the peak of the Altmann.

Tucked in between the highest peaks of the Alpstein Massif, the Säntis and Altmann, is the Rotstein Pass. At certain times of the day the limestone ridge along the watershed between the cantons of Appenzell-Innerrhoden and St Gallen is as red as its name.

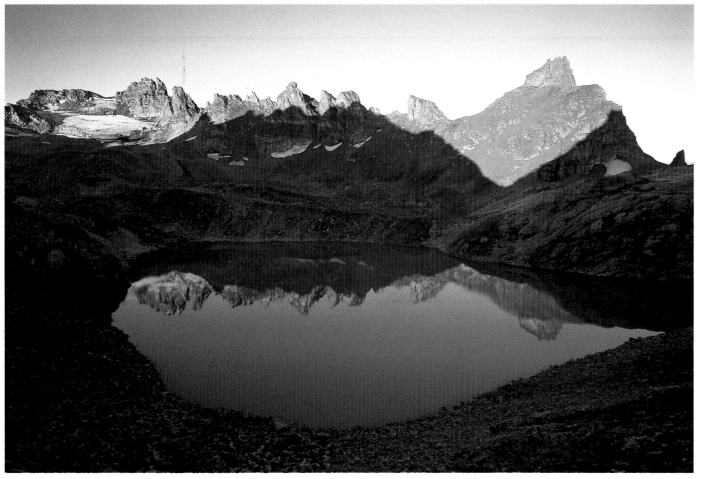

Deep down in the south of the canton of St Gallen the Graue Hörner jut up above the Wildsee. The mountainous region between the Rhine Valley and the border to the canton of Glarus is a little known hiker's paradise, the highest peak of which is the Pizol at 2,848 m (9,344 ft).

Page 116/117: Many superlatives spring to mind when describing Lucerne; it's such a wonderful place it's hard not to boast about it! One of its oldest and most beautiful attractions is the Spreuerbrücke from 1406 which forges a link between the north and south parts of the city.

115

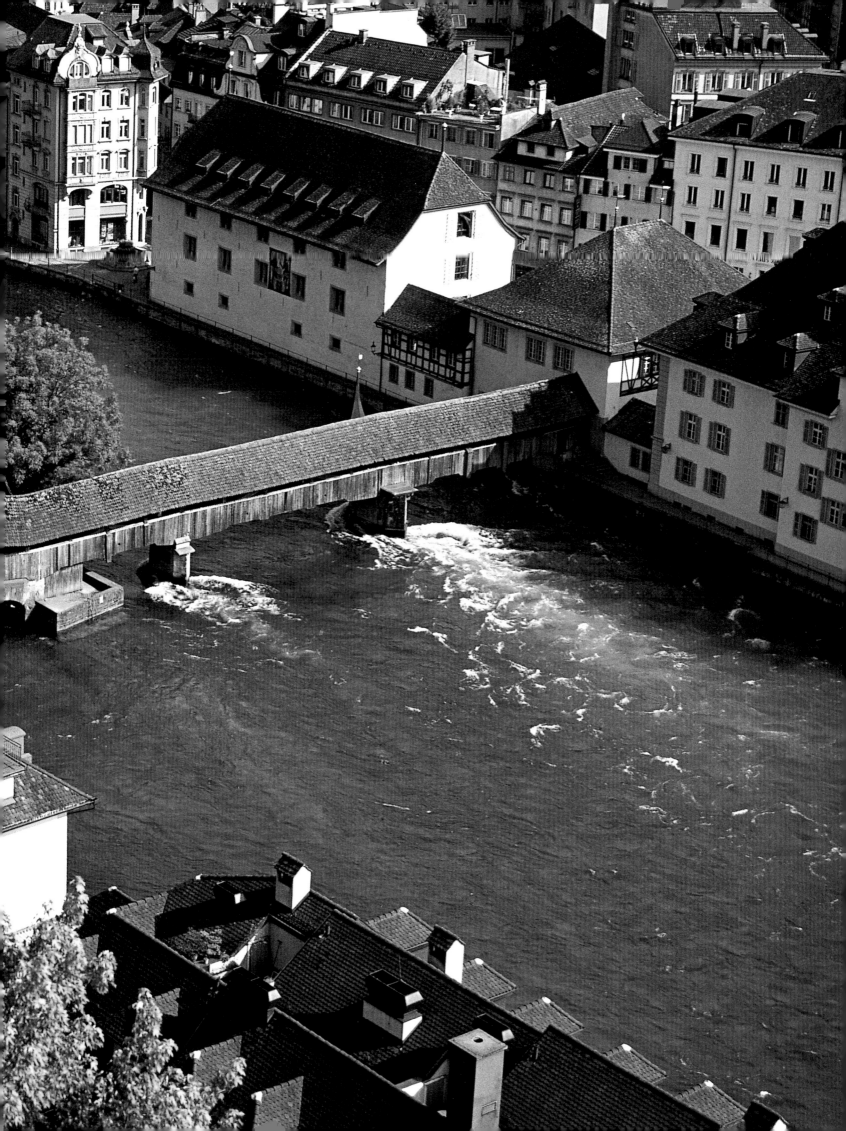

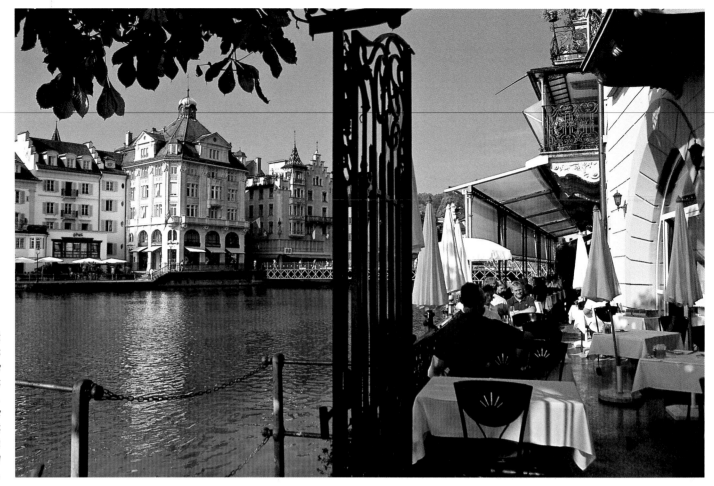

Some of the best upmarket restaurants in Lucerne can be found along the banks of the River Reuss. Fish caught in the local rivers and lakes is naturally included on the menu, including perch and whitefish.

The historic rooftops of Lucerne. The gateway to Central Switzerland is symbolic of the fortuity and cultural wealth of the country's towns and cities. Where two centuries of war reduced Switzerland's neighbours to ashes, the architectural treasures of the Alpine state were thankfully left unscathed.

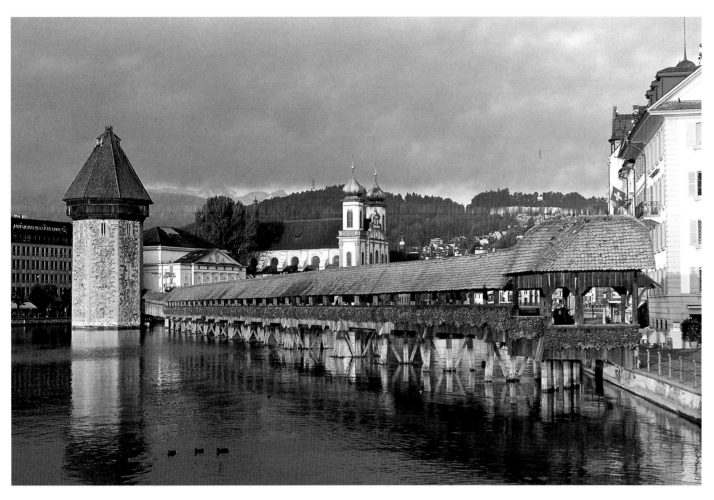

Lucerne's Kapellbrücke and water tower, both from c. 1300, are local landmarks. Only the foundations of the long bridge are original, however; the rest had to be reconstructed following the dreadful fire of 1993.

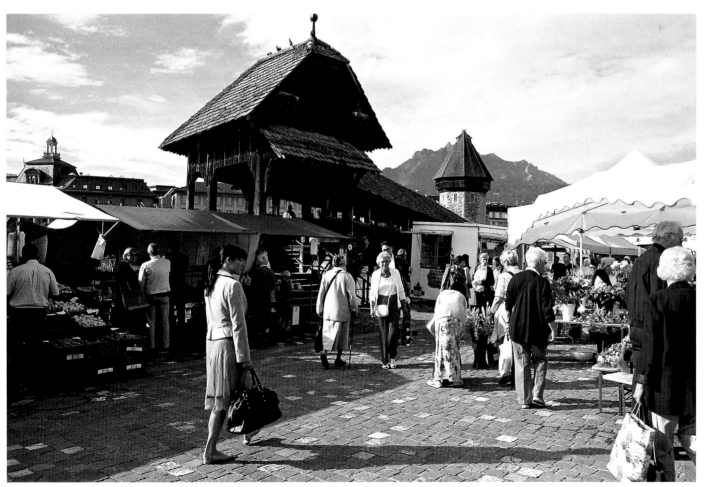

The Kapellbrücke hums with activity almost every day of the year, with markets, souvenir sellers and food stalls touting for custom among an international clientele. Yet what most people come here for is not the commerce but the culture; the 111 triangular paintings adorning the roof of the chapel are a must for any visitor.

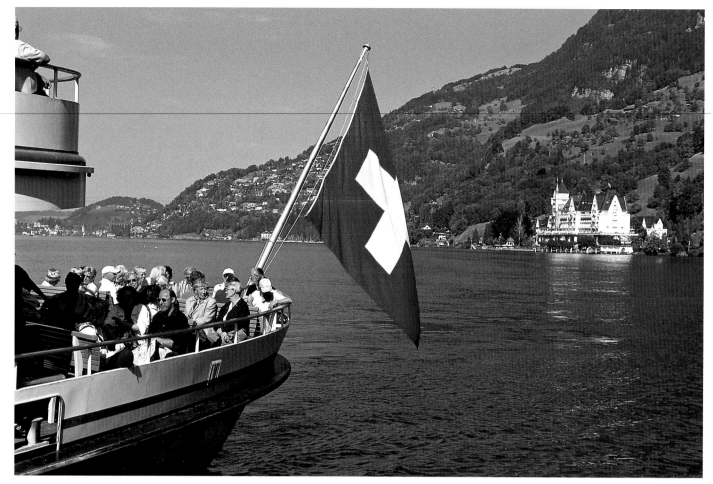

Travel the Victorian way on the paddle steamer to Vitznau and the mountain railway up to the top of the Rigi, opened in 1871. When you gaze down from the summit onto Lake Lucerne and the mountains of Central Switzerland, the view is as perfect and unspoilt as it was in the 19th century.

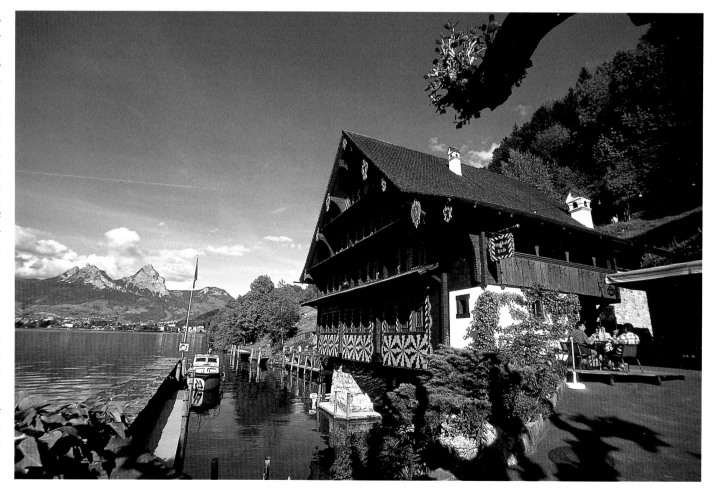

Where the Confederates once held conference, guests from all over the world can now enjoy the excellent fare and fine location of Haus Trieb, built in 1659 on a spit of land between Lake Lucerne and the Urner See. From here a cable car takes you up to the village of Seelisberg not far from the legendary Rütliwiese.

Right page: The Urner See, an offshoot of Lake Lucerne, seems dark and ominous when you look south. At the end of it the Gotthard Massif forms a giant barrier blocking the main thoroughfare through Switzerland.

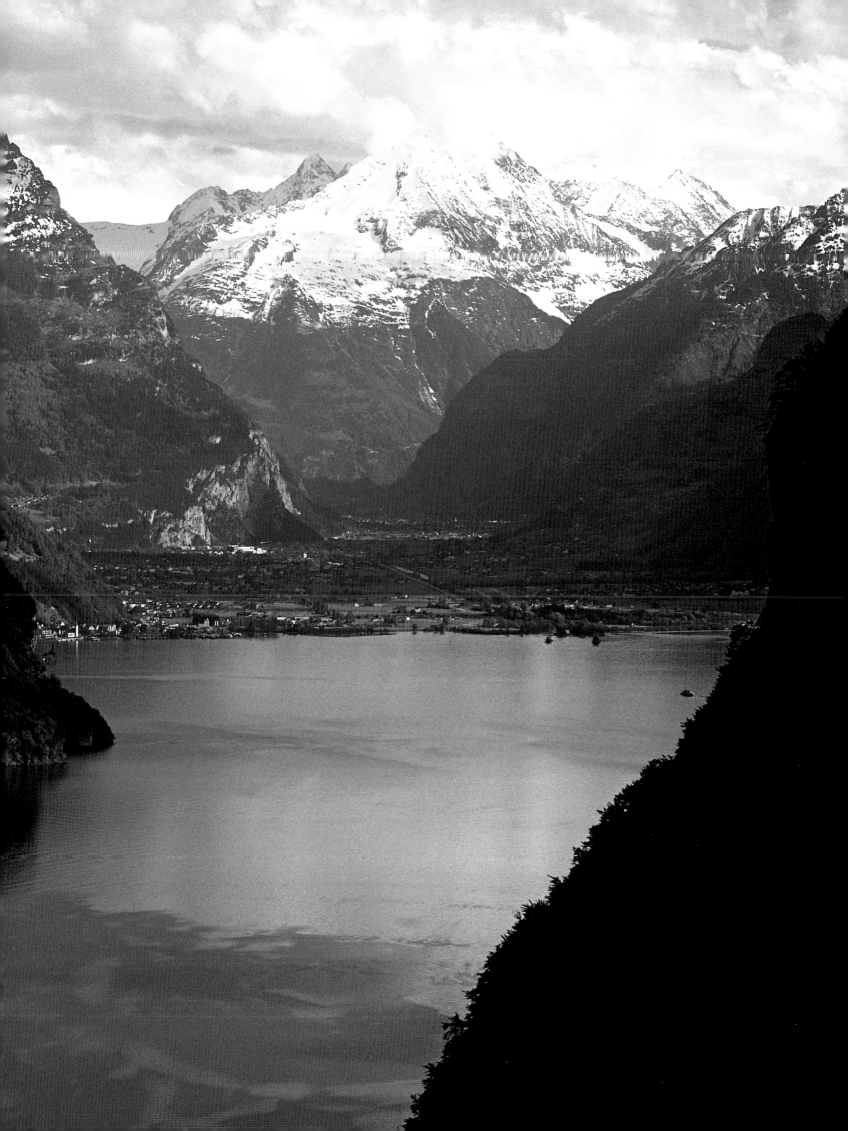

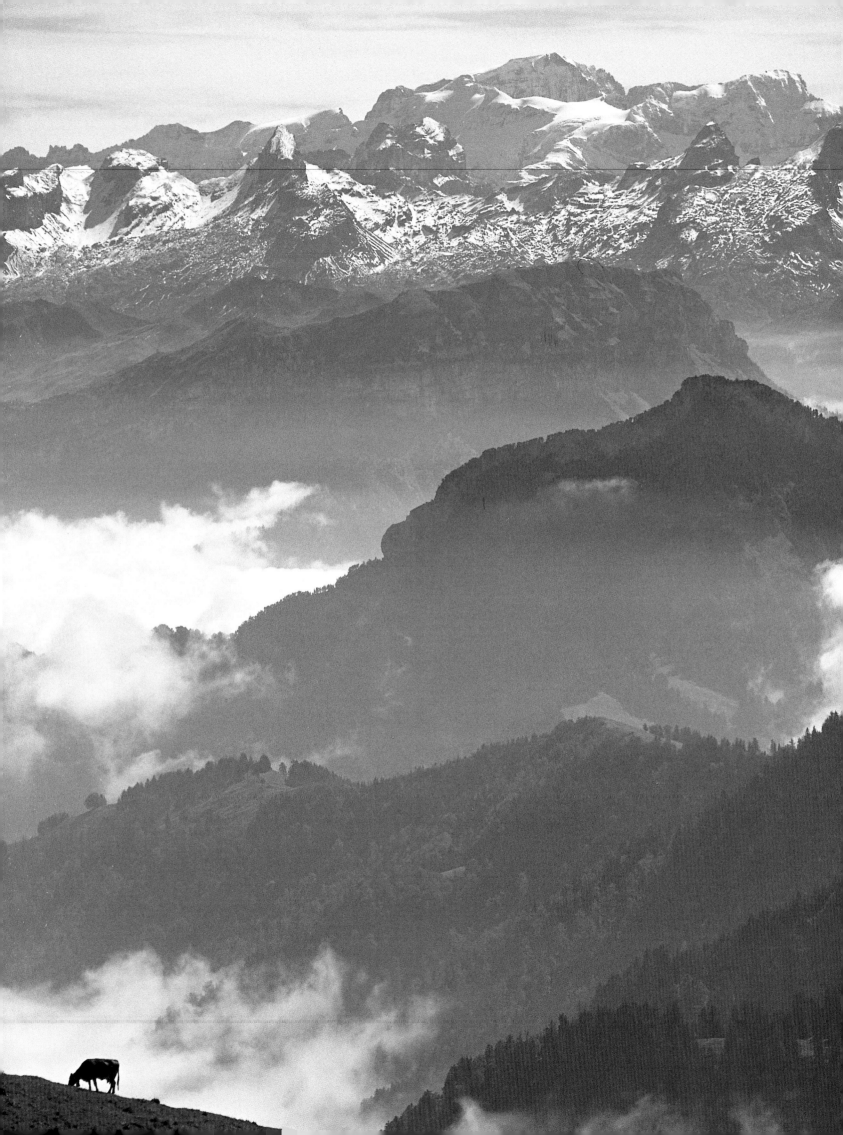

Left page:
Mount Rigi owes its fantastic views to its exposed and unique location. It's thus hardly surprising that travellers have been coming here for 200 years to take in its unbelievably magnificent panoramas.

The oldest rack railway in Europe chugs and puffs like it did when it was first built! The trains take about 30 minutes to cover the 7 km (4 miles) of track which run up to the top of the most famous elevation in Switzerland. Even the railway-mad Swiss still herald their Vitznau-Rigi-Bahn as a historical technical achievement of the first order.

In the days when there were no roads or railway lines linking Central and Southern Europe passengers and freight were usually transported by ship across Lake Lucerne and the Urner See. The harbour at Brunnen is now solely reserved for tourists. The many reminders of the Belle Époque and the wonderful views of the lake make Brunnen popular with holidaymakers.

123

Right page:
The weathered houses of Andermatt (Uri) betray much about the evolution of the village, strongly influenced by the influx of settlers from Valais. Famous for being on the main haul through the Alps, in the past few years Andermatt has undergone an interesting metamorphosis and is now an attractive ski resort.

Right:
The beginning or the end? Whichever way you're travelling, by road or by rail, north or south, one end of the Gotthard is at Göschenen in the canton of Uri (shown here) and the other in Ticino.

Photos, right:
Every Swiss child is familiar with the little town of Altdorf, the capital of the canton of Uri. If the legend is to be given any credibility, this is where William Tell shot the apple from his son's head with a bow and arrow. The monument in the town centre is from 1895.

Page 126/127:
The Blausee in the valley of the Kander is true to its name, its brilliant blue reflecting the jagged contours of the surrounding mountains. Halfway between Frutigen and Kandersteg in the Bernese Oberland, the lake is not far from the old Lötschberg railway line.

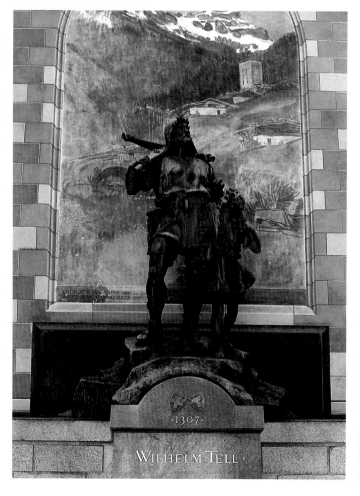

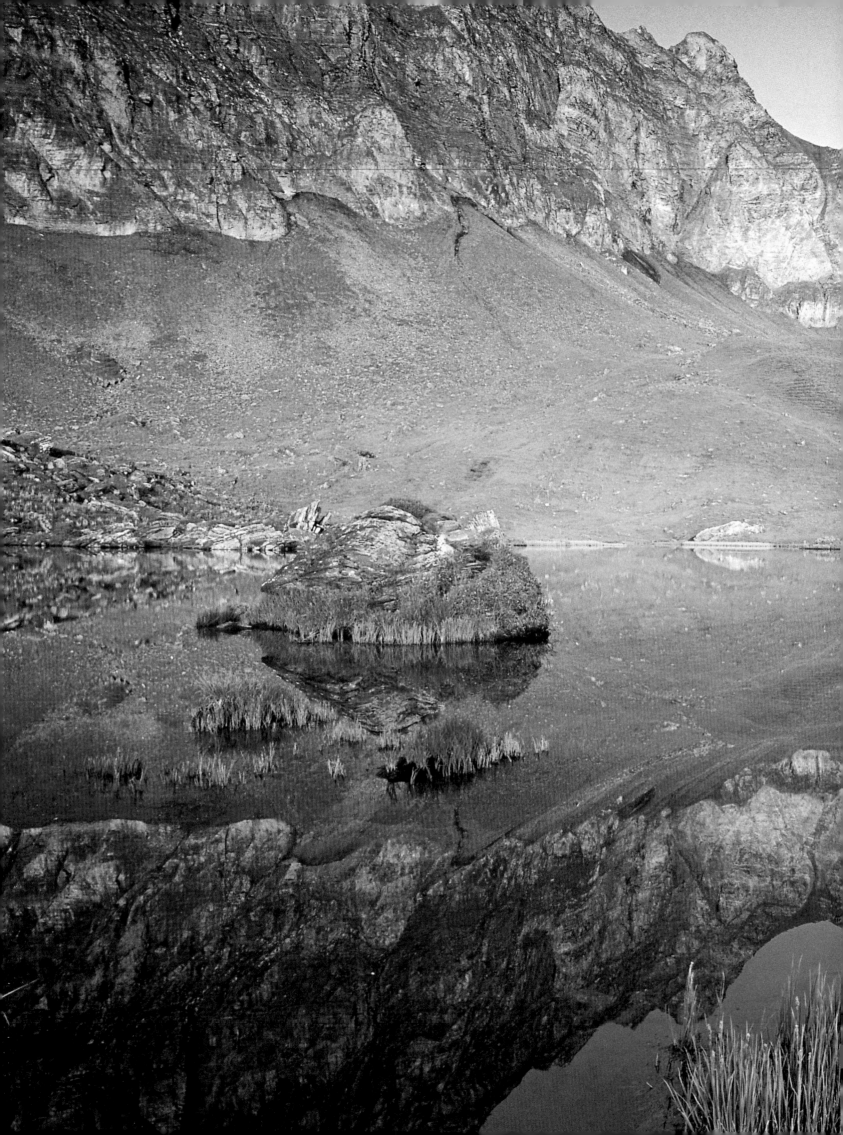

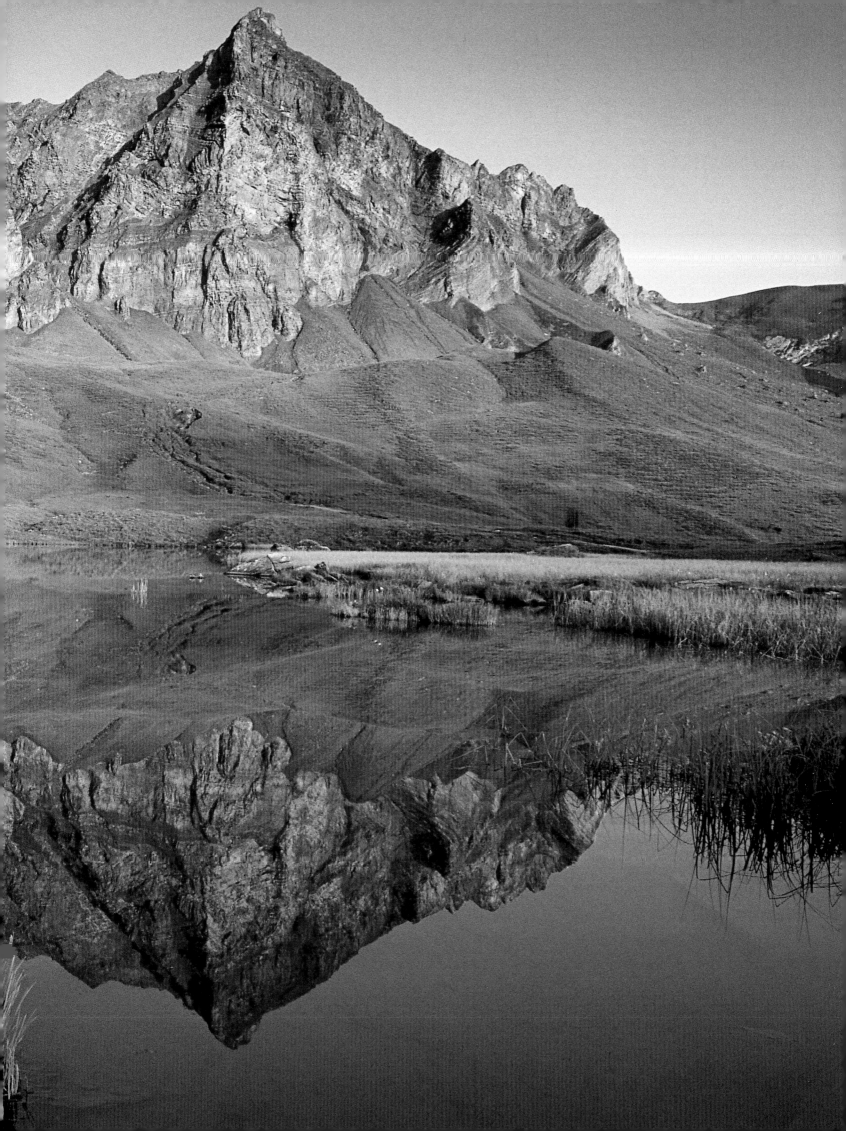

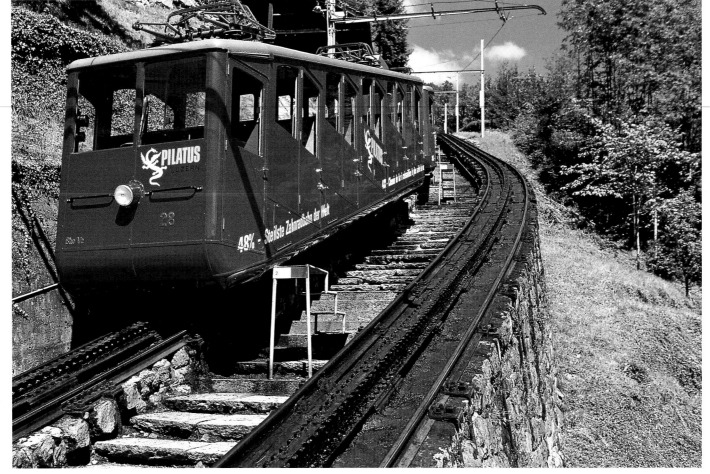

They don't come much steeper than this; the rack railway from Alpnachstad to Pilatus-Kulm covers a gradient of 48%! This pioneering example of Swiss engineering is not only technically fascinating but also rewarding – with grand views from the top station. However, it's a good idea to check the weather forecast before you embark; in Latin Pilatus means "covered" or "overcast", a reference to the not infrequent cloud which can mar the view here.

Right page: Engelberg's local mountain, the Titlis in the canton of Obwalden (3,238 m/ 10,624 ft), is popular in both summer and winter. As the nearest form of assisted ascent only reaches the 3,000 m mark, the summit of the highest mountain in central Switzerland is reserved for hikers alone.

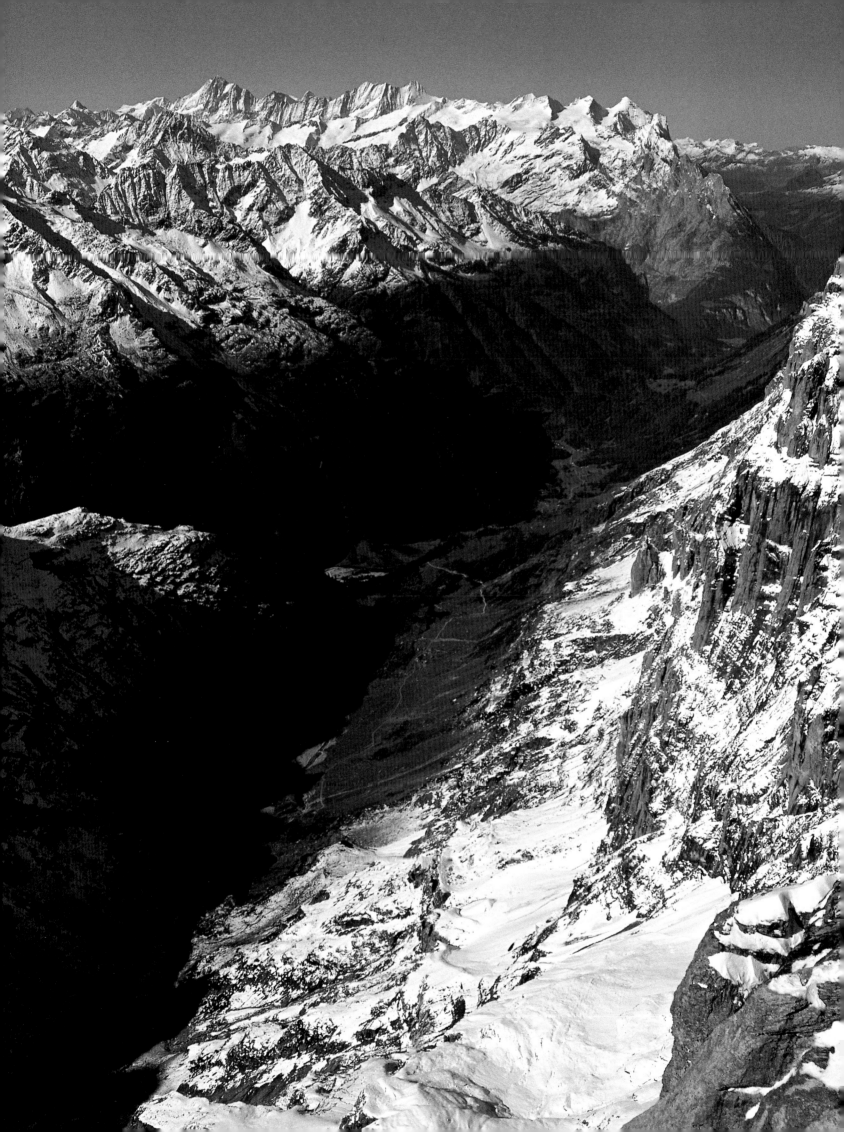

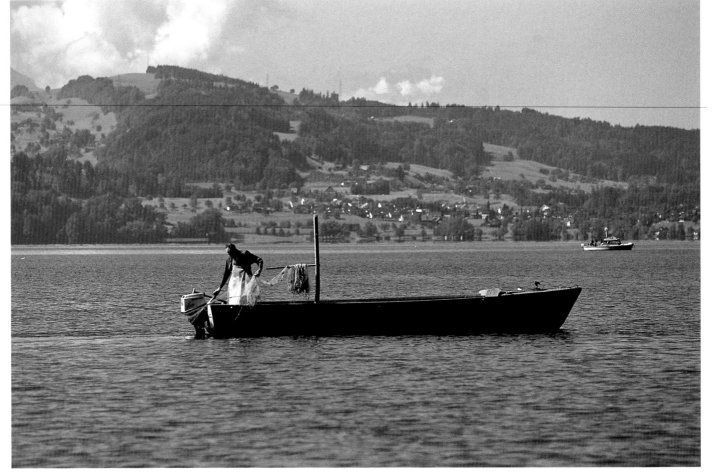

It may not be the largest of Switzerland's lakes but it is certainly diverse. Where the northern shores of Lake Zug are lined with gentle, rolling hills, the south tip cuts deep into the mountains of the Rossberg and Rigi. Those living here enjoy the beauty of the local area in more than one respect; the canton of Zug is not only blessed with lovely countryside, it also has the lowest tax rate in the country!

Hidden away in the hilly environs of Schwyz, well away from the major sights of the Swiss Alps, the Bödmerenwald is difficult to access but worth the effort. It's main claim to fame is its ancient stock of spruce trees which thrive in a jungle-like enclave not far from the Pragel Pass over into the Klön Valley in Glarus.

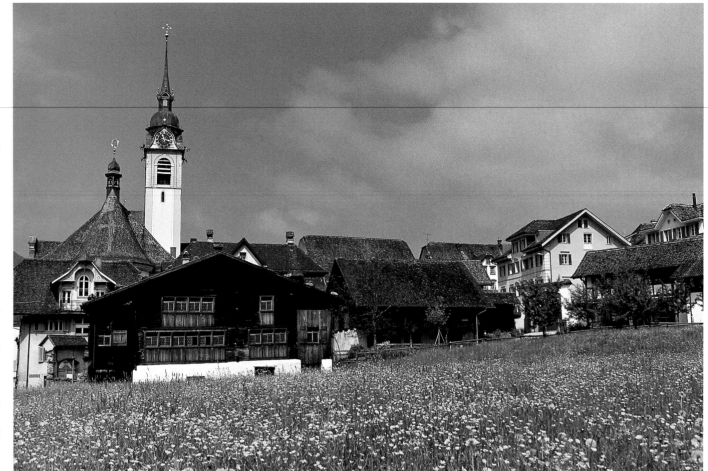

It is to the city of Schwyz, the historic heart of the Confederation, that Switzerland owes both its name and history. It's here in the rather officious sounding Bundes-briefarchiv or Swiss Archive of Letters that the founding of the country is so reverently recorded. The inaugural document held here, signed in August 1291, commemorates the oath of allegiance sworn by the ancient cantons of Schwyz, Uri and Unterwalden.

South of Lucerne, at the entrance to the Engelberger Tal, is Stans. Like Schwyz the little town is largely distinguished by its wealth of baroque buildings.

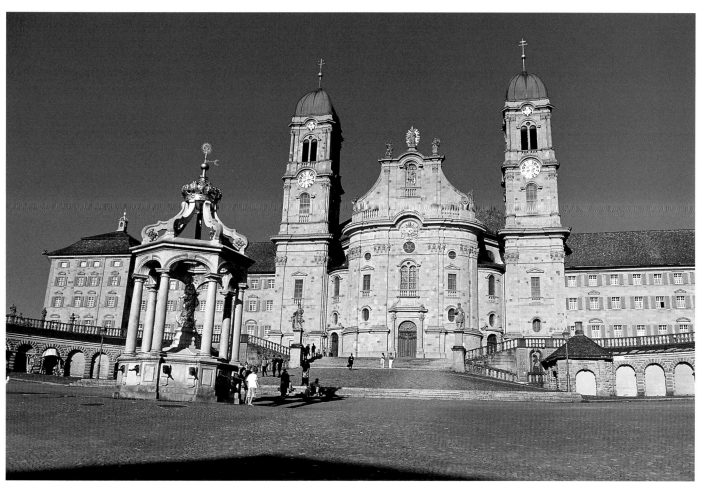

With a dominance
which can only be
described as impres-
sive the monastery
of Maria Einsiedeln
in the town of the
same name acts as a
monumental gateway
to the Alptal in the
canton of Schwyz.
Baroque at its most
characteristic can be
enjoyed at this place
of pilgrimage.

Page 134/135:
Visible far and wide,
the twin steeples of
the minster glow
ethereally over the
centre of Zürich. The
Protestant church
was where Ulrich
Zwingli weathered
the storm of the
Reformation in the
16th century. The
sobriety usually
associated with this
period in the history
of the church is,
however, now merrily
lacking in the modern
city which is today
suffused with a
vibrant sense of
warmth and energy.

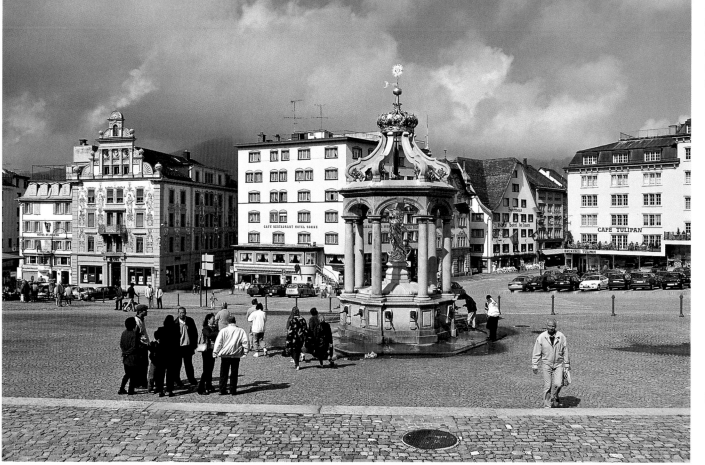

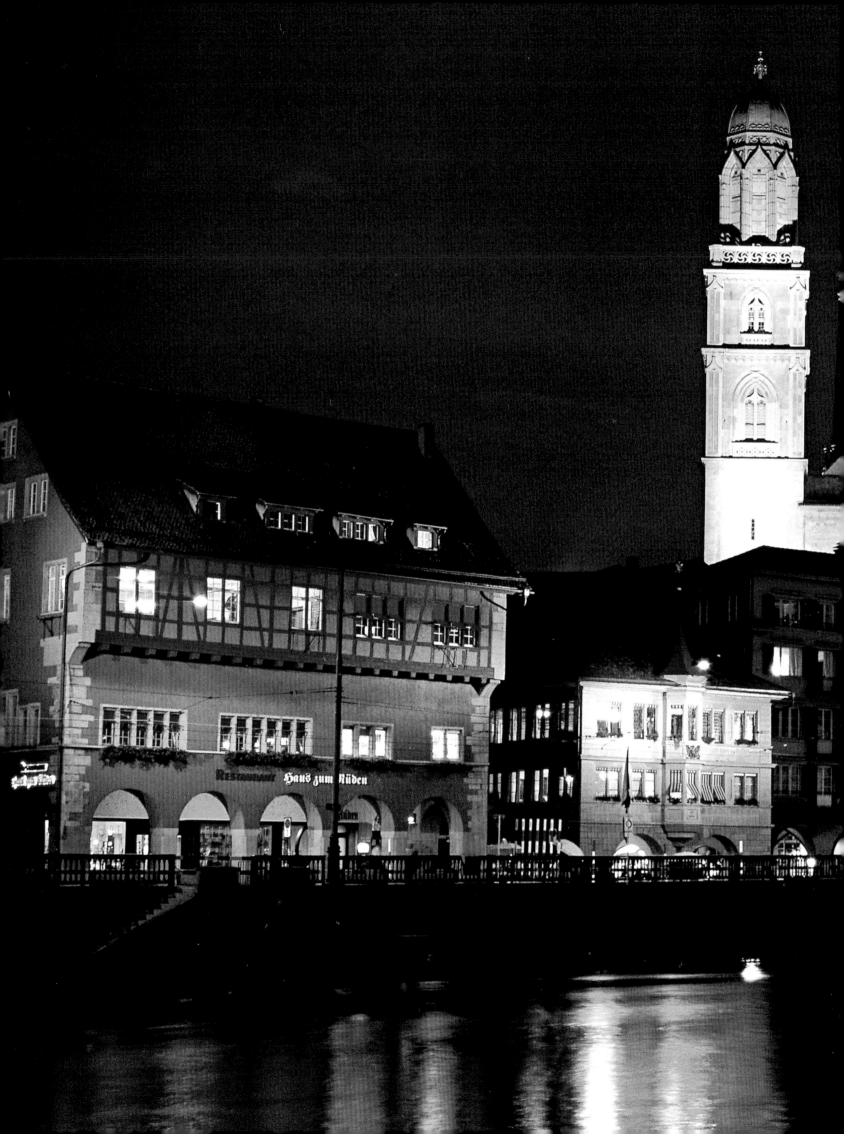

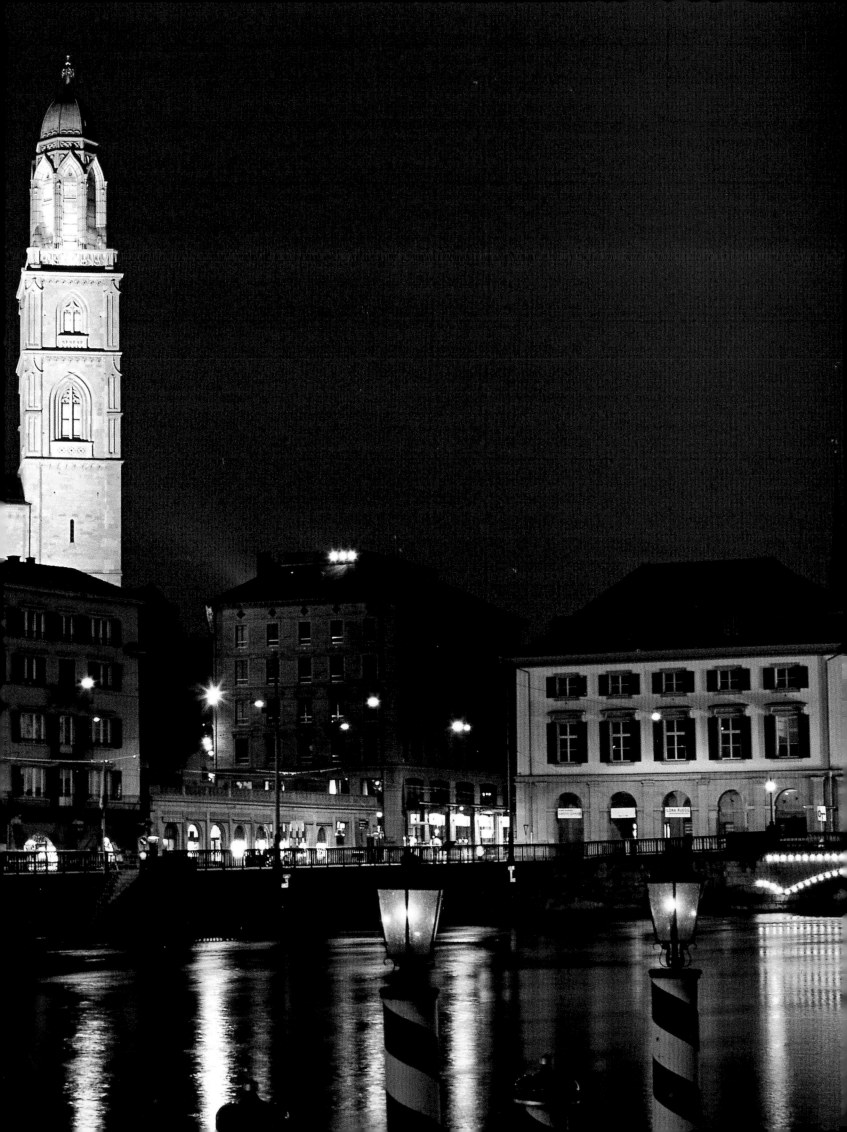

Right and right page:
One of the many chic shopping streets in Zürich is Augustinergasse. Its modish visage is greatly enhanced by the bay windows of its upmarket city dwellings found here in abundance.

Page 138/139: The old town in Bern has retained its timeless beauty. It sprawls lazily on a peninsular in a wide arc of the River Aare, seemingly blissfully unaware of the passage of time. Quite happy to be termed complacent, the Swiss capital is a fascinating contrast of historic architecture and the modernism of the 21st century.

Right: Chocolate in all its various permutations is the speciality of the confectioner's Sprüngli. The traditional Swiss company, which has several outlets in Zürich, is just one of the country's world-famous manufacturers of sugary delights.

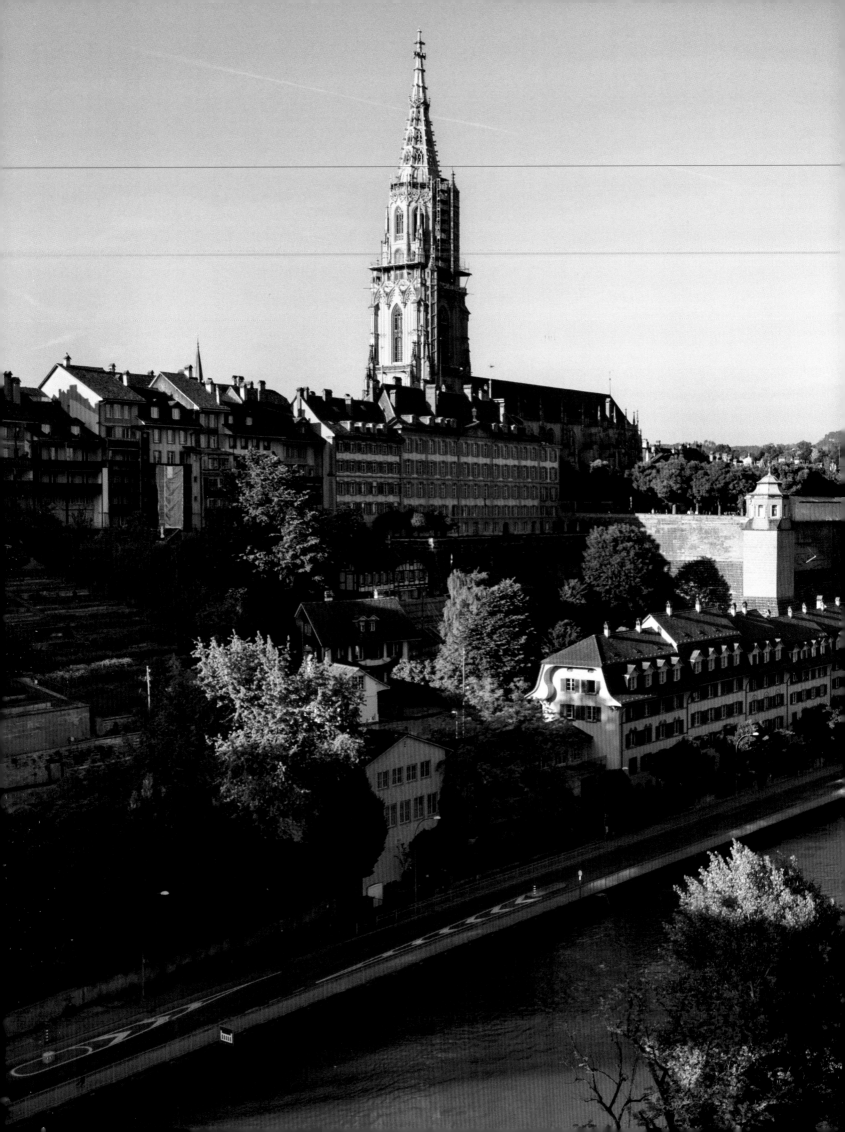

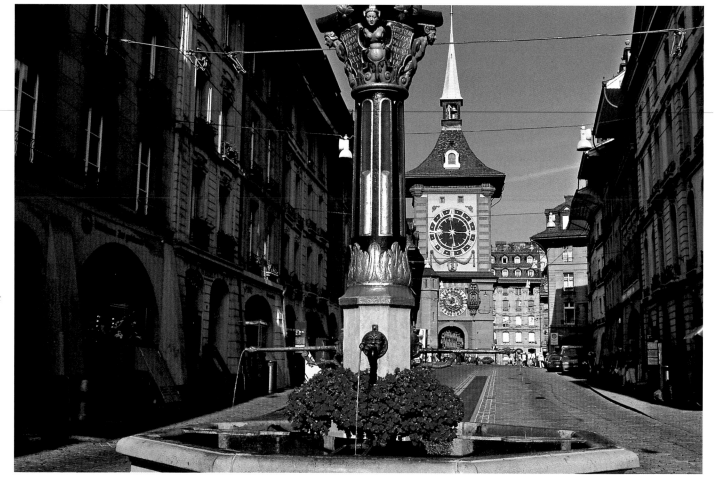

In the middle of Kramgasse, the east-west drag of Old Bern, the Zähringerbrunnen and Zeitglockenturm form a historic axis. The latter, the old west gate, was given its present guise during the 18th century and is now a local landmark.

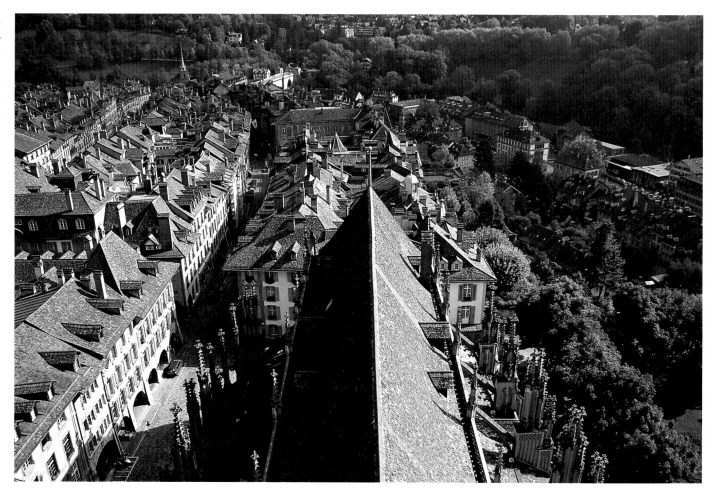

The view from the top of Bern Minster shows the historic old town in its full glory. Its intact and most pleasing fabric has earned it a place on the list of UNESCO World Heritage Sites.

Prosperity in what characterises the city of Bern, part of the Confederation since 1353. For centuries the present Swiss capital was the mightiest city state north of the Alps thanks to its strong economy, markedly feudal structures and aggressive policy of annexation. It's thus no wonder that Bern still has all the flair and subtle dominance of a fortified and powerful city.

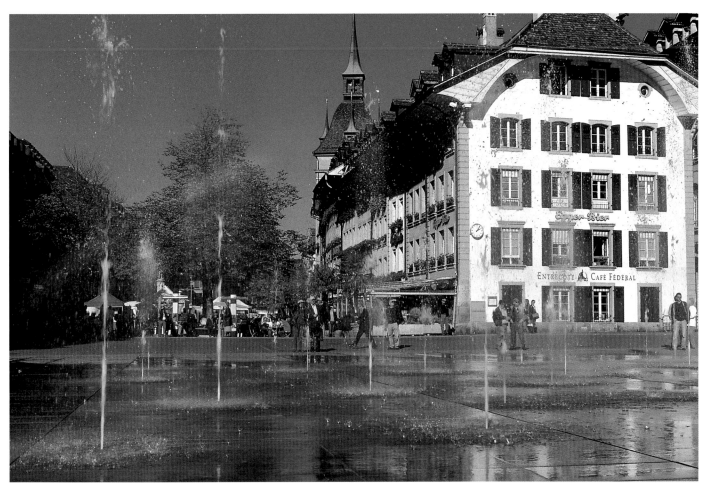

One of the main public squares in the centre of Bern is Bundesplatz, so called after its proximity to the Bundesregierung or Swiss government.

141

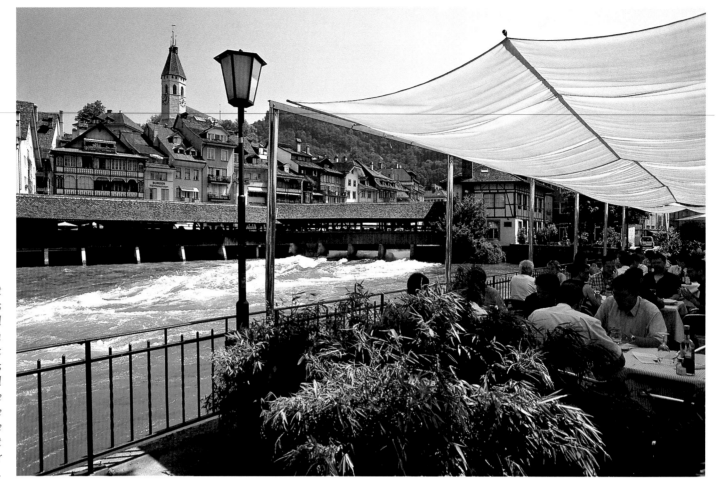

Situated at the point where the Aare exits Lake Thun, the old town of Thun is charm personified. Its chic shops and boutiques are built on an island in the middle of the river, close to the landing stages where steamers set out across the lake for Interlaken.

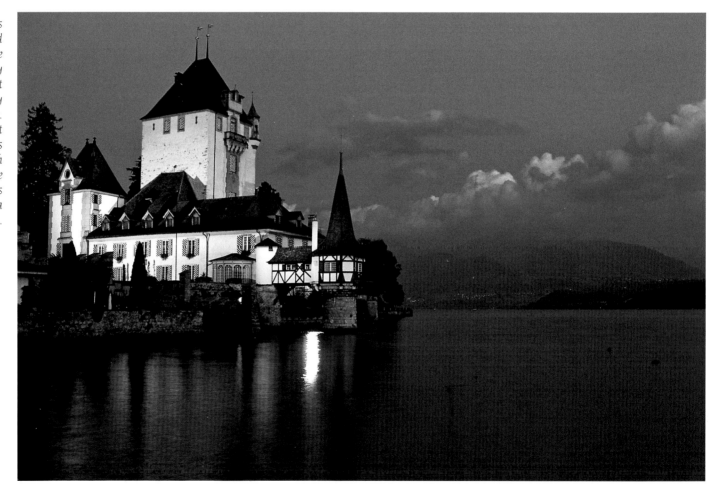

Already loved for its mild climate and views of the Bernese Oberland, the many castles dotted about Lake Thun only heighten its popularity. One of the most impressive is Schloss Oberhofen which dates back to the 12th century, its grounds now a beautiful park.

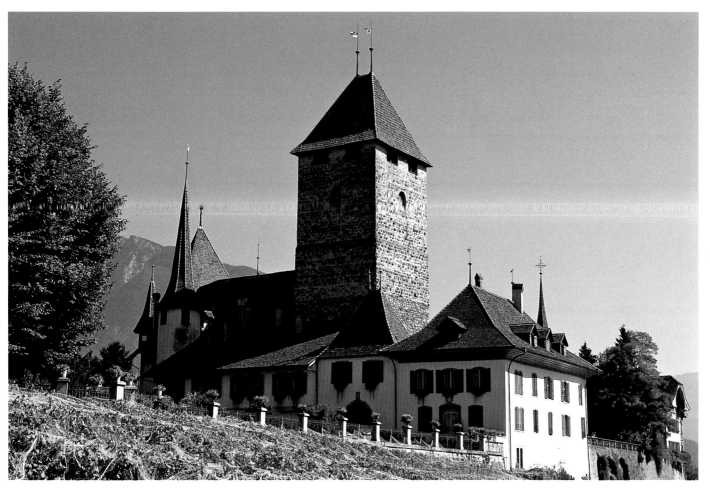

The "spirit of Spiez" is said to have helped the German national football team win the 1954 World Cup in Bern. The players were undoubtedly both stimulated and seduced by the charm of the lively little town on the southern shores of Lake Thun. The lower town and harbour are diligently guarded by Schloss Spiez, shown here with its sunny vineyards and mountain backdrop.

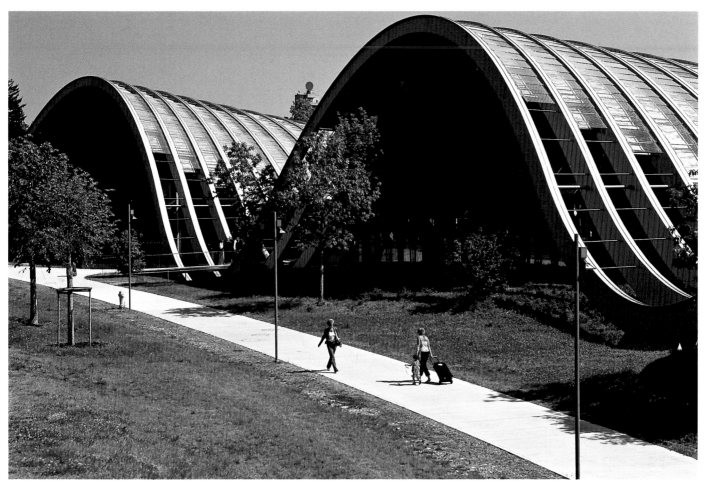

The Paul Klee Centre in Bern is the cultural icon of the entire canton. Its bold architecture and the quantity and quality of its collected works far exceed the usual expectations of such a venue.

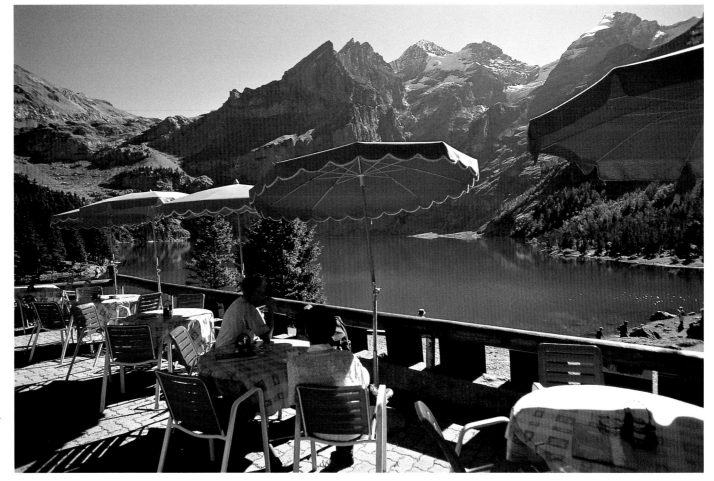

Not far from Kandersteg is the Oeschinensee, 1,600 m (5,250 ft) up. Its brilliant blue waters form a vivid contrast to the cheery umbrellas of this Alpine hut and the jagged contours of the Blümlisalp.

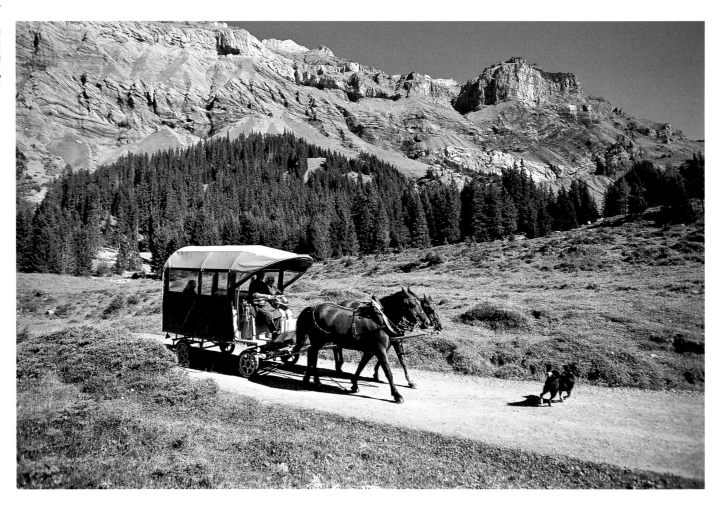

Cars are banned this far up, with transport provided by pony and trap, mountain bike — or your own two feet!

144

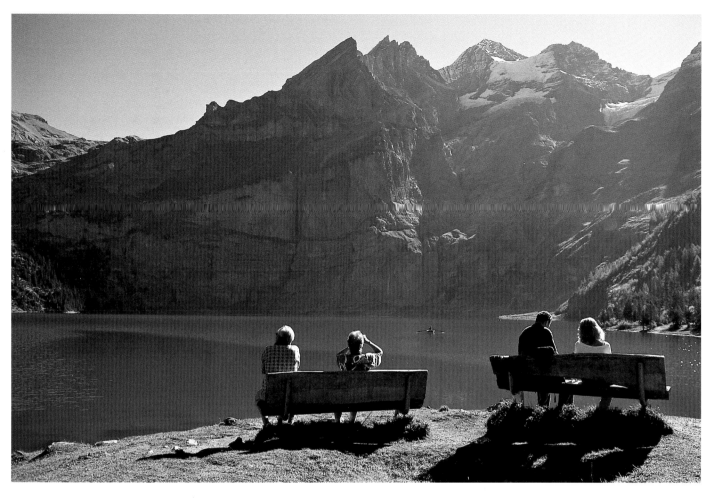

On an Alpine hike around the Oeschinensee the busy traffic down in the valley of the River Kander seems a long way away. The beauty of this serene spot in the Bernese Oberland is greatly enhanced by its absolute peace and quiet.

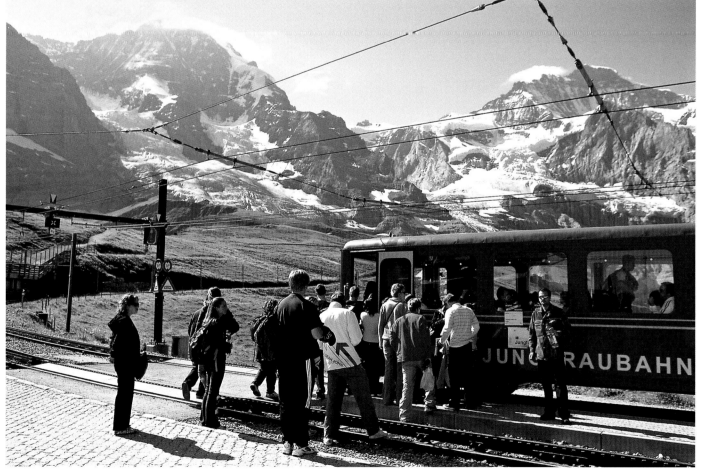

What is perhaps the most scenic railway junction in Switzerland is ca. 2,000 m (6,560 ft) above sea level. The narrow gauge tracks of the Berner-Oberland-Bahn converge at Kleiner Scheidegg, from whence the exciting journey to the Jungfraujoch begins.

Page 146/147: The huge Wetterhorn is Grindelwald's local Alp. Popular with hikers in search of some high Alpine adventure in summer, in the winter the ski circus throws open its doors to visitors from all over the world.

145

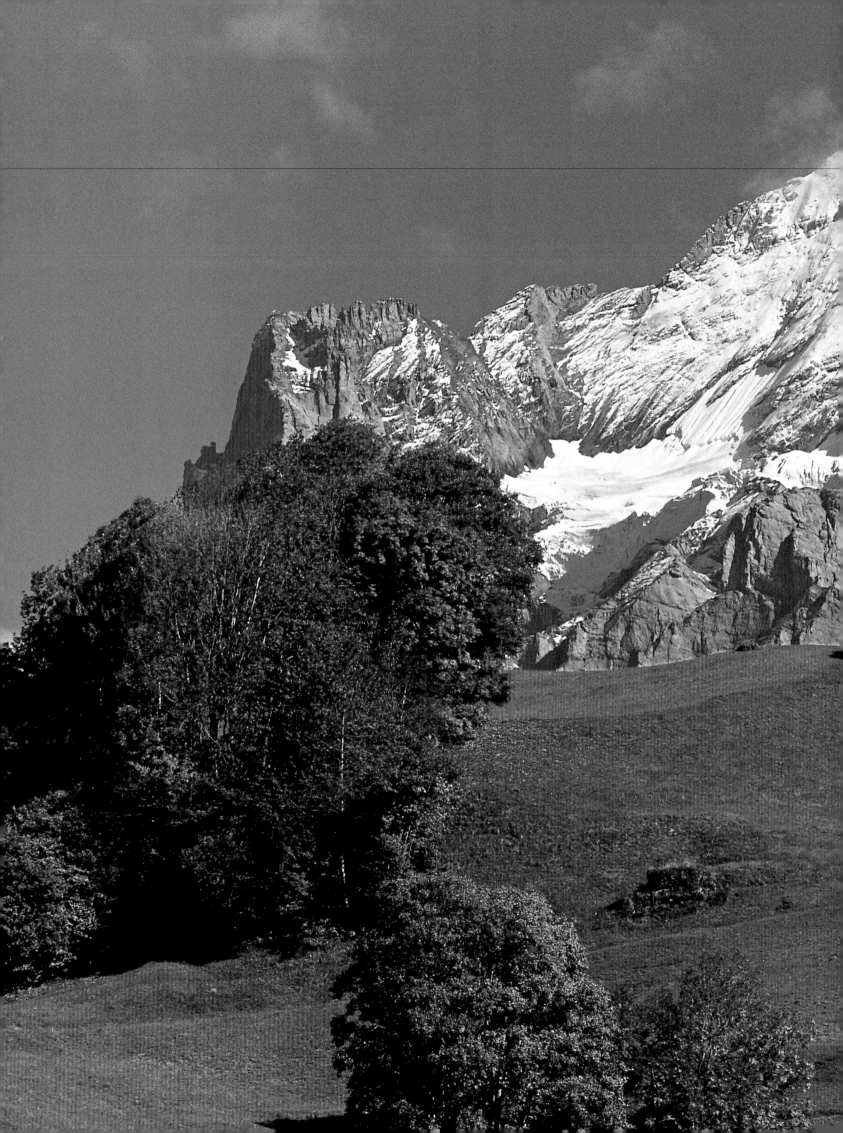

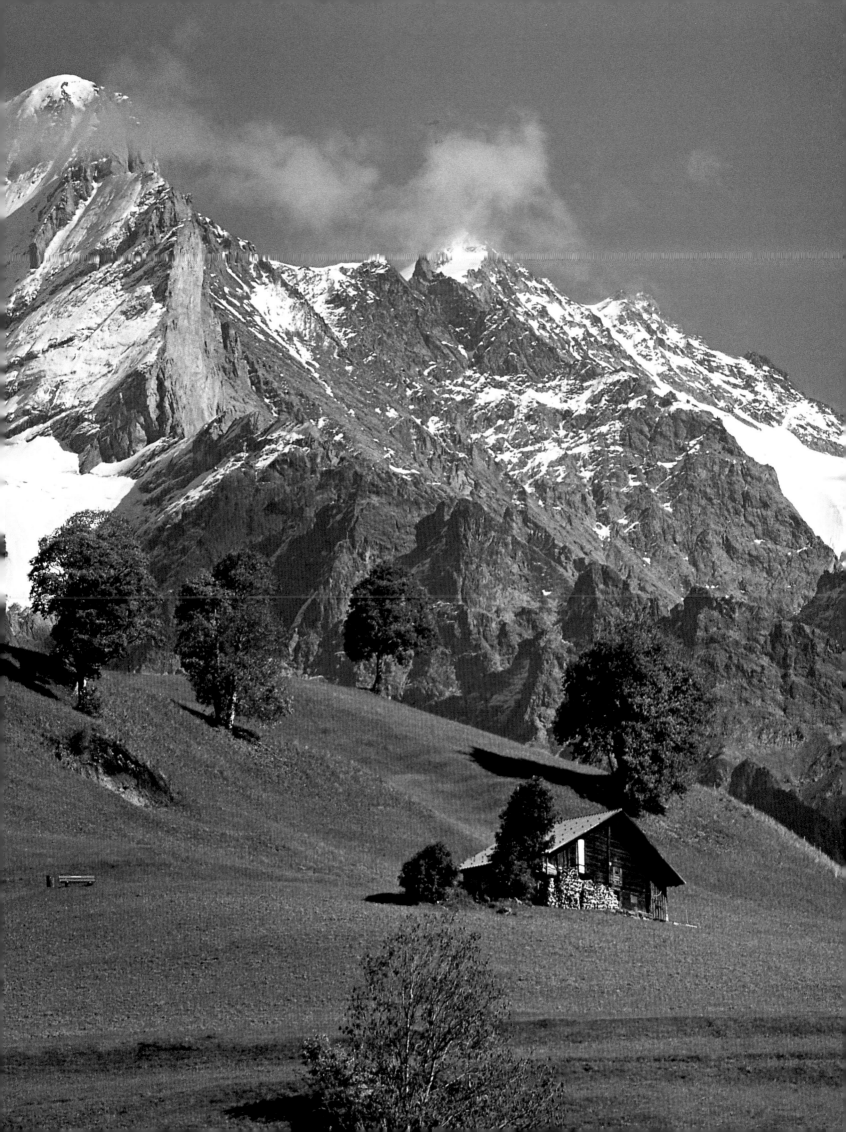

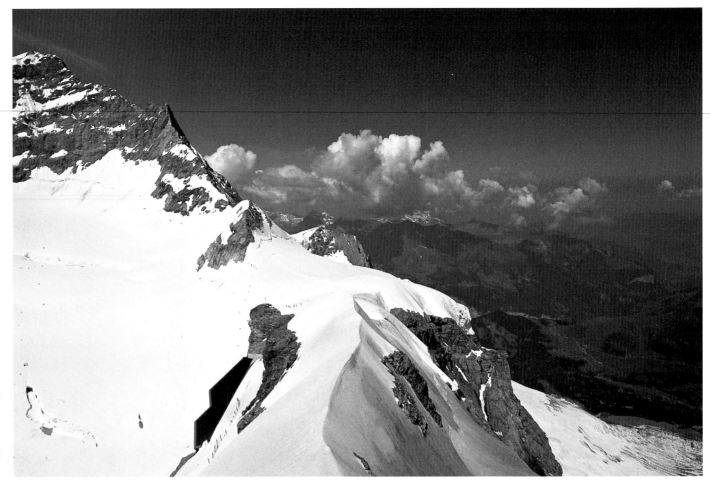

On a clear day you can see as far as the south of Germany and the Vosges in Alsace from the top of the Jungfraujoch. The trains take about one hour to reach the highest station in Europe. On the other side of the ridge is the Aletsch Glacier which sweeps down in an icy curve to the depths of the Rhône Valley.

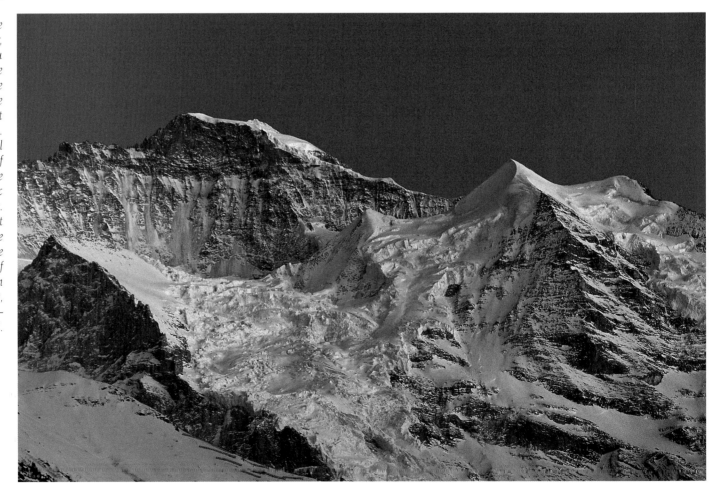

Like an impenetrable wall of rock the Eiger, Mönch and Jungfrau dwarf the Bernese Oberland. The highest of the three is the Jungfrau at 4,158 m (13,642 ft). The deeper you travel into the valley of Lauterbrunnen, the more majestic the mountains get. Some of the most marvellous views are to be had from the highland villages of Wengen and Mürren where the air is pure, the mood peaceful – and cars are banned.

148

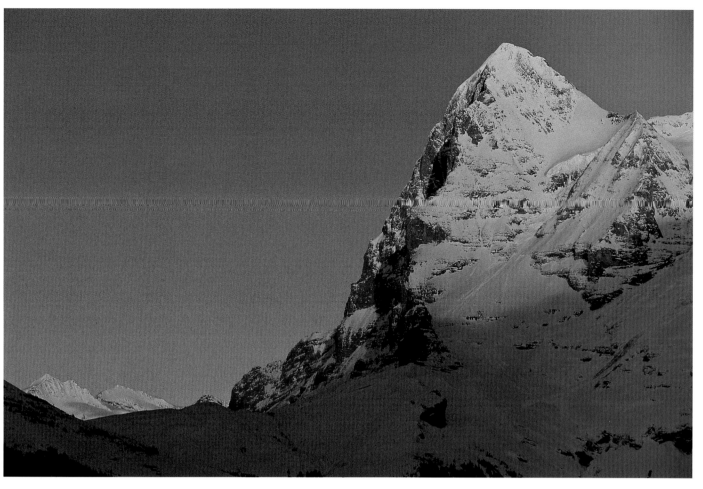

Practically no other mountain has possessed the world's mountaineers as violently as the Eiger, whose north face was long thought to be insurmountable. Many attempts to conquer it ended fatally. It wasn't until 1938 that the first German-Austrian team managed to successfully reach the summit along the direct north route.

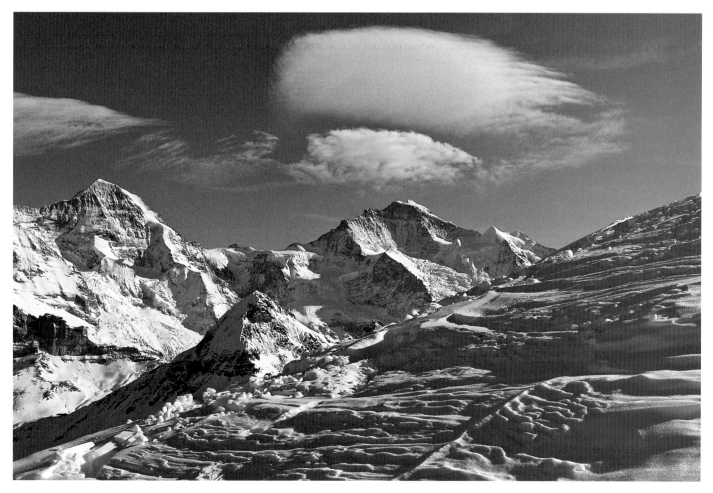

The border between the cantons of Bern and Valais runs along the ridge of the Mönch and Jungfrau.

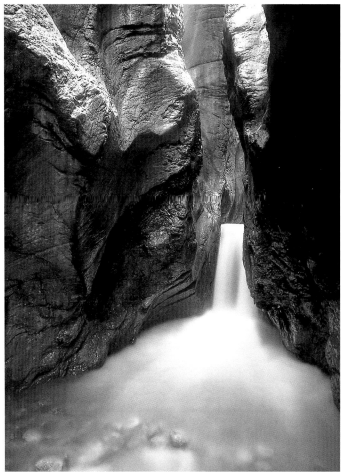

Far left:
The Giessbach –
officially a brook –
contains as much
water as a small
river. Here it crashes
down the mountain-
side into Lake Brienz
from a great height.
The best way to view
the falls is aboard
one of the many chic
pleasure boats
which operate here.

Left:
Beneath the Großer
Engelhorn water
forges its way through
the romantic
Rosenlauischlucht.
The ravine is one of
the most beautiful
in Switzerland.

Left page:
The spring waters on
Susten Pass trickle
down into the valleys
of the Reuss (Uri)
and the Aare in the
Haslital (Bern).

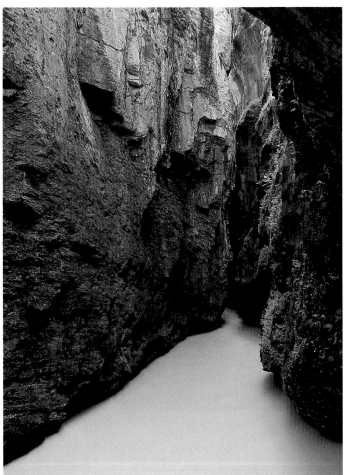

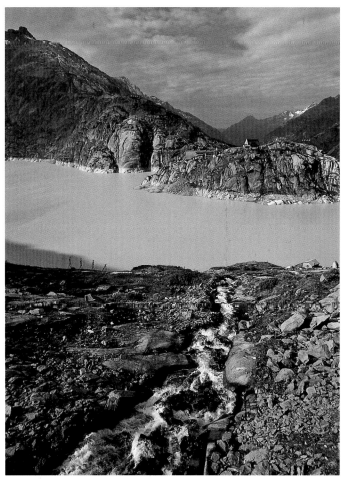

Far left:
In some places just
one metre (three feet)
wide and up to 200
m (656 ft) deep, in
the Aareschlucht near
Meiringen the river
has carved its spec-
tacular way through
the rock.

Left.
Near the Grimselpass
the Swiss power
industry has no
less than three
exploitable sources
of natural energy in
the Grimselsee,
Räterichsbodensee
and Gelmersee, all
of which flow into
the Aare River.

High passes and long tunnels: the intrepid journey from north to south

They were traders and pilgrims, farmers and merchants and they had but one aim: to cross the Alps as safely and with as little effort as possible.

The history of Alpine travel goes as far back as people have traded and preached religion. For Alpine countries such as Switzerland the exchange between Europe's north and south has not simply always been a means of wielding power by holding the monopoly on secure and easy passage; this exchange of ideas has also been an immense cultural boon and a mark of commitment to the international community.

Trade routes across the ridges of the Alps have been found dating back to the Bronze Age. First it was the people themselves who carried their loads on narrow paths widened into mule tracks

The road from Gletsch to the Grimsel Pass at 2,165 m (7,103 ft) is classic in its Alpine zigzag design.

Center:
The quickest way from Graubünden to Ticino is over or under the San Bernardino. Up on the pass road the mood is serene and still, the hospice an oasis of warmth in the silent but beautiful scenery — far removed from the heavy transit traffic zooming through the middle of the mountain below.

foot through the mountains; later the for pack animals who could transport larger quantities of goods through steep gorges and over dizzy heights. One of the most important transversals long before the Romans was the Splügen Pass. The little village of Splügen, which also lies at the entrance to the San Bernardino Pass, was for centuries a central hub for people crossing the Alps. The village boomed on the building of the pass in 1823 which greatly promoted the tourist trade. "Even my esteemed friend MacAdam could not have built such roads any better", was the comment on Switzerland's road system made by *Leatherstocking* writer James Fenimore

Cooper, who at the time was travelling the country. This was praise indeed; Scots engineer John Loudon MacAdam was the inventor of macadam, still used in road surfacing today. Nonetheless, however well the locals kept their modern passes in good order, with the advent of the Gotthard railway in 1882 traffic on the Splügen and many other Alpine passes became noticeably quieter.

The Splügen between Switzerland and Italy, now no longer so crucial to Alpine transit, was part of a network of passes which had grown in military importance ever since the Romans. From the Gallic Wars to the dawn of the modern age troops marched back and forth across Swiss soil via the Great St Bernhard and through the Alps of Valais, up the Julier Pass and down into Graubünden. The Simplon Pass, for example, owes its forced development at the beginning of the 19th century solely to the aggressive designs of one Napoleon I.

Crossing the Gotthard: an achievement for Europe

Even if it is overshadowed by the Matterhorn in the beauty stakes, the Gotthard Massif, rather overdone as the symbol of the steadfastness and defensiveness of the country as a whole is, like many of the individuals of the Valais Alps, a Swiss icon. For thousands of years an Alpine milestone on the north–south transit, during the Biedermeier period the Gotthard set impressive standards. In a necessary bout of engineering between 1827 and 1831 it was given the famous 99 bends of the Tremola Gorge, a brilliant achievement which caught the attention of people all over Europe. Relatively speaking, it can be compared to the present NRLA Gotthard Tunnel project in scale and ambition. As early as 1844 the post office in Altdorf was offering a "daily express run"; the travelling time between Lucerne and Milan was reduced to 31 hours thanks to the introduction of a new steam boat service on Lake Lucerne. Yet not only the

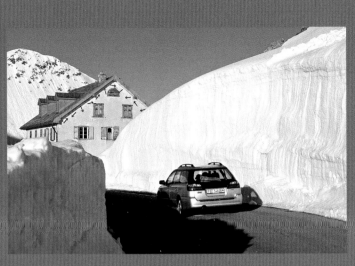

timetable was revolutionary; the mail coaches across the Gotthard could also operate in snow, their wheels replaced by sledge runners in a matter of minutes.

Enter the railway

It was the political situation in Europe which gave Switzerland the Gotthard Tunnel – with 50% financed by Italy and 25% each by the Confederation and the German Empire. The contract signed in 1871 by the three states governing the construction and maintenance of a Gotthard railway paved the way for the first of several spectacular tunnels in Switzerland, with the Simplon Tunnel following in 1905 (ca. 20 kilometres/12 miles long) between Valais and Italy and in 1913 the Lötschberg Tunnel, 18.5 kilometres (11 miles) in length, which linked the Bernese Oberland with the Lötsch Valley in Valais.

Left:
The shortest route from Valais to the neighbouring cantons of Uri, Graubünden and Ticino is along the Furka Pass which on its opening in May/June is still lined with walls of snow several feet high.

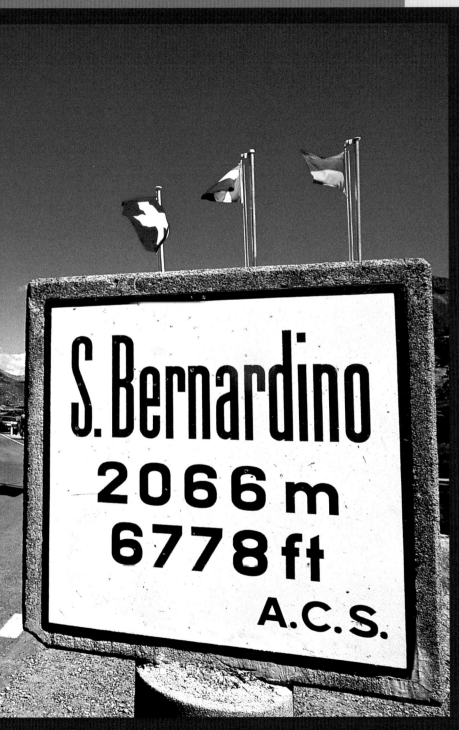

Monks have been breeding St Bernards on the Great St Bernard Pass since the mid 17th century. These huge cuddly dogs have saved many lives over the past few centuries.

The pace of life has quickened. In a few years we will be racing through the 57 kilometres (35 miles) of the new Gotthard Tunnel on trains travelling at 250 kmh (155 mph). To the Swiss, Italy and Germany will seem even closer. Maybe this would be a good moment to reflect on the words of poet, writer, journalist and plant researcher Carl Spitteler.

"Is there no area in the broad realms of the mind and the natural environment which the Gotthard does not divide? Language, custom, race, politics, history and culture, the plant and rock world, climate, colour and light: it is all different on the other side. Here north, there south ... The more marked the differences, the clearer and closer they appear, the more enjoyable their bridging by the means of the mountain pass. Thus we feel the heightened mood which occurs at the lower degrees on every pass to be unforgettably vibrant on the Gotthard. Here we feel more in Europe than anywhere else."

Der Gotthard (The Gotthard Pass)
by Carl Spitteler, Frauenfeld, 1897

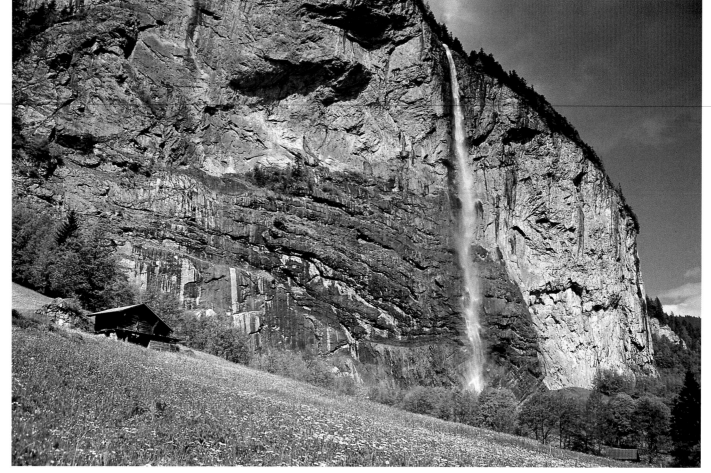

The Staubbach Falls in the Lauterbrunnen Valley (Bernese Oberland)are something of a local landmark. Depending on the levels of snow and rainfall up in the mountains the water tumbles up to 280 m (919 ft) down into the valley.

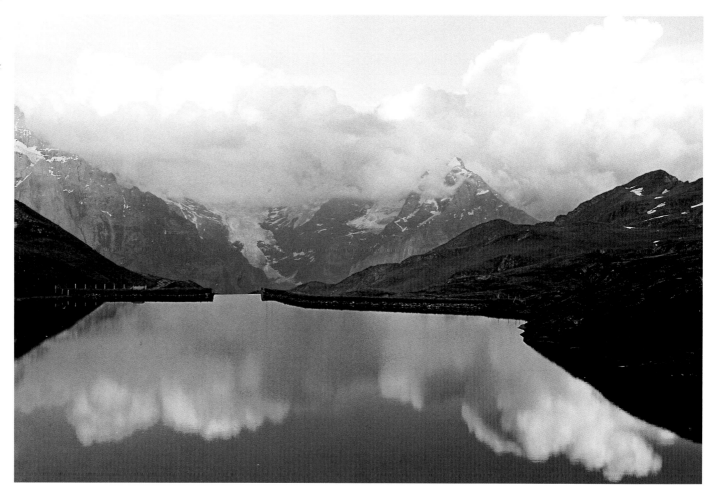

There is a wonderful panoramic route between the Alpine meadows north of Grindelwald and the Schynige Platte up above Interlaken. Good walkers can take in not only Lake Brienz from up on high but also the picturesque Bachalpsee and the Faulhorn.

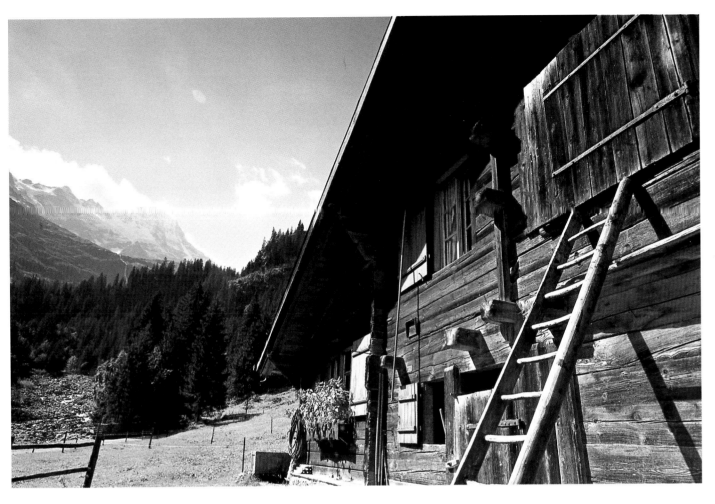

A piece of Swiss cultural history has been preserved deep in the valley of Lauterbrunnen. Now uninhabited, the Valais village of Trachsellauenen was where lead and zinc ore were extracted in the 18th century. The old workman's cottages and parts of the mines can still be explored.

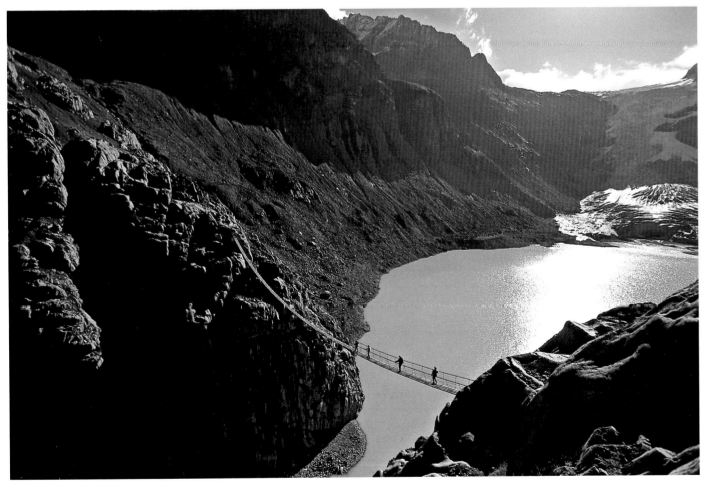

Not far from the Susten Pass lies the Triftsee. The basin at the tip of the Trift Glacier has only filled with water in the past few years.

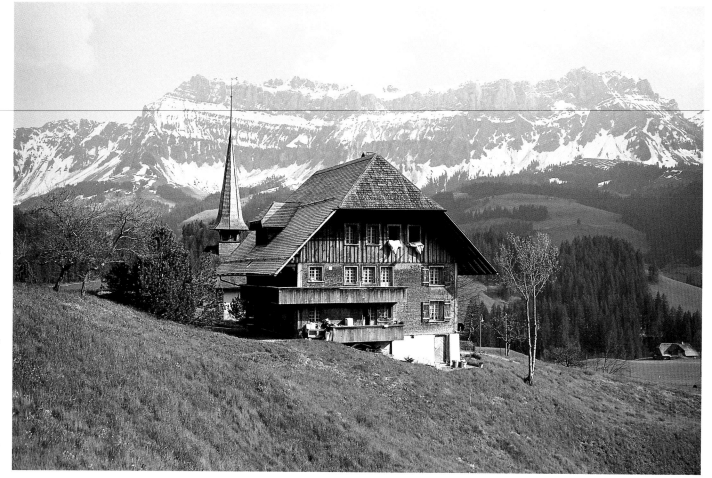

Rolling Alpine foothills dotted with isolated farmsteads lend Emmental in the canton of Bern and the Entlebuch in the canton of Lucerne a certain idyll. The countryside between Bern and Lucerne, here near Schangnau, is one of Switzerland's little known places of refuge.

Near Lützelflüh in the valley of the River Emme, the home of the famous Emmental cheese.

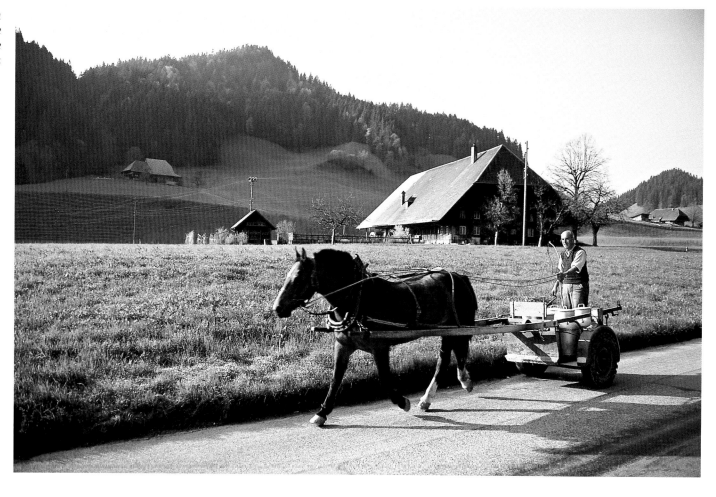

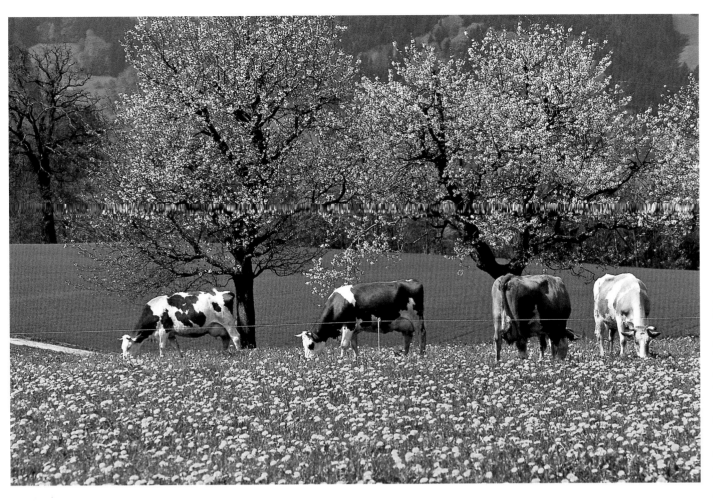

For the Swiss dairy farming is of the utmost economic and cultural importance. In the valley of Emme, here near Trub, milk is primarily used to make Emmental cheese which has made this rather quiet part of Switzerland famous all over the world.

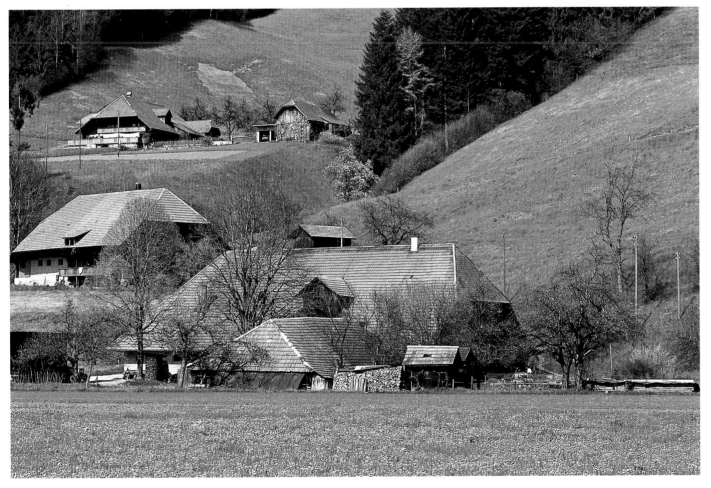

The size and nature of the farms in Eggiwil proudly reflect the wealth of the Emmental. Much of the money today comes from government subsidies.

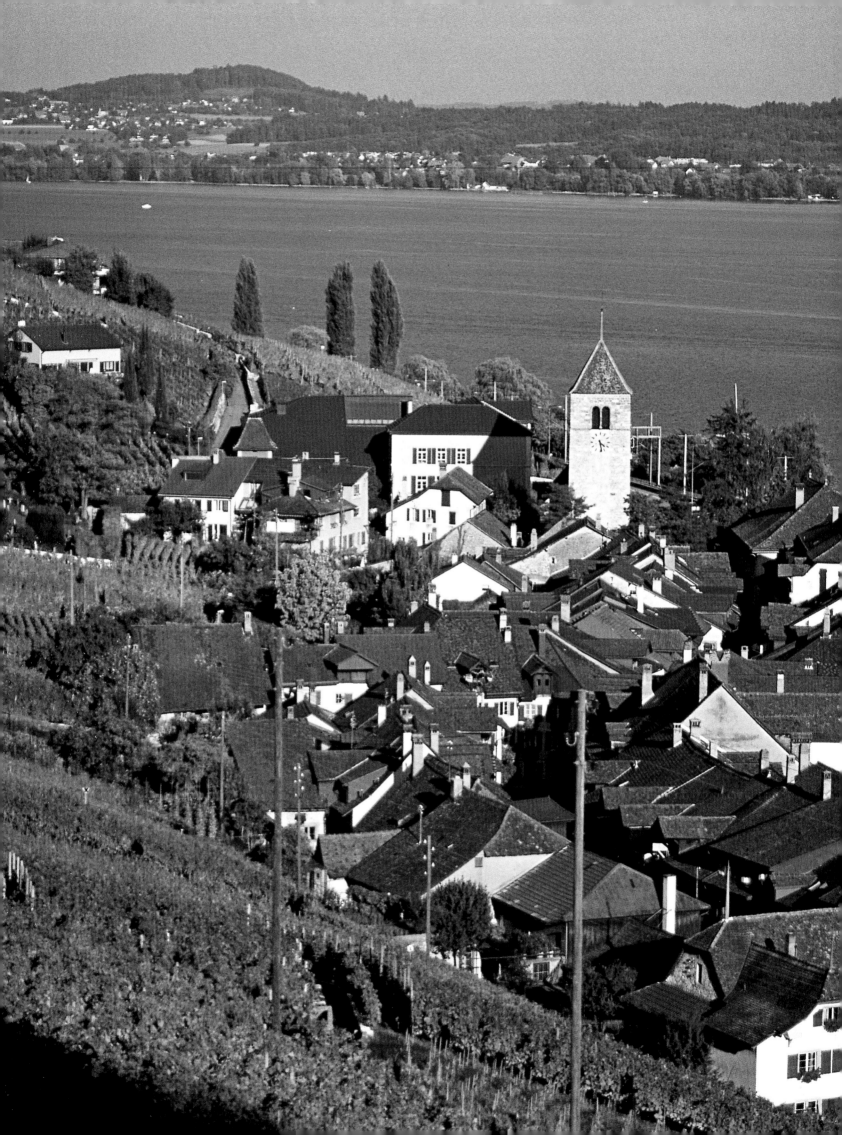

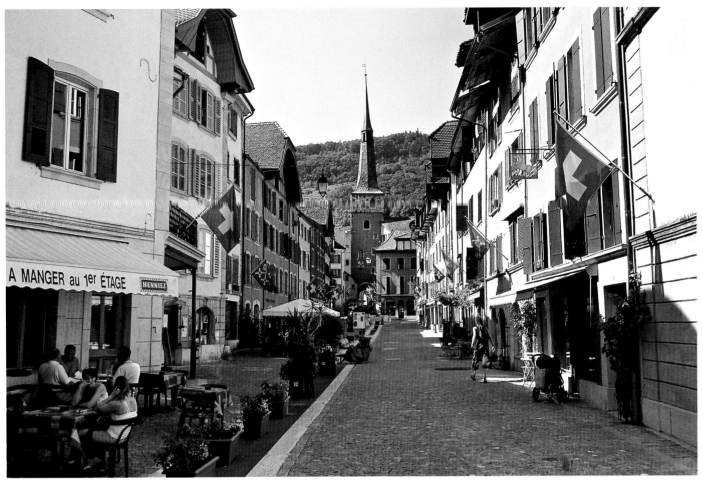

One of the prettiest little towns in West Switzerland is La Neuveville on Lake Biel-Bienne, its ancient centre enclosed by strong walls and towers. La Neuveville also forms the boundary between the cantons of Bern and Neuchâtel.

Left page:
A number of tiny wine villages line the shores of Lake Biel-Bienne. Like here in Twann there are often only a few metres between the vines and the lakeside promenade. Viniculture goes back a long way here, with the menus of local restaurants reading like a veritable catalogue of today's modern vintages.

At the south end of Lake Biel-Bienne the little village of Erlach leads a sleepy existence, its narrow streets, arbours and castle a peaceful reminder of days gone by.

159

DOWN SOUTH:
TICINO AND GRAUBÜNDEN

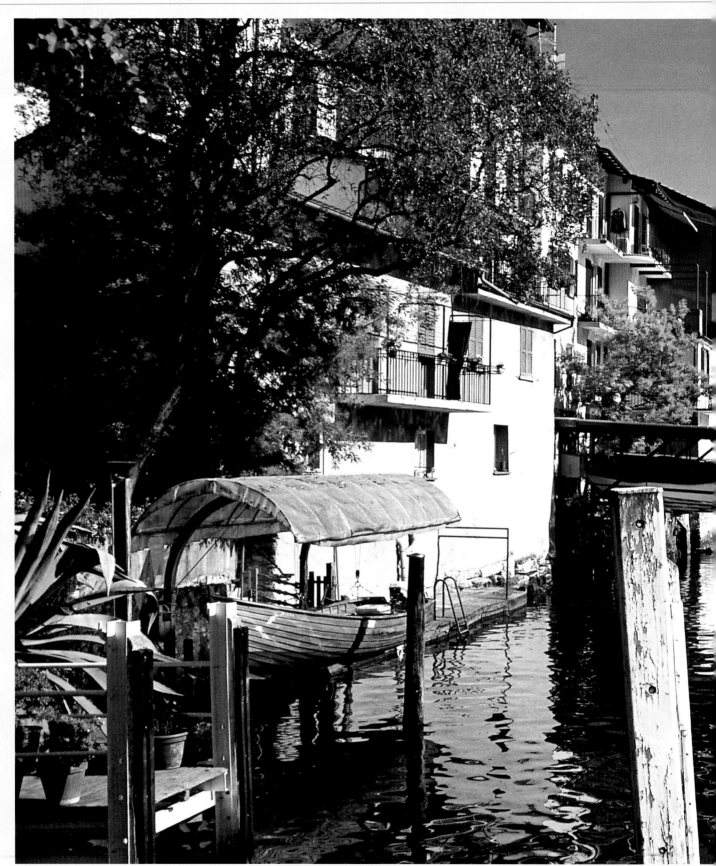

Tucked in between the precipitous slopes of Monte Brè and the aquamarine waters of Lake Lugano is Gandria. The old fishing village can only be reached by boat or on foot from the high road up above it.

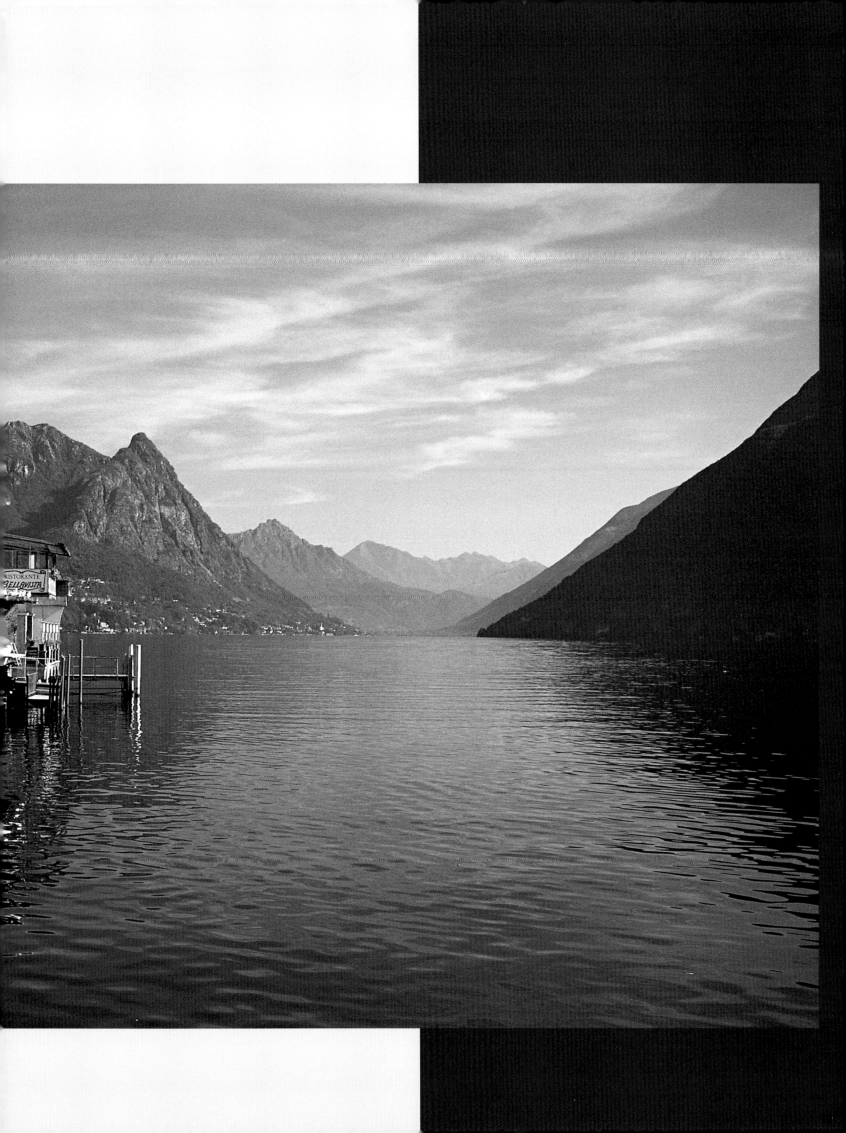

DOWN SOUTH:
TICINO AND GRAUBÜNDEN

In tiny Switzerland they form a world of their own: the two cantons of Graubünden and Ticino. Graubünden is ennobled by its size and diverse scenery and use of language; Mediterranean vegetation and an Italianate way of life inspire in Ticino.

The locals call it "the land of 150 valleys" – referring both to the dips in the landscape and the mountain ridges and peaks which rise up from them. By far the largest and most sparsely populated canton of them all, Graubünden or The Grisons, owes much of its character to its cleft topography. A composite part of this is its linguistic diversity. Between the Rhine Valley in the north, Austria in the east, Italy in the south and Ticino in the west you can hear Swiss German dialects, Italian and – particularly in the Upper Rhine and Inn valleys – various forms of the fourth official Swiss language, Romansch, being spoken.

The highest point in Graubünden, the summit of the Bernina, and the chestnut forests in Val Mesolcina in the south have a difference in height of ca. 3,800 metres (ca. 12,470 feet), making travelling through Graubünden tantamount to a trip through the various vegetation and climate zones of Central Europe. These range from the vineyards of the Rhine Valley in the north to Alpine flora and eternal snow and ice to the beginning of the Valtellina with its distinct Mediterranean flair in the south. Both the mountains and the rivers in Graubünden (the Rhine and Inn) give it its structure and myriad beauty. The Upper Rhine rises in the far west of Graubünden near the Oberalp Pass, flowing through the Surselva region from west to east and joining the Lower Rhine not far from Chur, whose lengthy course climaxes in the raging torrents of the Via Mala. The Inn, which

The mountains – and especially the waters – of Ticino and Graubünden epitomise the great force Nature often displays in extreme habitats such as the Alps. For example, heavy rain – a not infrequent occurrence in Ticino – turns the meandering River Verzasca into a raging torrent.

spills into the Danube near Passau, first sees daylight on the Maloja Pass in the Upper Engadine, traversing almost the entire width of the canton from southwest to northeast.

With ca. 35,000 inhabitants Chur, the provincial capital of Graubünden, is also the only city in the canton, with just five other communities scraping the 5,000 mark. The Romans called it Curia; the curative charm of the political and cultural centre of Graubünden only fully unfolds on a stroll through the narrow streets of its old town which contains some of the most beautiful historic legacies in Switzerland. The episcopal palace, the Romanesque and Gothic cathedral with the best winged altarpiece of the Swiss Late Gothic, Kornplatz and the Bärenlochviertel are grand remnants of the town's architectural past.

Between royalty and rurality

The list of holiday destinations in Graubünden reads like a travel guide to the trendiest hot spots in Europe; Arosa, Davos, Klosters, Pontresina and St Moritz are the playground of the rich and famous. It's not by chance that the yearly World Economic Forum meets in Davos instead of Geneva, where it's based; there are far more points for prestige to be earned here. Yet Graubünden has another side, a much more gnarled, weathered and authentic visage hidden away beneath the mask of glamour and glitter. It can be glimpsed in side valleys off the beaten track or high up on Alpine pastures away from the royal limos and busloads of well-endowed tourists. There are tiny mountain hamlets, such as those in the Domleschg near Thusis and in the valley of the Lower Engadine, the Italian-speaking enclave of the Poschiavo tucked away behind the Bernina Massif, or the Avers Valley, at the end of which Juf is the highest village in Switzerland inhabited all year round at

2,126 metres (6,975 feet) above sea level. Another of Graubünden's (agri)cultural riches are its rustic *Maiensässe*, simple wooden block huts and barns 1,000 to 1,600 metres (3,280 to 5,250 feet) up in a clearing in the forest. They were once used exclusively by Alpine farmers between spring and autumn; today many provide stressed city dwellers with a welcome (and comfortable) place of refuge. The mighty mountain ridges of The Grisons or Grischuns, as Graubünden is called in Romansch, are also far from the madding crowds of the canton's holiday resorts. At almost 4,000 metres (13,000 feet) the largest of these are Piz Bernina, Piz Roseg and Piz Palü, mostly unadulterated by the tourist trade. The arch of the Silvretta Group which separates the north of Graubünden from Austria is also little explored terrain – at least for Switzerland. One of the best spots in tourist Graubünden is the national park of the Engadine, the only national park in Switzerland and also the oldest in Europe. The massive UNESCO biosphere in the easternmost corner of the country offers its visitors

South of Thusis in the canton of Graubünden the Lower Rhine has worn away the deep canyon of the Via Mala over thousands of years. Many myths and legends are told about the dark and eerie ravine, its waters wild and furious.

an unusually rich ecological system; with a bit of luck you can watch chamois, marmots and stags close to – and also snakes, lizards and rare birds, such as the bearded vulture. Scots and mountain pine make up much of the forest which covers about one third of the park.

Spartan yet sweet: life in Ticino

If you travel south from the north side of the Alps over the passes of the Gotthard, the Nufenen from Valais or the Lukmanier from Graubünden, instead of driving underneath them, then you can understand why Ticino is so special – even in this country which isn't exactly lacking in diversity. It's primarily the light which makes the difference between the climate of Northern Switzerland, chiefly influenced by the Atlantic, and its southern complement, bathed in a warmer Mediterranean glow, so marked. On many days of the year the elongated Gotthard Massif forms a meteorological divide between the north and the south of Switzerland; with each kilometre further into Valle Levantina the sunlight becomes brighter, the sky bluer and

The small country of Switzerland gets even smaller in Melide on Lake Lugano. The model village has all of the Confederation's major sights on display in miniature – for people both big and small to enjoy.

the contours of the houses, churches and mountain peaks softer. Before you discard your macs and brollies and reach for the sunblock and shorts, however, you should be warned; despite 2,300 hours of sunshine a year in Locarno as opposed to 1,700 to 1,800 in the north, the "sun terrace of Switzerland" has a higher annual rainfall than the north. Ticino is thus blessed with clear air but also frequent short but sharp showers created by masses of moist air battered against the main ridge of the Alps by föhn winds from the south.

The canton of Ticino, with a population of 330,000, gets its name from the Ticino River which rises not far from the Nufenen Pass, passing through alluvial land not far from the canton's capital of Bellinzona before entering Lake Maggiore near Locarno. It dominates the scenery of the Sopraceneri, the rough Alpine territory north of Ticino, which is cut off from the softer folds of the southern Sottoceneri by the elevation of Monte Ceneri. Here, around Lake Lugano, the vegetation has an abundance of everything which makes Ticino so attractive to Northern and Central Europeans: oleander and mimosa, azaleas and magnolias, camellia and palm trees. Cork oaks, eucalyptus, cypress, figs and even olive trees have put down roots in the south of Switzerland. These Mediterranean and subtropical plants owe much of their lushness to human design, however; originally they made up just 15% of the natural vegetation of Ticino.

Stuck between the very different cultures of Germany and Italy, Ticino has been endowed with a vast number of exciting historic sites. Among the most splendid bequests from its Romanesque past are the around 40 campanile lining the old mountain passes with their typical round arch friezes, blind arcading and pavilion roofs. The luxurious Renaissance and baroque architecture of the south, on the other

hand, perfectly mirrors the historic fads and fashions of Lombardy. The most recent cultural phenomenon of Ticino is possibly the great magnetism it holds for artists and writers, such as Hermann Hesse, Patricia Highsmith and Golo Mann. Some of Switzerland's most famous contemporaries who have spent their final years here include authors Max Frisch and Alfred Andersch, both of whom made a home for themselves in Berzona, the main town of the wooded Onsernone Valley. Monte Verità up above Ascona was another cultural stronghold of social and political reform and a one-time artists' colony, earning itself a world-wide reputation as a refuge for free thinkers right at the beginning of the 20th century.

Living out in the sticks

Impossible to overlook and as ugly as it is in places, on its opening the Gotthard motorway created both an important transit route between Germany and Italy and also threw an economic lifeline to the former poorhouse of Switzerland. Trade and tourism from the wealthy north have bound Ticino stronger than ever to the German-speaking parts of Switzerland. It's now just a stone's throw from Zürich and Bern to second homes on the warm shores of the Ticino lakes; the arts scene in Locarno and Lugano can now be compared first hand to that of their northern counterparts. Yet this fast, modern and lucrative way of life is just one side to Ticino. Its other is hidden in the valleys which stretch north from Lake Maggiore into the depths of the Ticino Alps. The romantic pivot of Centovalli on the route to Domodossola and the Simplon is well serviced, yet the further you get into the valleys of Val Verzasca and Valle Maggia, the more isolated life becomes. Not only is the pace of life slower on the streets; the people here have to adjust to the conditions thrown at them by their natural surroundings – and not the other way round. In winter no light reaches the valley floor here for weeks in many places. Floods, avalanches and landslides are a permanent threat. Conditions such as these do not suit the rationalisation of the western world, causing many villages to constantly fight eradication. Strangely enough it's often people from the urban centres of the north who manage to heal the deepest wounds by buying up abandoned farms and houses. Their dream lies in the acquisition of one of the quaint, unclad, granite-roofed stone houses which cling to the slopes like bird's nests. The best example of this trend are the twelve hamlets of the Bavona Valley, where the new owners not only carefully tend their *Rustico*, as the stone cottages of Ticino are called, but also mow the meadows in return for a modest payment, making their valuable contribution to the preservation of Ticino's cultural landscape.

Near Tenero on Lake Lugano. The reservoir at the end of the Valle Verzasca collects the water from the River Verzasca, with the lake spilling into Lake Maggiore close to Locarno.

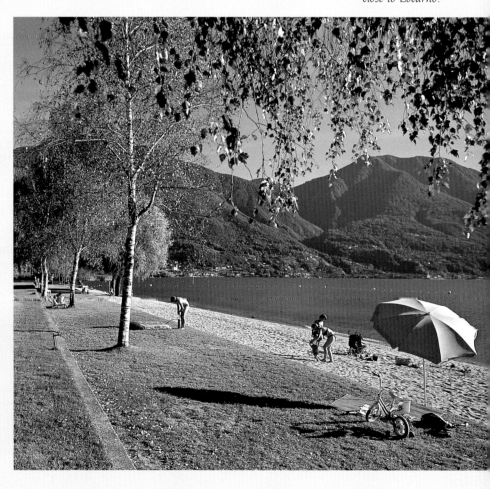

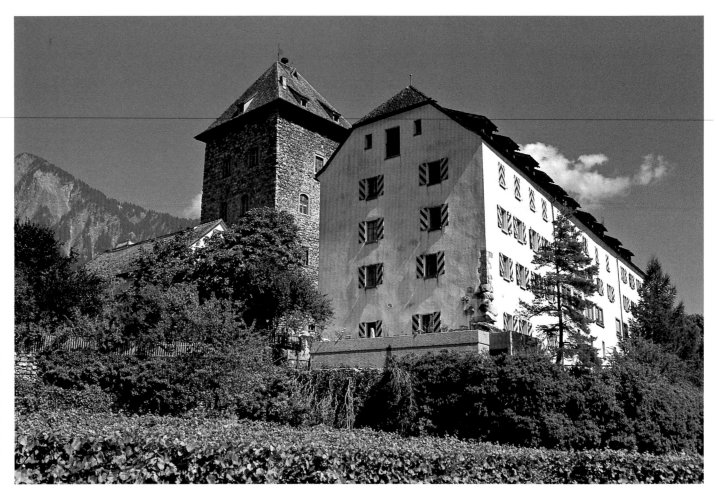

Schloss Brandis from the 11th century rises tall above Maienfeld on the slopes of the Rhine Valley in Graubünden. The little town with its many manorial dwellings was made famous by Johanna von Spyri's "Heidi" books.

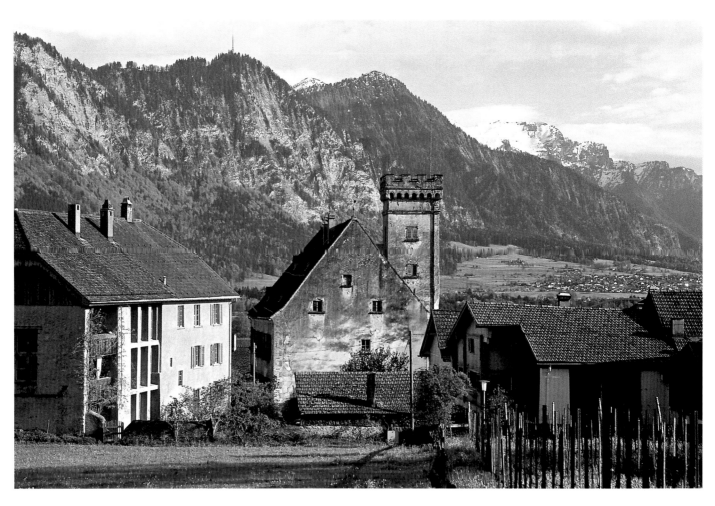

Close to where the Landquart flows into the Rhine is Malans. The wine village with its 17th-century houses is dominated by its castle of Bothmar.

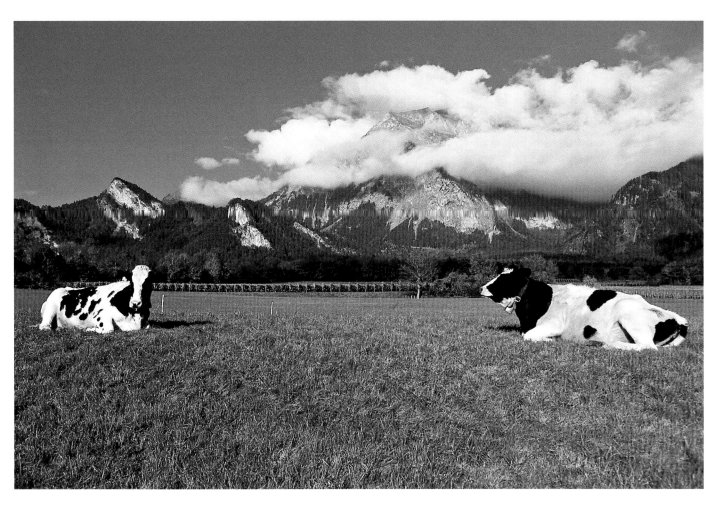

The lush pastures of the Rhine Valley roll gently towards the ominous precipices of the Alps, here near Fläsch.

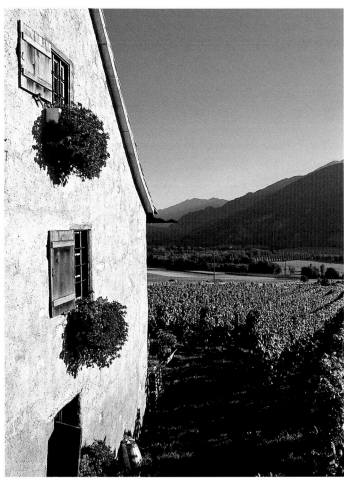

Far left:
From high-lying Jenins row upon row of vines stretch in an orderly fashion down into the valley of the River Rhine. This can be viewed in all its splendour from the nearby Mount Älpli, 1,802 m (5,912 ft) above sea level.

Left:
Schloss Bothmar up above Malans. The view from the fortified manor house, founded in the 16th century, of the valleys of the Rhine and Landquart is glorious, as is the baroque garden, one of the most beautiful in Switzerland.

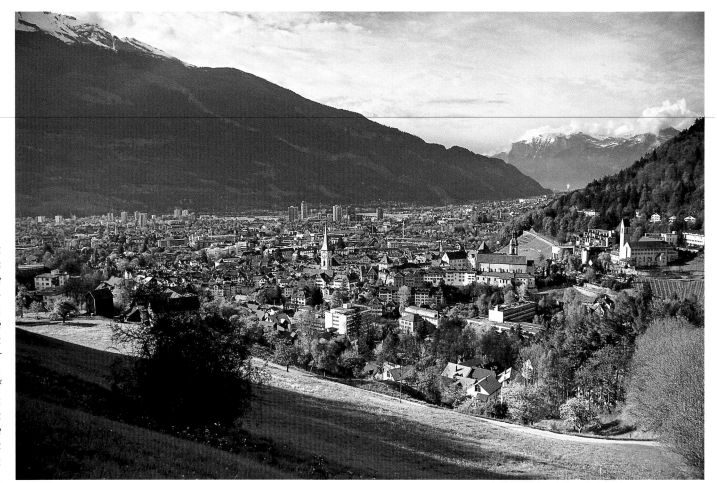

It has the highest average temperatures in the country, is the oldest city in Switzerland and has been the major pivot on the north-south transit across the Alps for several millennia: Chur, the capital of Graubünden. Seen from the motorway it seems to hold little attraction; its historic centre is, however, an absolute delight.

Old Chur gets much of its character from its smart and prestigious town dwellings. The Protestant counterpoint to the cathedral built by Chur's Catholic bishops is the St Martinskirche (right) whose treasures include choir stalls from the 15th century and three glass windows by Augusto Giacometti, an uncle twice removed of sculptor and painter Alberto Giacometti.

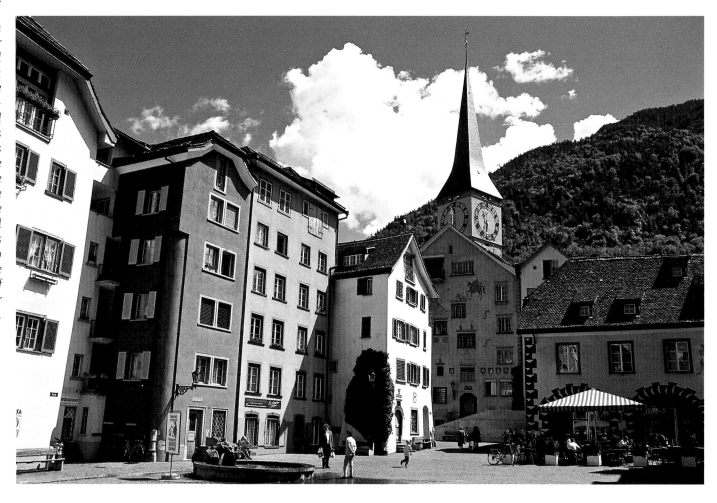

Despite the horrific damage suffered during the Thirty Years' War Chur has been on the up since the mid 17th century. The streets and squares of the old town reflect the history and prosperity of this charming little place.

There are many smart shops and boutiques to be discovered in Old Chur. Their interior, appearance and range of products have often been chosen to sensitively echo the ancient fabric of the buildings in which they reside, many of which date back to the 15th century

169

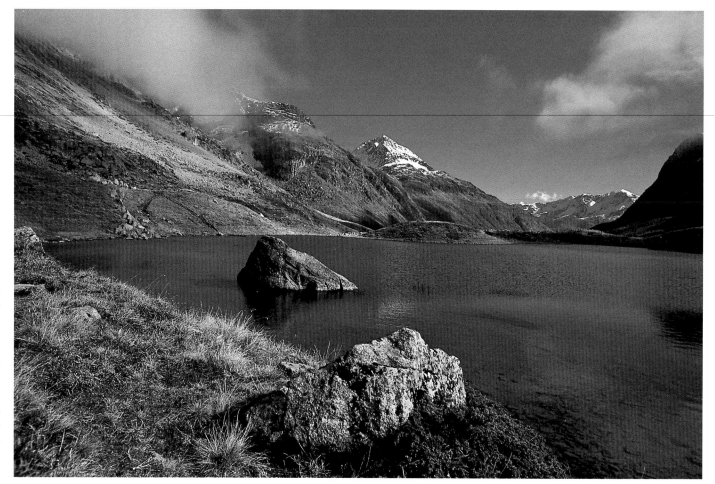

Between the Upper Rhine and Upper Engadine is Oberhalbstein – or Sursès in Romansch. Life in the valley of the River Julia is shaped by agriculture and a little light tourism. The Julier Pass, one of the two routes into the Engadine, was once used by the Romans.

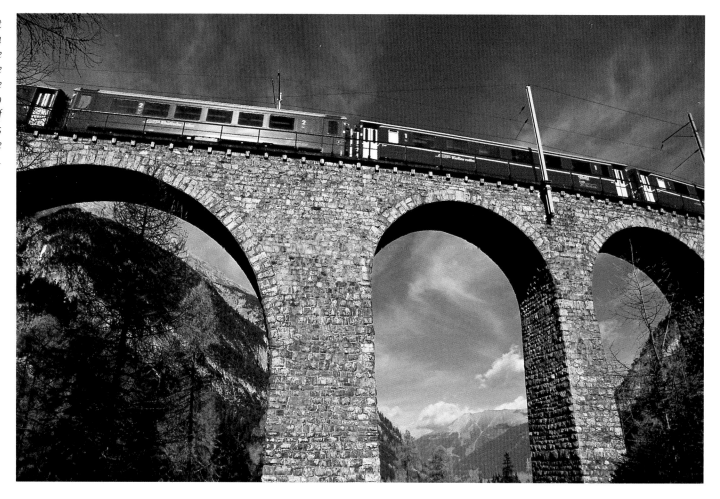

One of the most famous viaducts in Switerland crosses the river near Filisur. The narrow gauge line which links Chur to St Moritz is one of the showcase routes managed by the Rhätische Bahn.

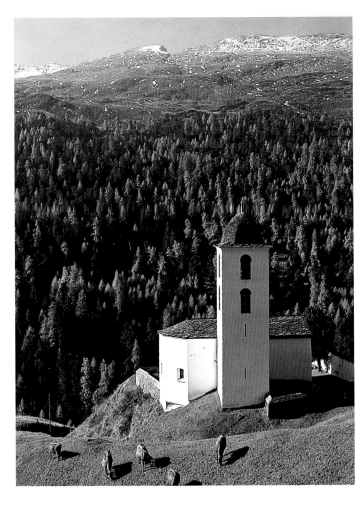

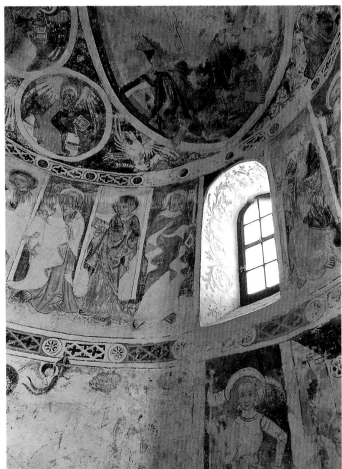

Far left:
The halcyon valley of
the Avers is worth
leaving the busy A13
for; it not only has
many pretty villages
along its course but
also the highest-lying
settlement which is
inhabited all year
round: Juf, 2,126 m
(6,975 ft) above
sea level.

Left:
Ornate frescos adorn
St Peter's in Mistail.
Situated northwest
of Tiefencastel the
church from c. 800
is one of the oldest
in Switzerland.

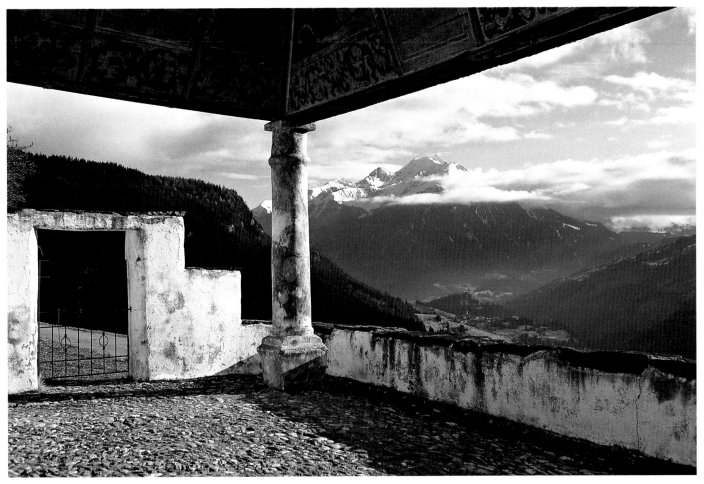

Halfway between
the Albula and
Lenzerheide, on an
Alpine route which
sees relatively little
traffic, is Muldain.
From the church of
St Johannes Baptista
(1677) there are
grand views of the
valley. The carvings,
paintings and fine
stucco also greatly
commend this place
of worship.

171

A fine move:
the Swiss railways

When in 1847 the first train on Swiss soil began its journey from Zürich to Baden Switzerland's neighbours were miles ahead of her. Now, in the 21st century, Switzerland is the most advanced railway nation in the world, her engines running to the remotest corners of the countryside, deep under the biggest mountains and up to the highest peaks. Nowhere else has such a dense network of railway companies; nowhere else do railway lines hold such a great international significance in such a small area; and nowhere else was the railway able to have such a great effect on the local economy with the building of locomotives and railway infrastructure.

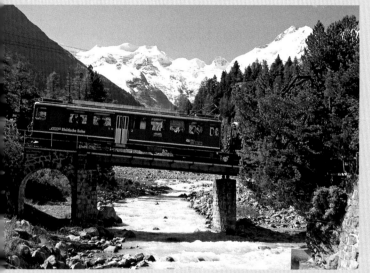

From the metropolis of Zürich to the outlying valleys of Graubünden and Ticino the entire country is serviced by rail; with the precision of Swiss clockwork trains and buses keep to a rigid and frequent timetable deep into the night. Even the boats on Switzerland's many lakes are often scheduled to coincide with train arrivals and departures. Almost everybody in Switzerland has a Halbtax or Generalabo railcard, enabling them to travel for a year either half price or completely free of charge across the whole country. Breakfast at the market in Domodossola, lunch on Lake Geneva and dinner in Zürich? No problem; just hop on a train!

In the beginning was the toothed rack

Out to enjoy themselves and see the wonders of the world, in the mid 19th century Europe's rich upper classes "discovered" Switzerland. The influx of paying guests from abroad soon became too much for the hotel owners and transport companies – and for the sedan bearers, who were having to heft their bejewelled cargo up various mountainsides with increasing frequency. This state of luxury – in the literal sense of the word – resulted in Switzerland's fascinating network of railways which with the help of the toothed rack were soon able to master even the steepest gradients.

Switzerland's prototype, which heralded a new dawn in the history of the European mountain railway, was the Vitznau-Rigibahn, opened in 1871. Along a track of about seven kilometres (four miles) steam engines coped with a difference in height of 1,315 metres (4,314 feet), an achievement which had the travellers of the day oohing and aahing in astonishment and wonder. The race was on! Keen to profit from the boom in Swiss Alpine tourism, other mountain railways began furiously operating new lines, the majority of which are still in use today. One of these is the Rothornbahn which runs from Brienz up to 2,350 metres (7,710 feet) above sea level; another is the little rack railway from Wilderswil near Interlaken up to the viewing platform of the Schynigen Platte, ca. 2,000 metres (ca. 6,560 feet) up. The best of them all is of course the Jungfraubahn, absolutely unparalleled in Europe; along the track opened in 1898, underneath the rocky masses of the Eiger and Jungfrau, it travels to the highest station in Europe at an impressive 3,454 metres (11,332 feet).

Travelling for the fun of it

One of the interesting traits of the Swiss is their unconditional love of their railways. Most of them of course travel to get from A to B – but travelling for the sheer fun of it is also extremely popular. If you just count the many grand panoramic routes crisscrossing the country, you'll know why. Let's take the slowest fast train in the

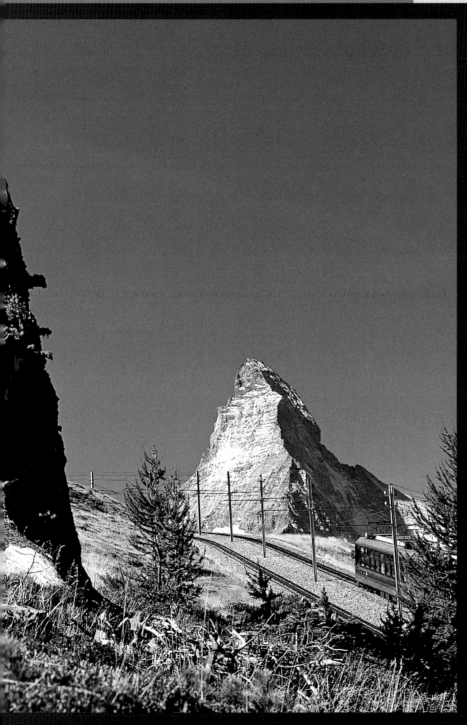

world as an example. The Glacier Express has to cross over 291 bridges, travel through 91 tunnels, overcome the 2,033 metres (6,670 feet) of the Oberalp Pass past glaciers and through the longest meter-gauge train tunnel in the world on its route from Davos/St Moritz to Zermatt through the Valais and Engadine Alps. With seven to eight hours needed for the 290 kilometre (180 mile) journey, you don't have to be in a hurry. A similar tempo and views which are hardly less spectacular are also provided by the Golden Pass route, which runs – with changes – from Lucerne via the Brünig Pass, Interlaken and Gstaad to Montreux, linking Central Switzerland to Lake Geneva.

A great way of travelling from German-speaking Switzerland to Ticino is on the Lötschberg and Centovalli railways. The journey begins in Bern, takes in Lake Thun and then crosses the Bernese Alps through the Lötschberg Tunnel. Once past Brig in the valley of the Rhône and through the Simplon you arrive at Domodossola in Italy. The carriages of the narrow-gauge Centovalli railway then take up the route, passing through the wild and wonderful Centovalli on the two-hour journey to Locarno on Lake Maggiore.

Left:
The Vitznau-Rigi-Bahn in the canton of Lucerne covers a maximum gradient of no less than one in four (25%). The trains, many of which are still pushed by steam engines built between 1920 and 1925, stop for a breather at Rigi-Kaltbad (shown here).

The Furka-Oberalp-Bahn near Gletsch. The railway forms a link between the cantons of Valais, Uri and Graubünden. In the summer classic trains service the line between Realp and Gletsch.

Switzerland's importance as a place of transit for international rail travel was confirmed in 1882 with the opening of the Gotthard Tunnel. In an attempt to meet the increasing demands of future transportation and travel the country has now planned no less than two mega tunnels. The motion to build the NRLA (New Railway Link through the Alps) was recently passed by national plebiscite; with the opening of the new Lötschberg Tunnel (all 34 kilometres/21 miles of it) between the cantons of Bern and Valais the first Alpine crossing was finished in 2007 – at least one line of it. The longest and most expensive railway tunnel in the world will be the new Gotthard Tunnel; from 2015 it will join the little village of Erstfeld in the canton of Uri to Bodio in Ticino, 57 kilometres (35 miles) away.

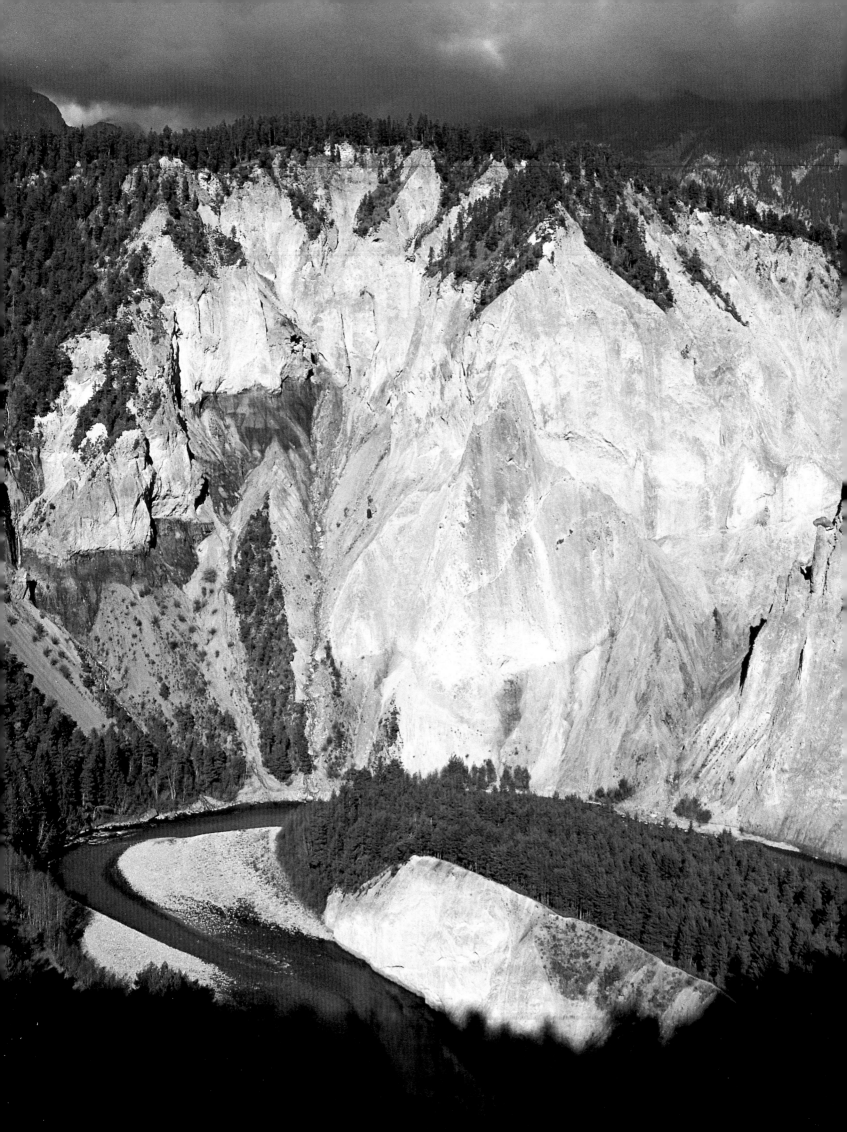

At the north end of the wide valley of the Domleschg is Schloss Rhäzüns, high up above the valley of the Lower Rhine. The castle, whose oldest sections date back to c. 1300, is now privately owned by the controversial nationalist, conservative political and former Swiss minister Christoph Blocher.

Left page:
The Ruinaulta, the great landslide which once blocked the valley of the Upper Rhein near Versam, forms an impressive backdrop to the Rhine Canyon. The sheer rock face, blue Alpine sky and grey-green river create an ensemble which in certain light conditions may seem threatening and dramatic – but always breathtakingly beautiful.

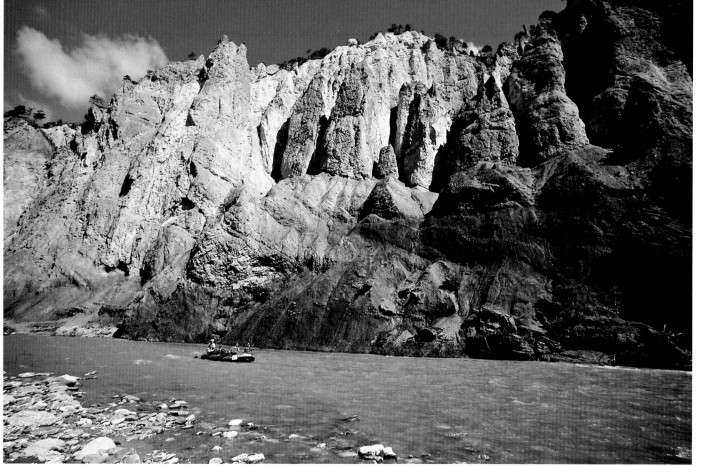

The Upper Rhine in the Rhine Canyon is something of a challenge for water sports fanatics. Armed with dinghies, canoes and kayaks people come here to test their mettle – and to enjoy the fantastic setting and largely unspoilt scenery.

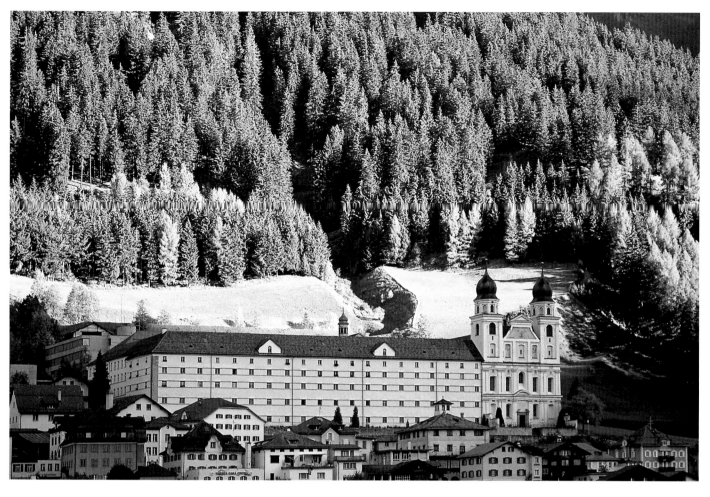

Left page:
Ilanz, built on a crossing on the Upper Rhine, was granted its town charter in the 13th century. The old town reads like a glossary of architectural history from the 15th century onwards.

The spiritual and cultural centre of the Surselva region is Disentis, known as Mustér in Romansch. The village is the seat of the Benedictine monastery of St Martin which was established in 720. Destroyed several times during its turbulent history, the mighty complex has still managed to hold on to many of its ecclesiastical treasures.

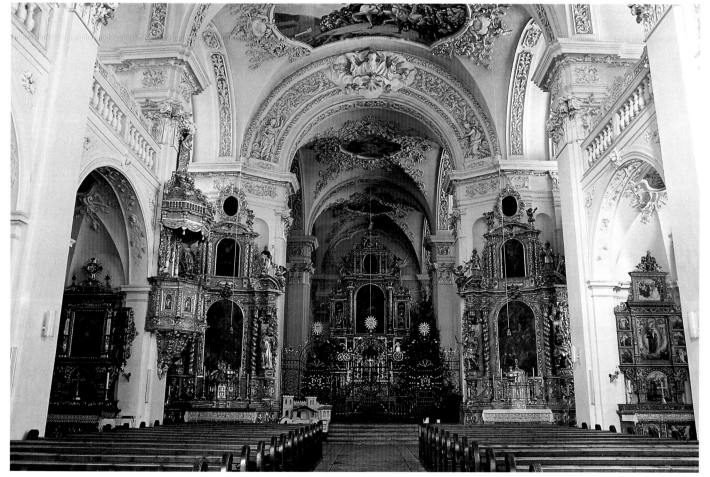

The twin towered abbey church of St Martin in Disentis from 1695 to 1712 is one of the best of its kind in the Central Alps. Set on fire by French Revolutionaries in 1799 the church sadly lost most of its magnificent original interior. This has since been painstakingly reconstructed.

Page 178/179:
Ski and health resort Arosa is favoured not so much for its architecture but for its location high up on an Alpine plateau below the Weisshorn and Schwarzhorn mountains.

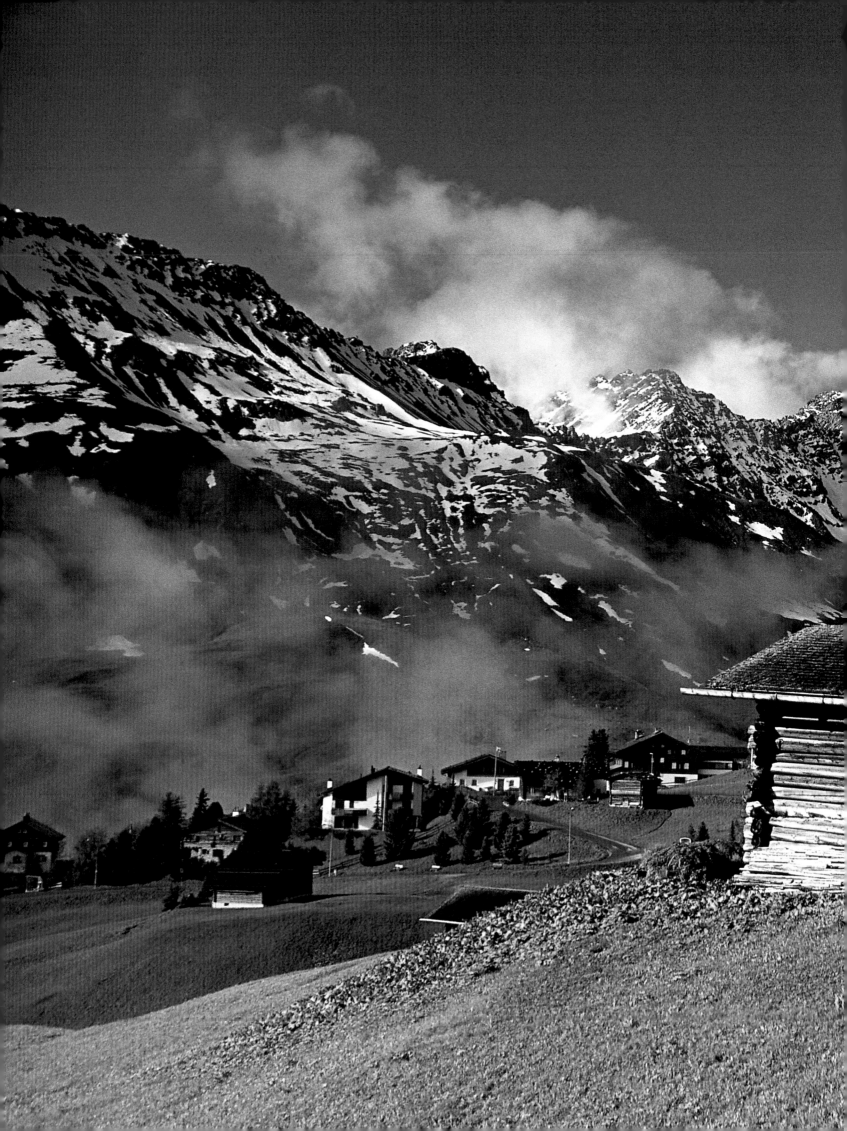

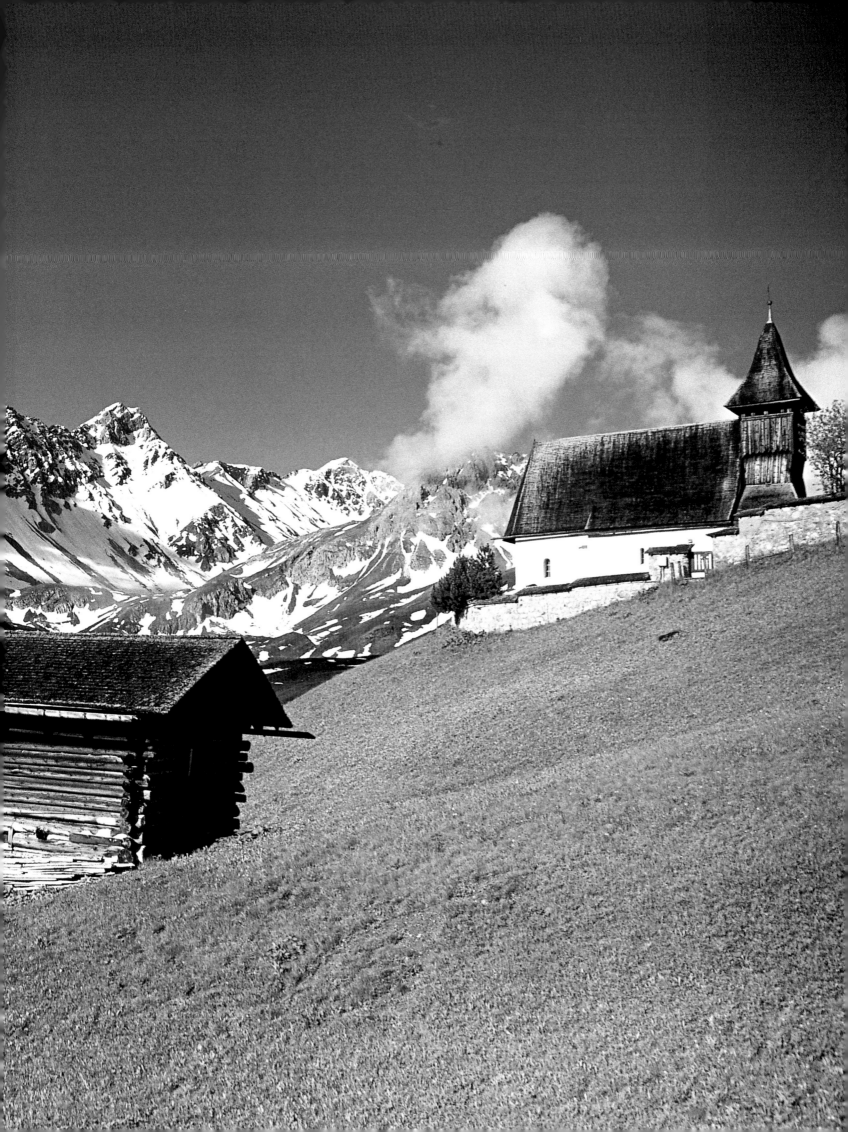

The old mountain village of Splügen underwent a sudden boom on the opening of the Splügen Pass into Italy in 1823. For 60 years tourists en route from Germany to Italy and vice verse spent many a happy hour recuperating in the pretty little village. On completion of the Gotthard Tunnel Splügen suddenly became redundant. It wasn't until the advent of the San Bernardino Tunnel for cars in 1967 that the village was able to once again loom large on the tourist itinerary.

The Lej da Silvaplauna is at the heart of the lake district of the Upper Engadine. Surfers have discovered it in abundance, keen to exploit the fall wind from the Maloja to try out their skill and expertise.

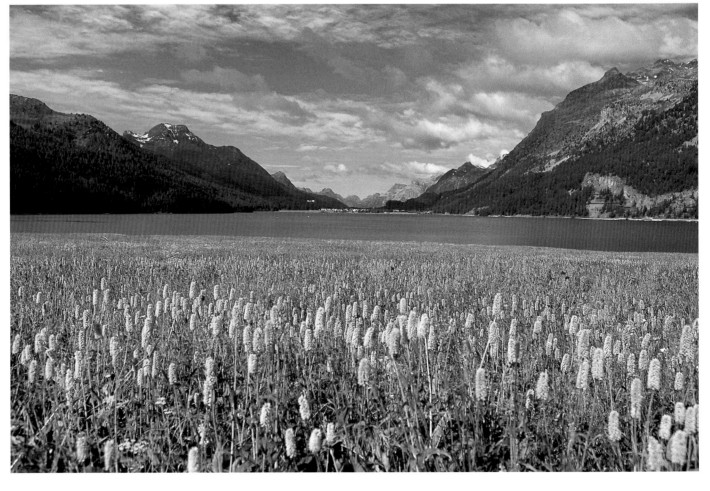

The ca. 2,000 in-
habitants of the
Val Lumnezia south
of Ilanz speak
Sursilvan, forming
one of the westernmost
outposts of the
Romansch-speaking
world. The village of
Lumbrein is famous
for its tower houses
and its Gothic altar,
hidden away in the
chapel of Nossadunna.

The verdant valley
of the Schams is one
of the regions fed by
the Lower Rhine.

Up above Maloja at the foot of the pass the belvedere of the counts of Renesse pierces a brilliant blue sky. Never finished, the complex is less older than it first appears; the pseudo-medieval crenellation is a product of the 19th century.

Right page: High up above the River Inn is Schloss Tarasp, the impressive landmark of the Lower Engadine Valley. For centuries the official seat of the governors of Austria it's now under private ownership.

The beauty of Lake Sils or Lej da Segl has inspired many an artist and writer, including German philosopher Friedrich Nietzsche. The house where he spent seven consecutive summers in Sils-Maria is now open to the public.

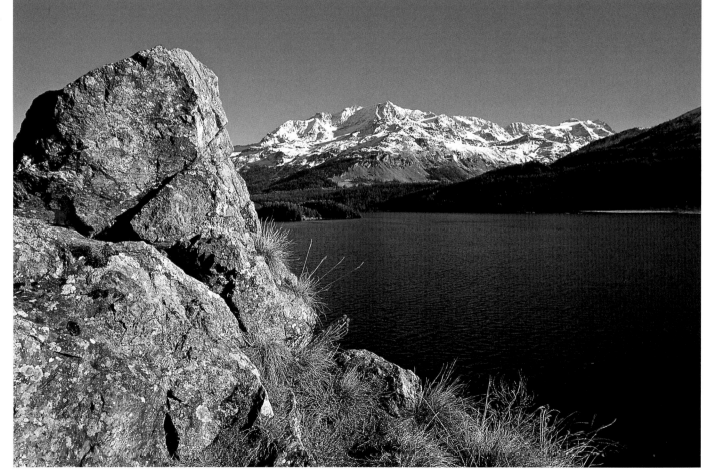

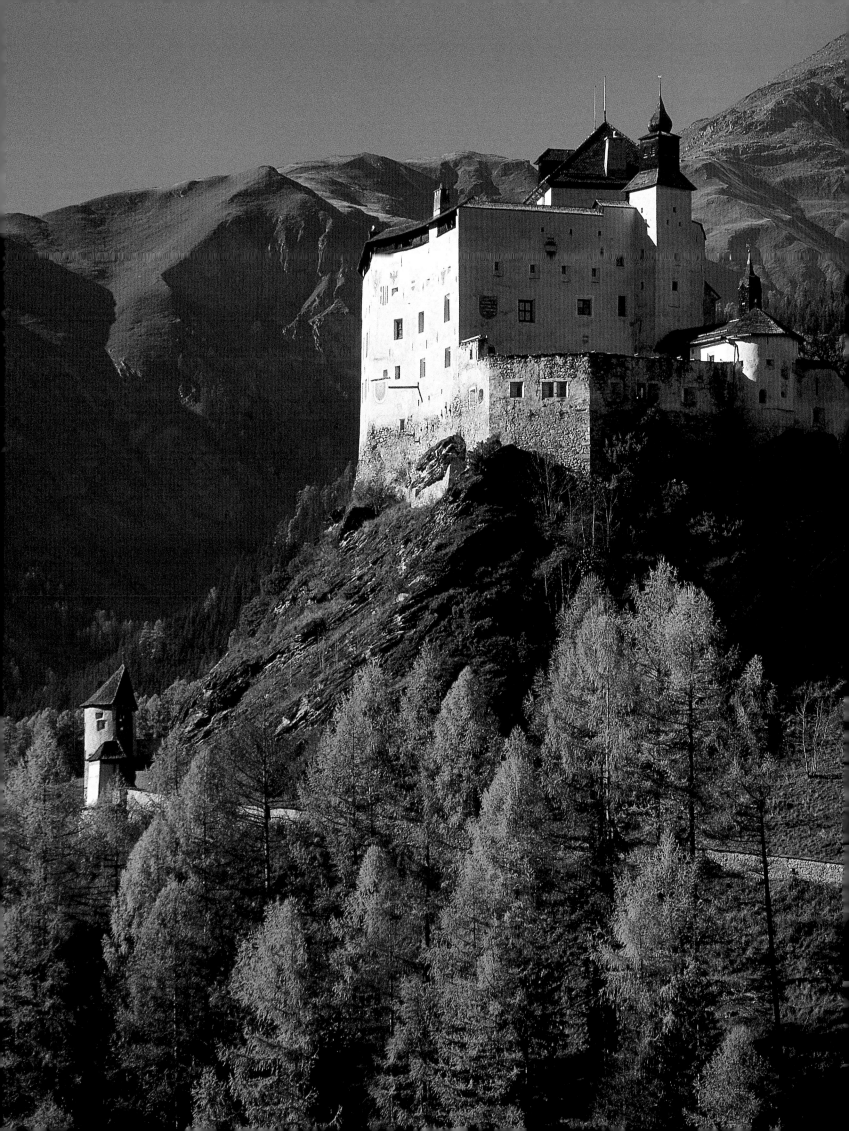

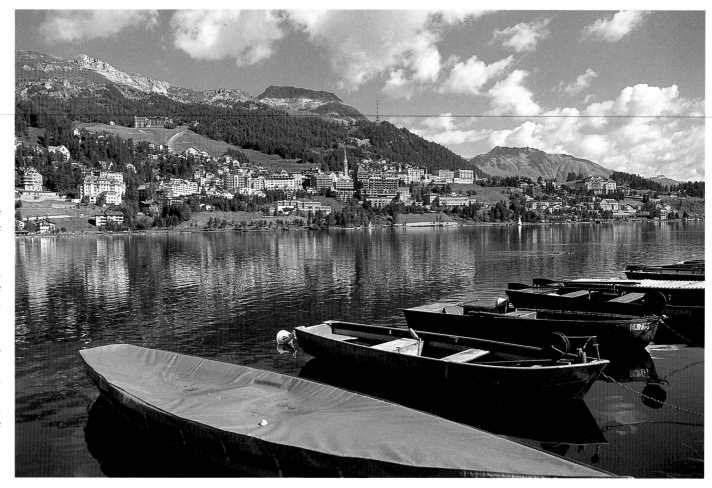

Across the lake of St Moritz the view of the chicest ski resort in the Alps is nothing less than grand. The crème de la crème of society, complete with all its would-bes and has-beens, has convened here for over 150 years. Long before the advent of the jet set Paracelsus lauded the healthy climate of San Murezzan and its healing spring waters.

With around 320 days of sun a year St Moritz can happily hold its own against many a Mediterranean resort. Despite its elevated location it can still get quite hot in the summer, making the shady umbrellas of the pavement cafés in the centre the focus of attention. The frequent dry weather in winter ensures that temperatures stay low – with snow thus guaranteed.

St Moritz has hosted
the Winter Olympics
no less than twice –
in 1928 and 1948.
The streets of the
scenic little town
were then packed
with sportsmen and
women and their
fans from all corners
of the globe.

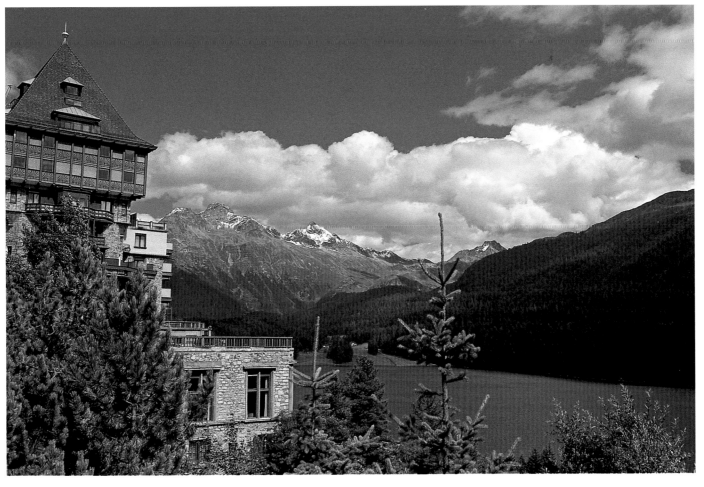

The turn of the
19th century
bequeathed to
St Moritz a most
unusual hotel with
the promising name
of Badrutt's Palace.
The rather weighty
edifice, first opened
for custom in 1896,
is now one of the
Leading Hotels of
the World, welcoming
countless famous
names to its
hallowed halls.

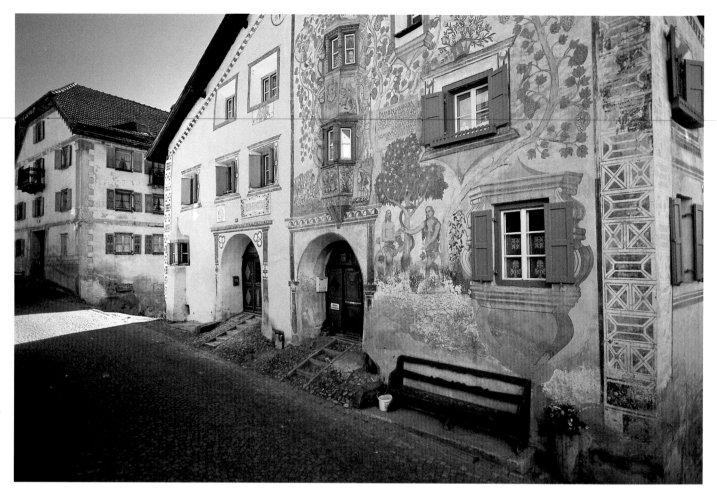

One of the distinguishing features of the villages of the Lower Engadine, such as Ardez (above) and S-chanf (below), are the huge whitewashed stone houses. Sgraffito frescoes, pretty oriels and wrought ironwork around the windows make each village an attraction in itself.

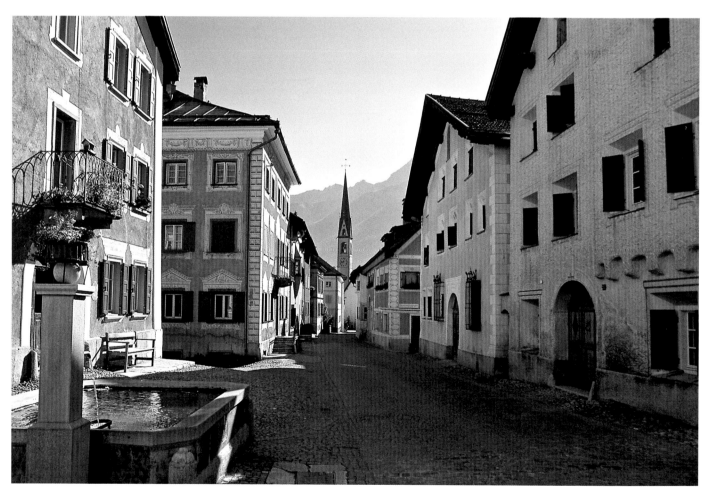

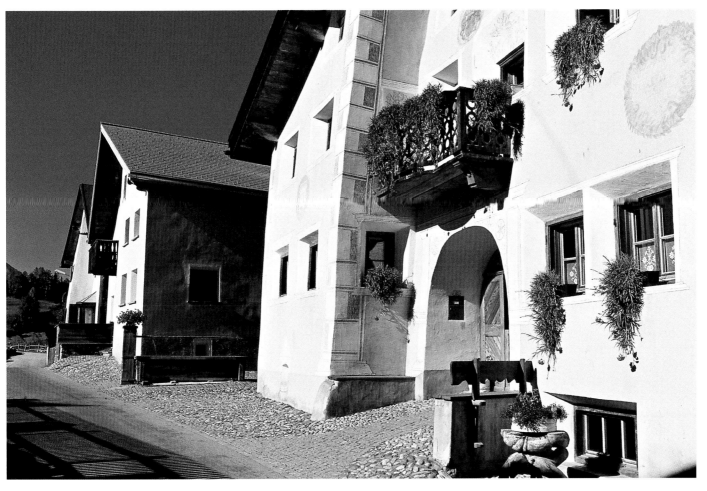

For hundreds of years the Lower Engadine was ruled by the diocese of Chur, with Austria also exerting a strong influence throughout the valley well into the 17th century. Today the population is largely Protestant and speaks Romansch. The little villages of Ftan (above) and Guarda (below) are simply delightful.

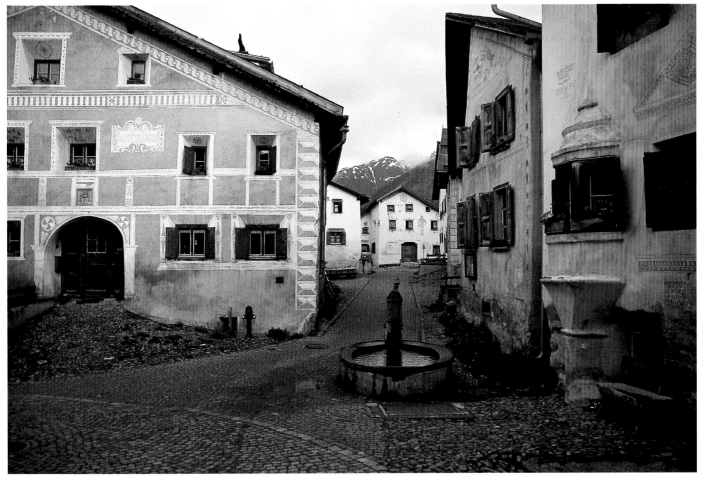

Page 188/189: Morteratsch in the Val Bernina. Wonderful hiking trails lead off from here into the Bernina Massif with the mountains of Piz Morteratsch, Piz Bernina and Piz Palü. If you follow the course of the Ova da Bernina you eventually reach Lake Bianco on the Bernina Pass.

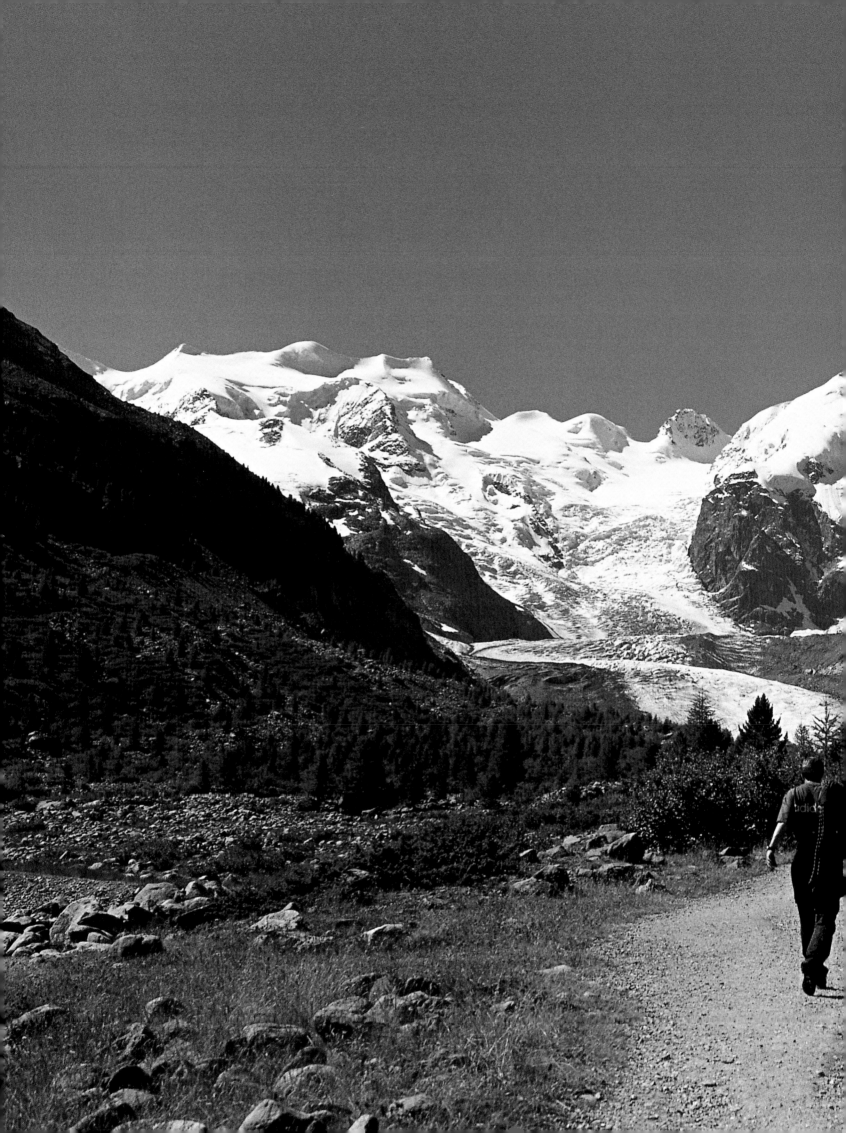

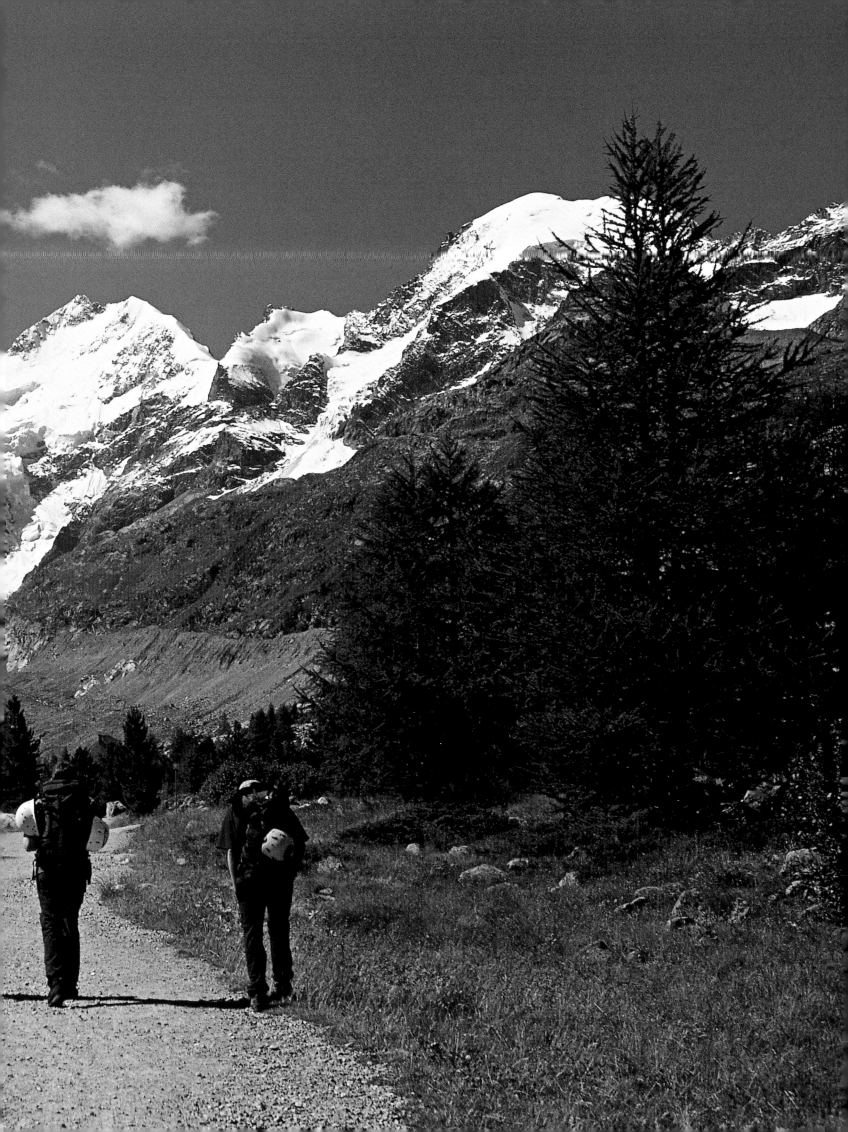

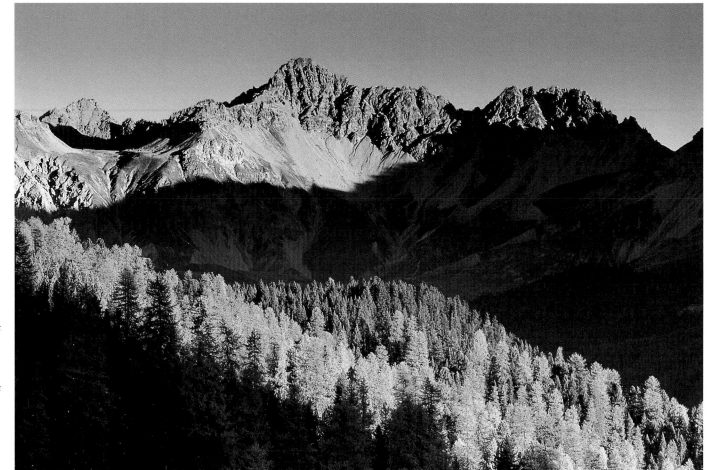

The area between the valley of the Inn, the Italian border and the Ofen Pass in the canton of Graubünden is amalgamated under the auspices of the Swiss National Park. On its founding in 1914 it was the only nature reserve of its kind in Europe. Unspoilt und unadulterated it is not, however; from the 11th to 17th centuries intensive mining resulted in much of the forest being eradicated. One of the first steps thus taken by Switzerland's nature conservancy groups was to replant 172 square km (66 square miles) of the park. The Italians have also contributed to the giant undertaking on their side of the Alps at the Parco Nazionale dello Stelvio.

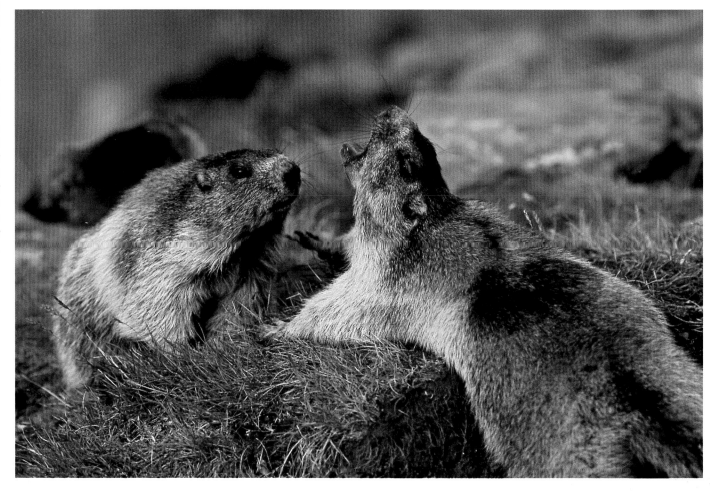

190

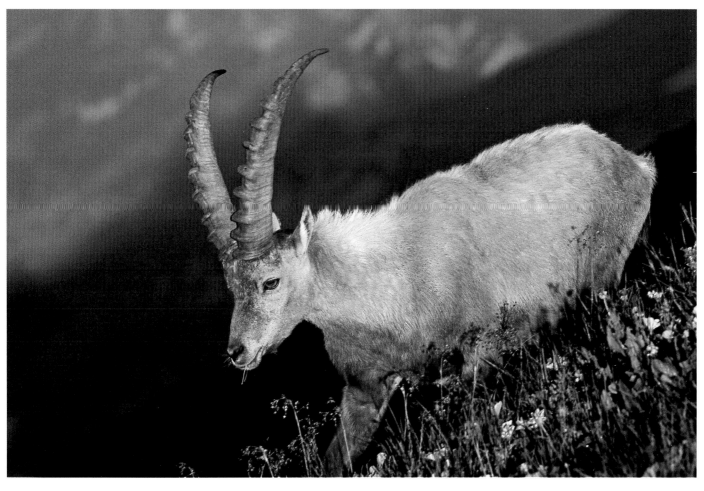

The plant and animal
world can now safely
be left to fend for itself
in the Swiss National
Park. According to
official statistics there
are over 5,000 species
of animal and
650 types of plant
resident here. You
still have to be very
patient, quiet and
extremely lucky to
spot marmots, ibex
and chamois in the
wild, however.

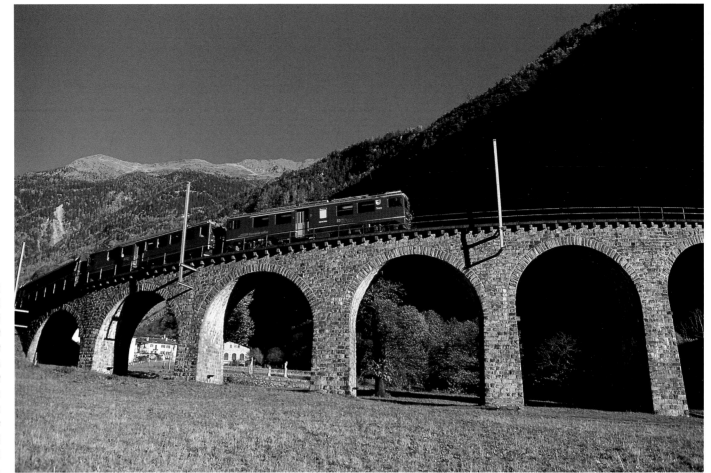

The looped viaduct in Brusio, along which the Bernina railway covers a sharp decline before entering the terminus in Tirano in Italy, is famous the world over. On warm summer days you can enjoy the slow but incredibly scenic journey in an open carriage.

Prosperity and the proximity of Italy are clearly discernible in Poschiavo, the centre of the Poschiavo region. The Italian-speaking tip of Graubünden is still something of a secret to the tourist trade. With its campanile, lively piazzas and palazzi built by well-heeled citizens Poschiavo has all the flair of the Mediterranean.

Val Müstair in the southeasternmost corner of Graubünden is also something of an anomaly. Embedded between the Ofen and Umbrail passes the valley opens out onto the Etsch in South Tyrol. The border to Italy is formed by Müstair or "monastery", so called in reference to the Benedictine convent here. The abbey church of St Johann with its interesting Carolingian frescoes is a UNESCO World Heritage Site.

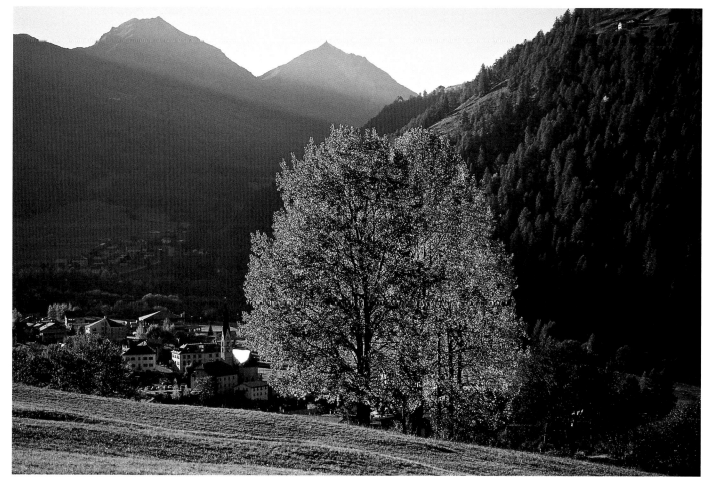

Autumn in Valchava. The little village in Val Müstair is a place of encounter for creative minds from all over the world.

The classic journey across the top of the San Bernardino Pass is always a grand alternative to transit through the tunnels. The pass links the German and Romansch-speaking parts of Graubünden with Valle Mesolcina. For centuries the picturesque mountain valley which fizzles out in Ticino was traversed by mule traders, pilgrims and merchants on their then extremely arduous journey across the San Bernardino.

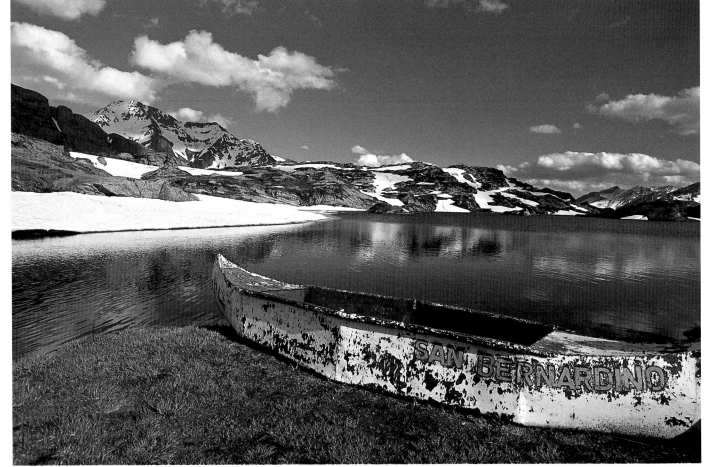

The Castello di Mesocco was once the ancestral seat of the counts of Sax of Mesolcina before they sold it and the entire valley to Milan. The decision was to prove unfortunate; the castle was destroyed by the population of Graubünden in 1526 in protest against foreign rule from the south.

194

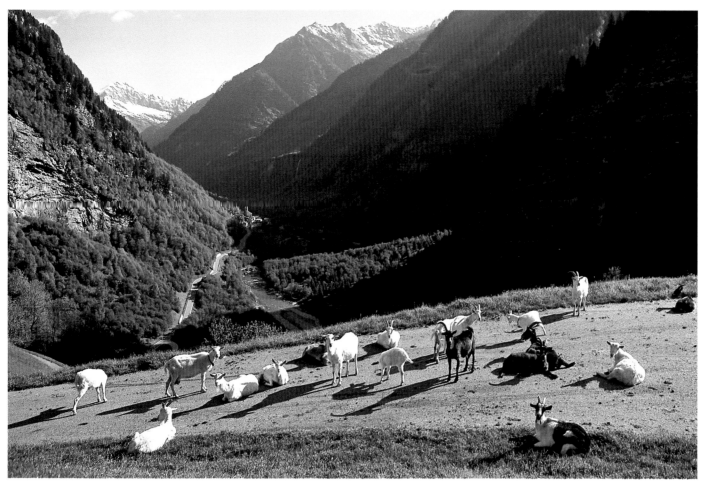

The narrow Val Calanca, which runs due north from the southerly Valle Mesolcina, is probably the most remote area in Graubünden. This makes it something of a refuge, one disturbed only by hikers taking advantage of the many great walks signposted here.

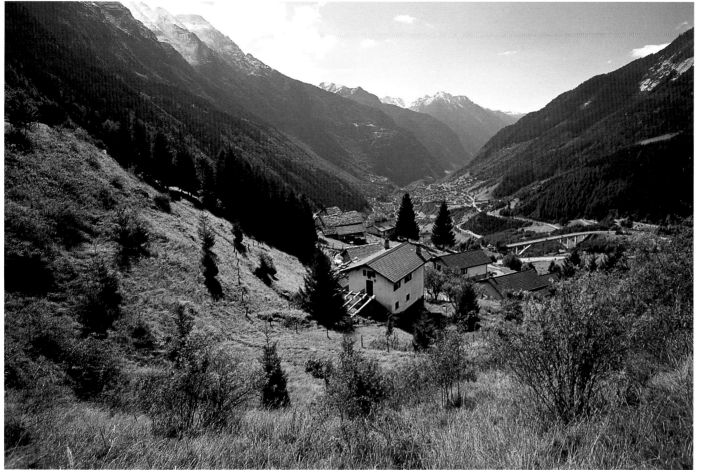

From higher ground there are good views of the valley floor of Valle Mesolcina.

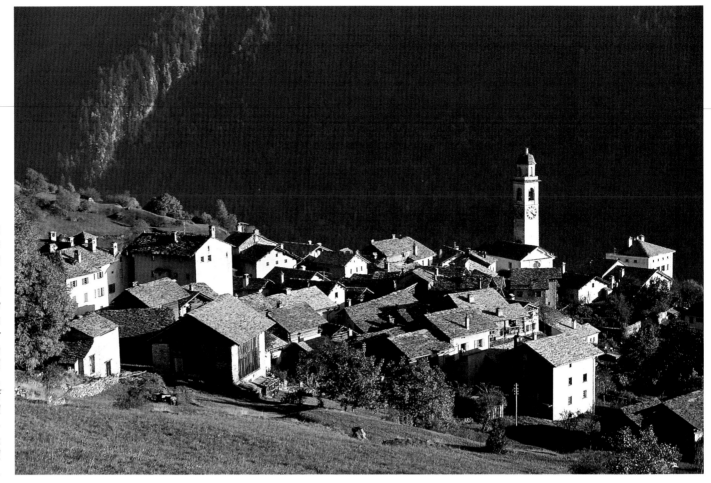

Soglio in Val Bregaglia (Graubünden) hugs a plateau facing the Sciora Group. One of the many features of the village are the prestigious palazzi built for the Salis dynasty between the 16th and 18th centuries. The Salis were one of the most influential families in Graubünden – both politically and economically.

Each autumn the shady glades of chestnut forest near Soglio are harvested. The nuts are still painstakingly picked by hand.

The village well
in Soglio provides
a welcome and
convenient source
of water in the hot
summer months.

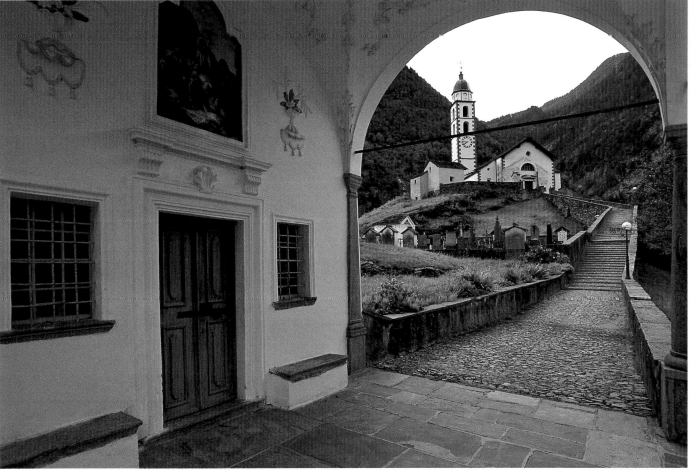

The pretty little
village of Soazza
in Valle Mesolcina
is also surrounded
by chestnut forest.
Its most prominent
building is the church
of San Martino.

Page 198/199:
When dusk
descends over Lake
Lugano there are still
wonderful panoramas
to be had from the
summit of Monte
Brè, Lugano's local
mountain. Looking
south, the lights of
the cars and trains
on the dam near
Melide gleam like a
jewelled necklace
draped across the
deep blue water.

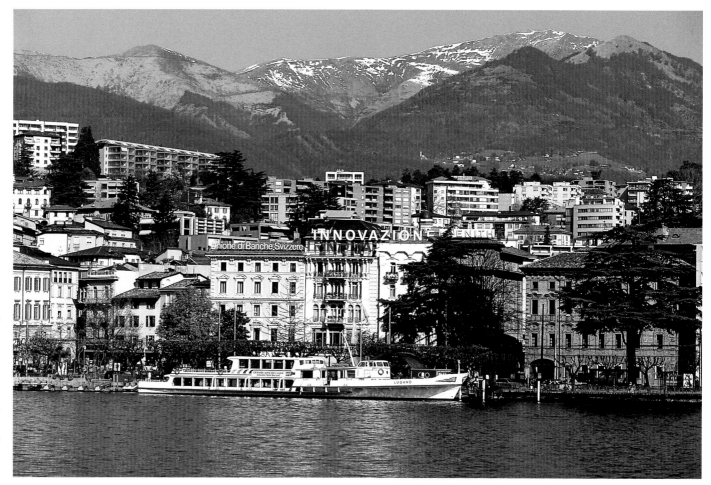

The largest town in Ticino sprawls across the northern shore of the lake to which it lends its name: Lugano. The ambience of this flourishing centre of trade at the intersection of Switzerland and North Italy is one of taste, quality and affluence.

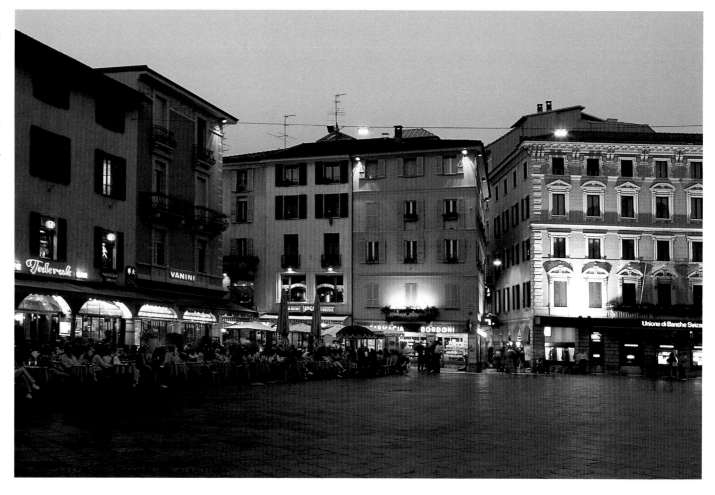

The Piazza della Riforma is one of the most delightful spots in Old Lugano. Along its perimeter are a number of resplendent town dwellings whose arcades provide an atmospheric setting for outdoor restaurants and chic boutiques.

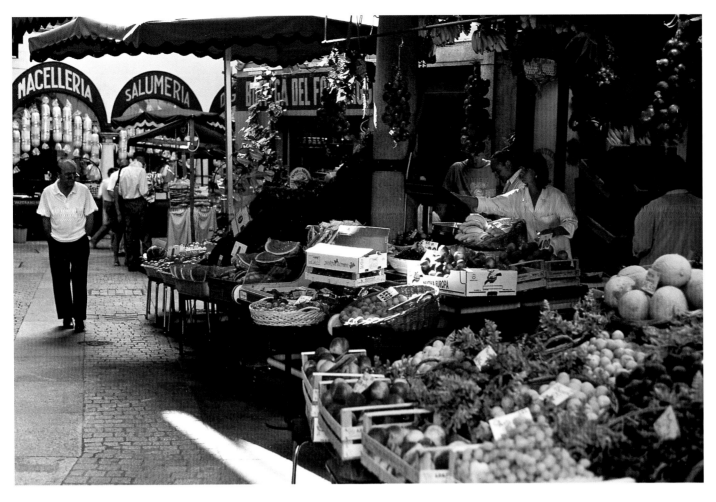

Flowers, fruit, cheese and wine can be purchased on Via Pessina, one of the attractive shopping streets in the old town. Lugano's affinity with its Italian neighbours is unmistakable.

The park along the shoreline of the lake provides welcome shade in the heat of summer. Here you can leave the bustle of the centre of Lugano behind and enjoy the view and serenity of the spectacular scenery.

Just a short walk or boat trip away from Lugano is the suburb of Castagnola beneath Monte Bré. One of its attractions is Villa Favorita with its subtropical gardens which has belonged to the Thyssen family since 1932. Not far from here the Museo delle Culture Extraeuropee is housed at the no less impressive Villa Heleneum.

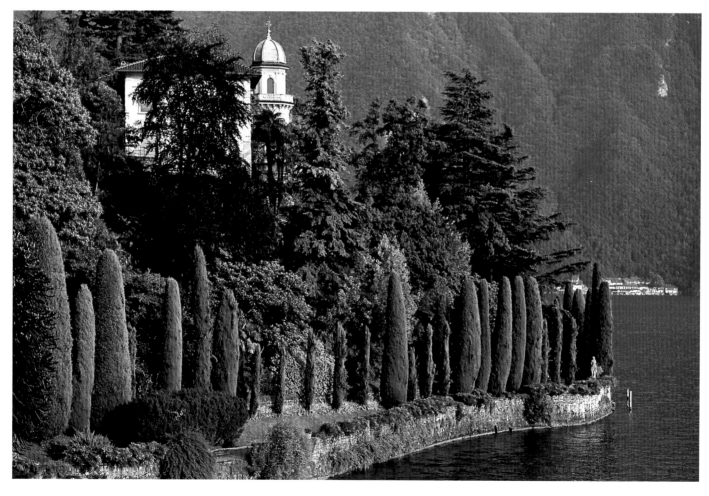

The hour-and-a-half's walk from Castagnola (*below*) to Gandria (*above*) has often been the subject of poetry and song. The Sentiero di Gandria trail behind San Domenico has marvellous views of the Ceresio and Monte Caprino opposite it. Protected from the north winds less hardy plants thrive here, among them the rustyback fern, bayleaf and hackberry.

Right page:
One of the loveliest
spots in the
Sottoceneri can be
found on a small
terrace up above
Gentilino, where an
artistic avenue of
cypress trees leads
up to the baroque
complex of
San Abbondio.
German writer
Hermann Hesse and
conductor Bruno
Walter lie buried in
the cemetery here.

The Denti della
Vecchia or "teeth of
the old" stick up
between Monte
Brè and the chain
of the Cima di
Foiorina west of
Lugano.

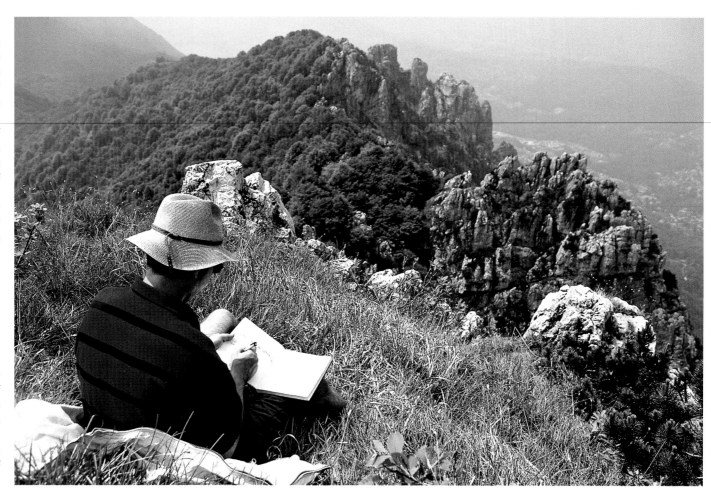

In the mountains
not far from Carona,
with Lake Lugano
ever visible in the
distance.

Page 206/207:
Morcote is the "trea-
sure-trove of Ticino",
its palazzi and town
houses the perfect
contrast to the more
modest fisherman's
hovels and taverns
which line the lake
shore. A long period
exempt from duties
and excise promoted
the wealth of the local
inhabitants and
earned them a special
status within Ticino.
Some of the monetary
privilege was poured
into the construction
of Maria del Sasso,
given a prominent
position on its
verdant hillock.

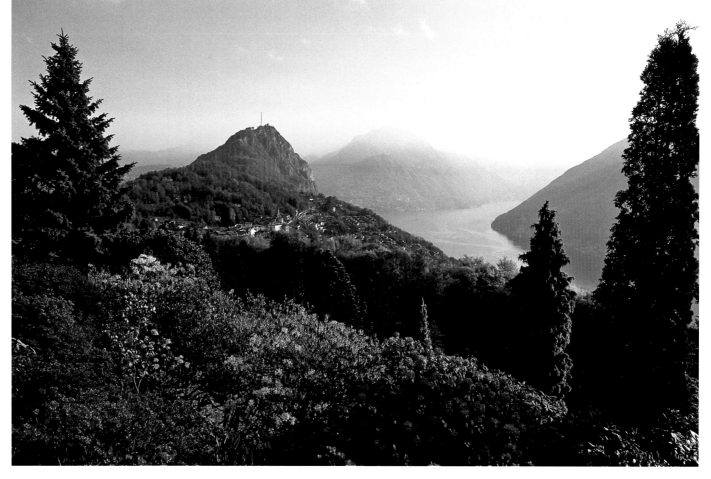

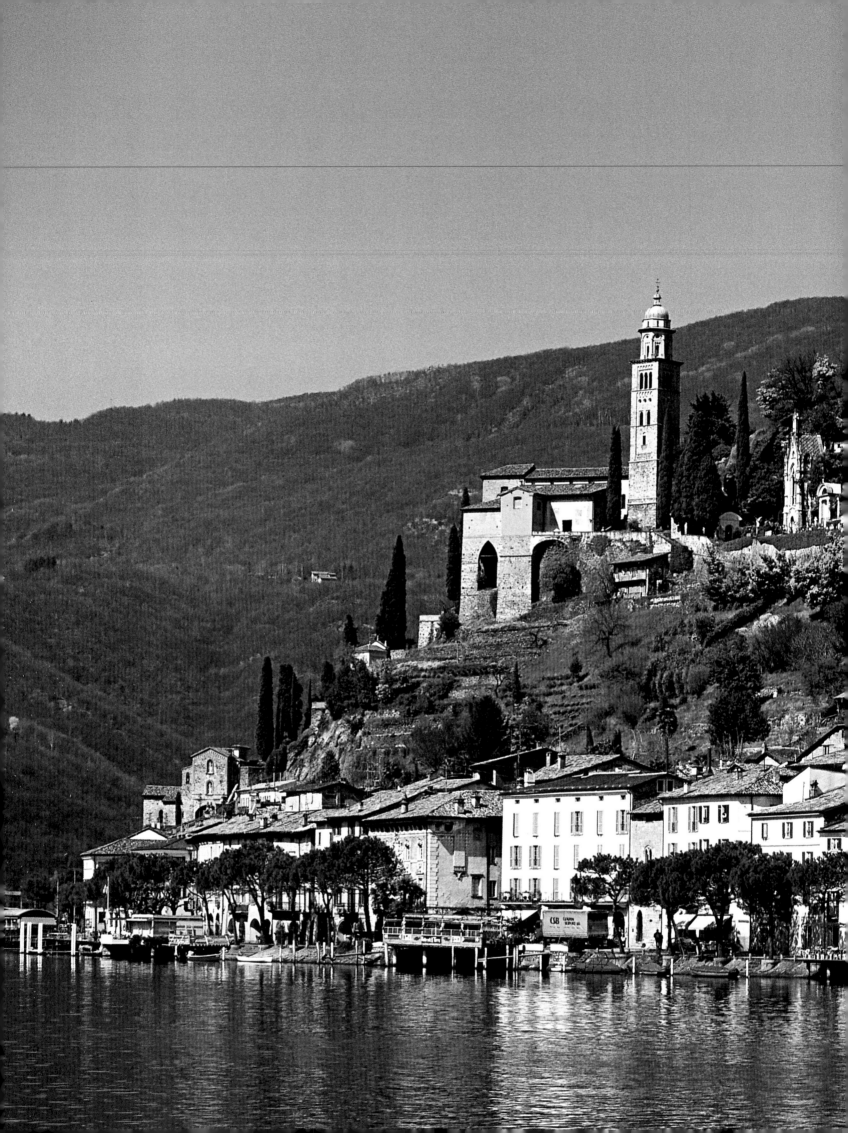

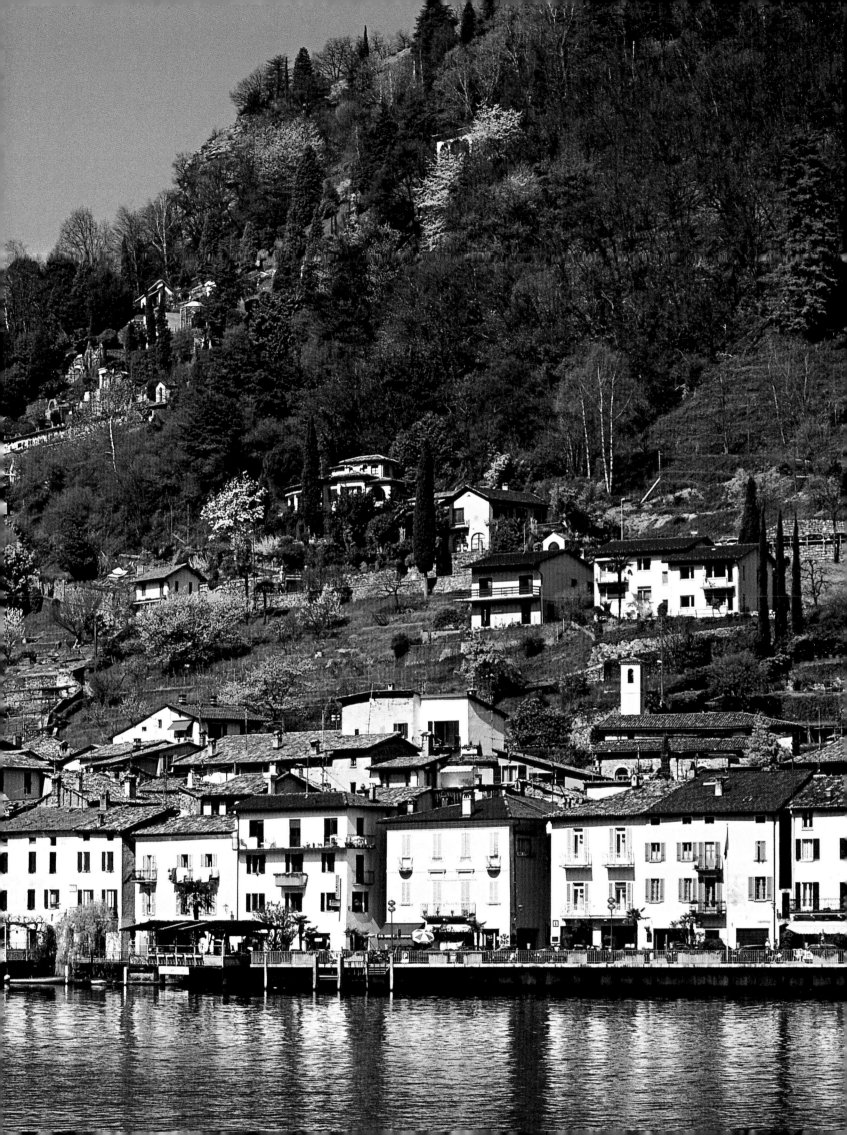

Locarno is also dwarfed by its chief religious venue, the pilgrimage church and local landmark of Madonna del Sasso. The setting is just as grand as the building itself, begun in the 16th century. The pilgrims who come here are ensured a warm welcome at the Capuchin monastery.

October sees the celebration of various chestnut festivals in the Lake Maggiore area where the produce of the local forests is served roasted to an appreciative audience. In Locarno the Castagnata is one of the biggest outdoor happenings of the year.

Evening light on the strand of Ascona on Lake Maggiore. As on all of Ticino's lakes palm trees thrive here, first introduced to the region from Africa around 100 years ago.

On a warm evening life is lived out in the open – with a definite twang of the Mediterranean in the air – on the many streets and squares kissed by the mild Ticino climate.

The wealth of the cities: an expedition from Basel to Lugano

Center:
Above the rooftops
of Bern. You can
still make out the
plan of the old
medieval town.

Mountains, lakes and Alpine pastures: that's the one side to Switzerland. Cities whose fabric and charm go back hundreds of years and way of life is up to the minute: that's the other – and just as enthralling as the former. Swiss urbanity? This reads like a contradiction in terms when you consider that Zürich, the biggest town in the country, has just 350,000 inhabitants. Civic unrest and disquiet? Impossible in a country which appears to simply sit out all the aberrations of our recent European history, you might cry. Things are done differently here. Many of Switzerland's cities seem somewhat fossilised; they still have some of the original purpose of a town, namely to offer its citizens protection and security. Inhospitable peripheries and the catastrophic concrete bunkers of the 1970s and 1980s have made their ugly mark but not done any real damage. Meandering through the centre of Fribourg or Lucerne, you get a sense of what urban life can be like away from the mainstream: a spring day under the palm tress of Lugano, a warm summer's evening on the idyllic shores of

The church of San
Giovanni Battista in
the hamlet of Mogno
– designed by Swiss
star architect Mario
Botta – is remarkable
with its sloped glass
roof and amalgama-
tion of white marble
and grey granite.

Lake Zürich or a swim in the River Aare, floating in a wide semicircle around the old town of Bern.

Solidity, self-confidence and defensiveness are characteristics Switzerland's towns and cities display in varying degrees. Some of the tasteless modern housing blocks and commercial properties in the centre of Basel or Geneva seem to almost apologise for the fact that the bombs and firestorms of war have given Switzerland a wide berth in the past 200 years. Where in Germany and England town planners were forced to redesign entire cities in the aftermath of the Second World War, in Switzerland architects faced the challenge of marrying ancient buildings with the new creations of the modern age. The ongoing process is constantly gathering momentum. This applies more or less exclusively to the north and west of the country, however; with the exception of Bellinzona, Locarno and Lugano in Ticino and Graubünden's Chur and Davos only towns in German-speaking and French Switzerland meet the criteria of at least 10,000 inhabitants to earn the title of *Stadt*. In many of these the skilled union of the Middle Ages and the chic of the 21st century has proved successful. A relaxed tempo is something all of Switzerland's cities have in common, with a certain Alemannic stolidity, French laisserfaire and Mediterranean composure knitting the community together like an invisible thread.

A World Heritage Site: the capital of Bern

Its intact medieval centre is one of the largest in Europe, its broad arcades running for miles under elegant town houses adorned with colourful window boxes. Eleven fountains with facades from the 17th and 18th centuries complete the impressive picture; the old town of Switzerland's capital city Bern has really earned its placed in the esteemed list of UNESCO World Heritage Sites. Its full glory is best admired on a wander through its wide streets and picturesque squares.

Bern owes its founding in 1190 to the dynasty of the Zähringer, as does Frei-burg im Breisgau in Germany, Fribourg in Switzerland, Morat/Murten with its won-derful old town, preserved in its entirety, and Thun at the northwestern end of Lake Thun. Its turbulent history, during the course of which Bern was the most powerful city state north of the Alps for centuries, is tangible all over town. The professions of the Middle Ages are best documented in Matte on the banks of the Aare, the old craftsmen's quarter at the foot of the mighty old town.

History on a European scale can also be intensely experienced in the streets and buildings close to the castle of Neuchâtel. Despite its membership of the Confed-eration the little French Swiss town on the shores of Lake Neuchâtel was not only the capital of the canton but also a Prussian principality up until 1847. Today Neuchâtel has a tasteful French atmosphere; sipping a cup of coffee on the Place des Halles or outside one of the city's many splendid palatial residences, the Seine doesn't seem that far away.

The passage of time

At 1,000 metres (ca. 3,300 feet) above sea level it's the highest-lying larger town in the country. Laid out as a rectangle after a devastating fire in 1794, La Chaux-de-Fonds seems to be anything but Swiss. Except for the clocks, that is, which have catapulted the native city of car manu-facturer Louis Chevrolet and architect Le Corbusier to international fame. In the mecca of the Swiss clockmaking industry time seems to take on a new dimension; a visit to the international clock museum is a relentless demonstration of the pas-sage of time, measured in timepieces from the Ancient Egyptians to the mod-ern age.

Left:
The old town of Ascona is full of representative build-ings and city palaces. Among the most elaborate examples are the 16th-century town hall and Casa Serodine from 1620.

Deep in the moun-tains of Ticino is the Lavizarra, an offshoot of the Valle Maggia. Typical architecture for the region can be found in Prato Sornico, one of the most beautiful villages in the valley.

211

Left page:
Perched on the slope
of the Corona dei
Pinci is the church
of San Martino in
Ronco. The marvel-
lous view of Lake
Maggiore is just
as impressive as the
cluster of buildings
on the church square.

Lake Maggiore
stretches deep into
Italy, its grand
proportions clearly
discernible from
the church square
in Ronco.

Lake Maggiore near
Tenero. At the rear
of the beach the road
begins its steep ascent
into the Val Verzasca
whose wildness seems
all the more fierce
and slightly discon-
certing after the
tranquillity of the lake.

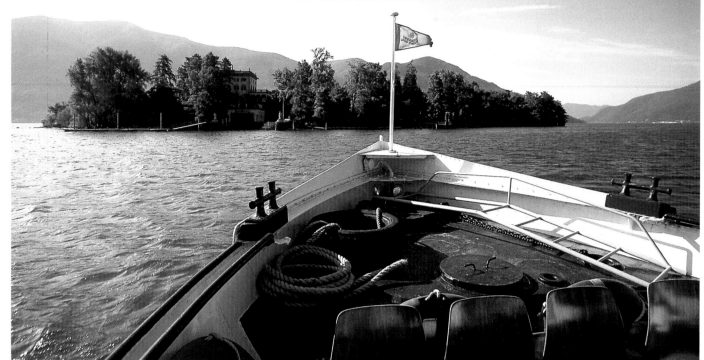

In the middle of Lake Maggiore are the Brissago Islands of Isola Grande and Isolino. The larger is open to the public and can be reached from Porto Ronco, Ascona, Locarno and Brissago; the smaller of the two, Isolino, is a nature reserve and cannot be accessed. Originally the site of a monastery run by the penitent order of the Humiliati, the two islands fell into decay during the 16th century. On their purchase by Russian-born Baronessa Antonietta de Saint-Léger in 1885 they underwent a glorious transformation, catapulting them into the 20th century with style and aplomb. The former wilderness is now a wonderful park, overseen by a grand Lombardian villa.

In the later course of their history, during which Hamburg businessman Dr Max Emden had a neoclassical palazzo erected, in 1949 the Brissago Islands were taken on by the communities of Brissago, Ronco and Ascona and the Swiss nature conservancy association. It's to this initiative that the Brissagos owe their status of Parco Botanico del Cantone Ticino. Ticino's horticultural showpiece now boasts about 1,800 species of plant, most of them subtropical.

Brissago, the last place on Swiss soil before the Italian border, is famous far and wide for its Brissagos, long, thin cigarillos manufactured here since the mid 19th century.

Page 216/217:
Close to Magadino, not far from where the Ticino flows into Lake Maggiore. The good quality of the water yields yearly catches of about 160 metric tons of fish.

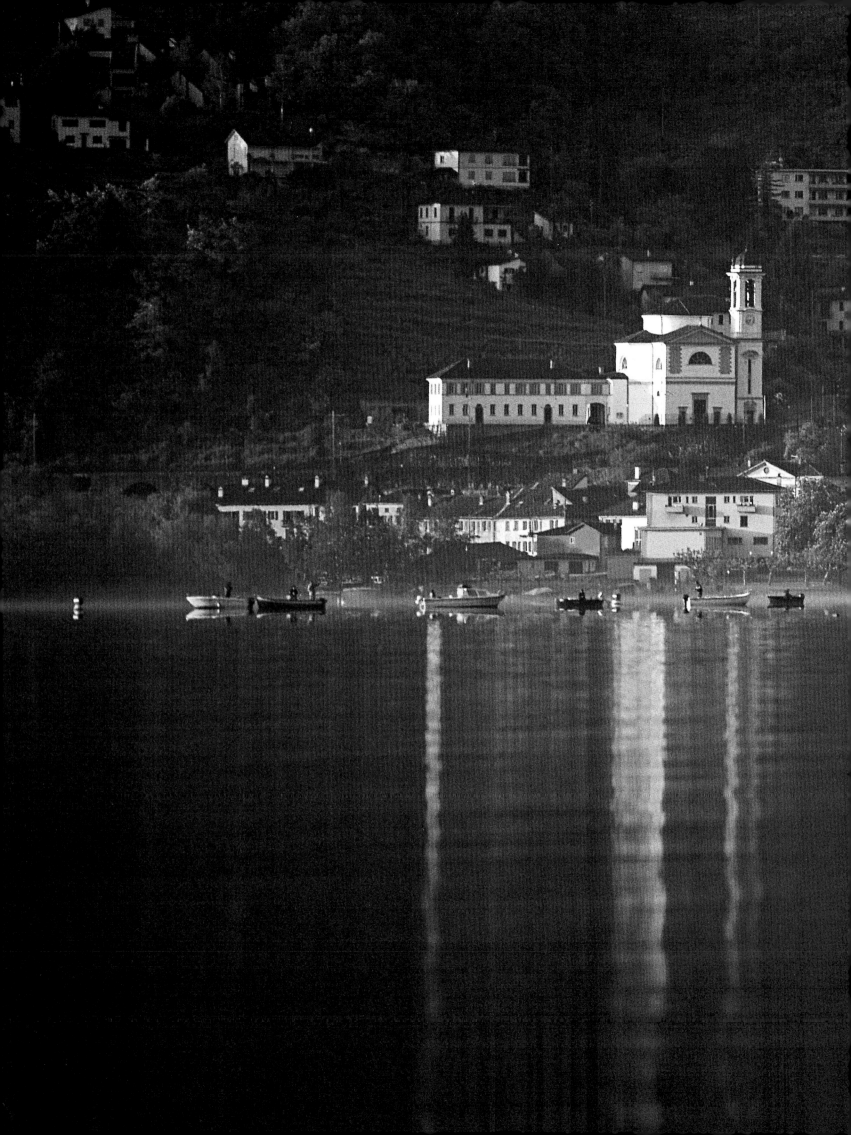

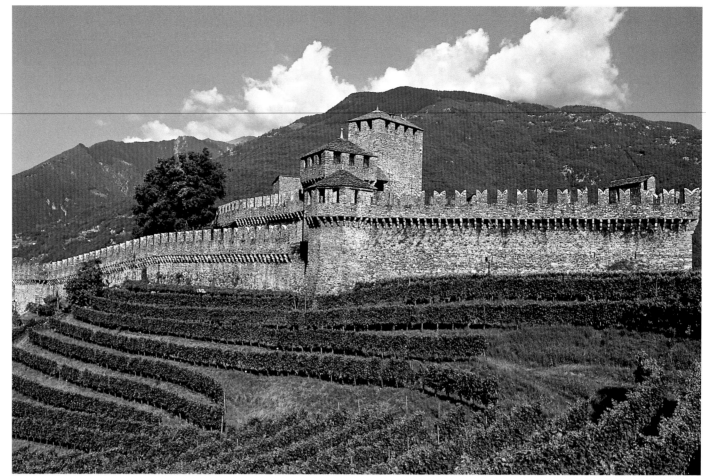

Like something
out of a medieval
epic the 13th-century
Castello di Montebello
positively dominates
the slopes of
Bellinzona, the
capital of Ticino. Its
strategic importance
in the battle against
the ancient Swiss
cantons prompted
the dukes of Milan
to turn to town into
a fortress. Their
efforts proved futile,
however; in 1500
the town fell to
the Confederates,
becoming part
of the canton of
Ticino in 1803.

18th-century
buildings, glorious
arcades, portals and
wrought-iron
balconies characterise
the old town of
Bellinzona. Squashed
in between the Alpine
passes of St Gotthard,
San Bernardino and
Lukmanier, the town
is most famous for its
three castles which
helped earn it a place
on the list of
UNESCO World
Heritage Sites.

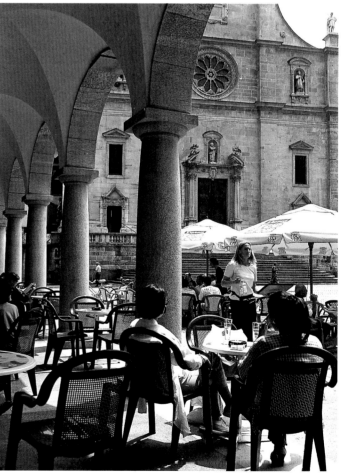

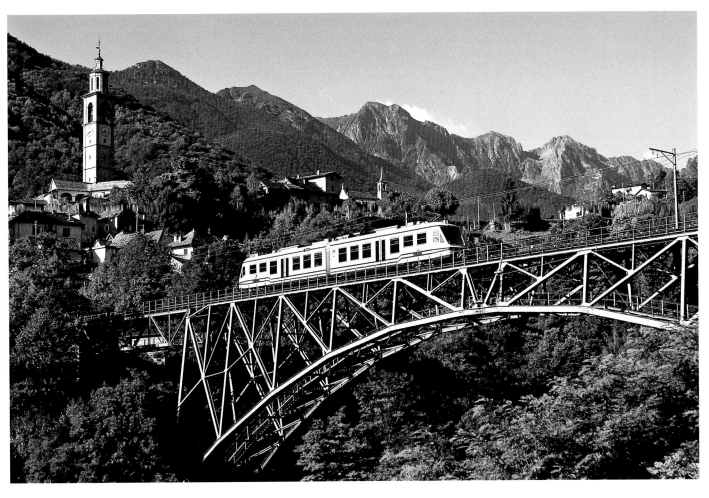

One of the best train journeys in Switzerland passes through the Centovalli. The metre-gauge Centovallina line takes in one of the most beautiful mountain regions of the southern Alps. Through countless tunnels and across numerous viaducts, through vineyards and along precipices of rock the trains wind their way from Locarno in Switzerland to Domodossola in Italy.

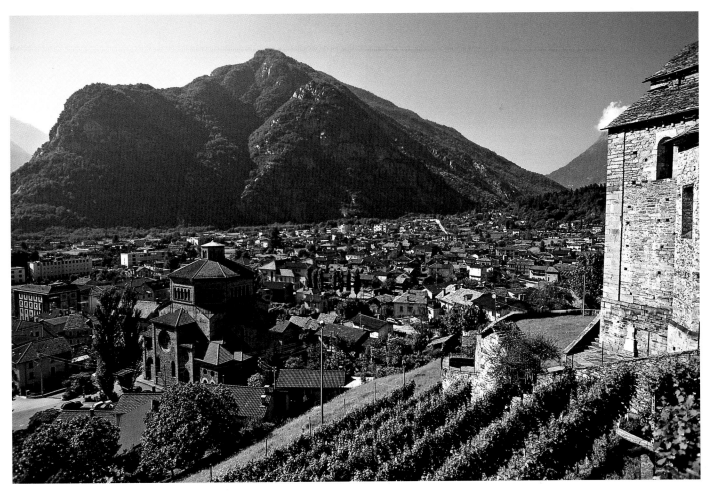

The little town of Biasca straddles the valley floor between the Gotthard and Lukmanier passes where the Ticino and Brenno rivers also converge.

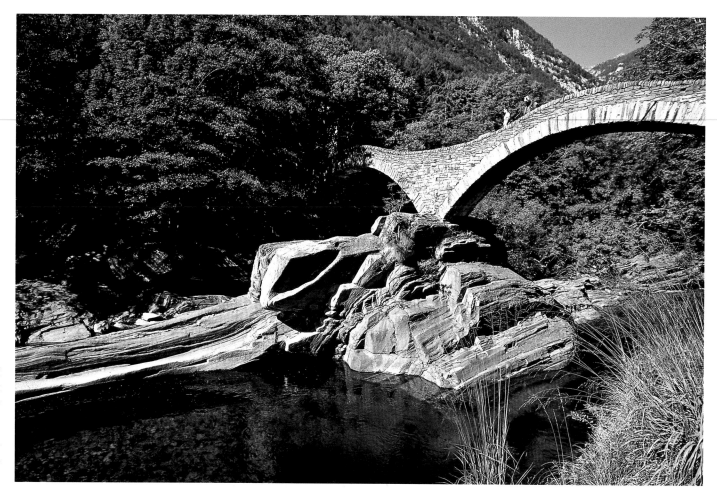

The Ponte del Salti is one of the most spectacular bridges in the Val Verzasca. Constructed from rough hewn stone, it dates back to the Middle Ages.

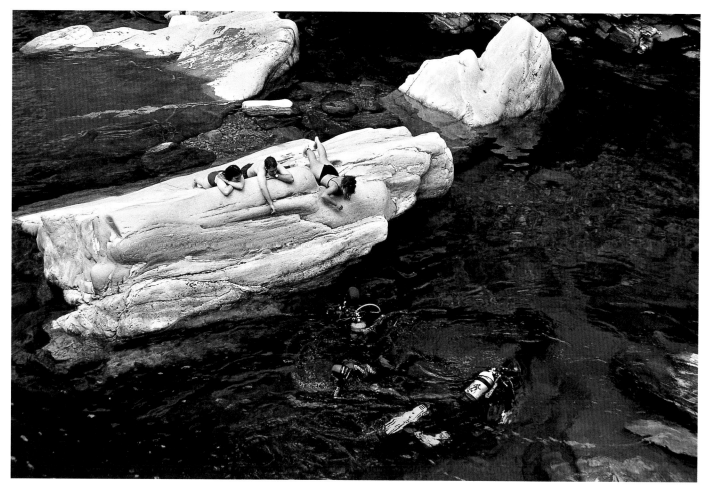

A bizarre rocky landscape lends structure to the frothing waters of the River Maggia and is one of the most striking of Ticino's many beauty spots. In the warm summer months the river is popular with bathers and sports fanatics.

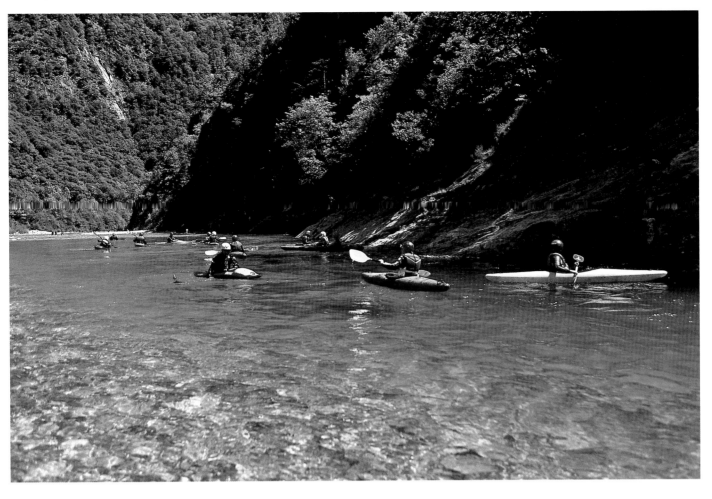

Its emerald green waters are the Maggia's major selling point. When the snows melt quickly or after a heavy summer storm this rather peaceful-looking rivulet can turn into a raging torrent in the space of a few hours. The raw natural force of the northern Alpine valleys forms a sharp contrast to the neat and tidy shores of Ticino's various lakes.

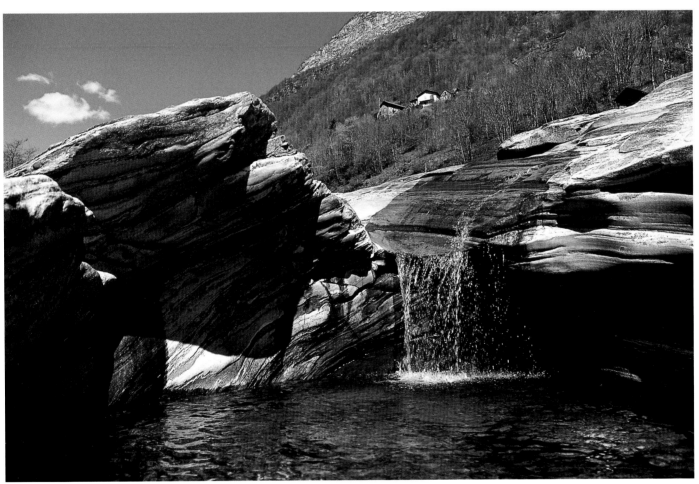

Val Verzasca in Ticino gets its name from "verde aqua" or green water. Together with the Valle Maggia and the Centovalli it's one of the three major valleys in the Lake Maggiore area.

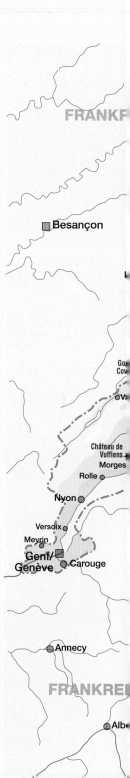

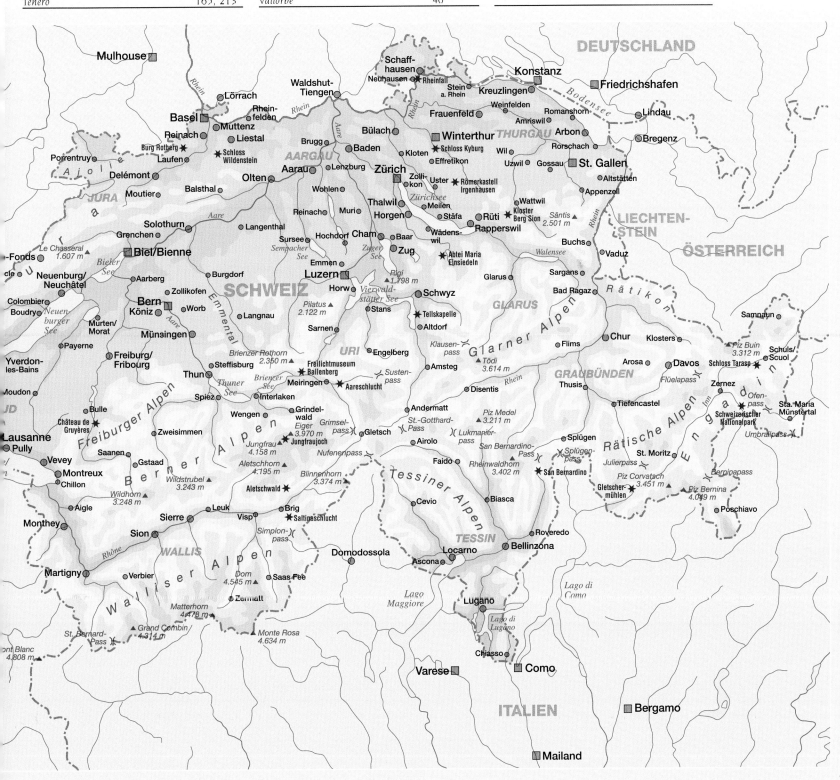

223

Design
www.hoyerdesign.de

Map
Fischer Kartografie, Aichach

Printed in Italy
Repro: Artilitho snc, Lavis-Trento, Italy
www.artilitho.com
Printed/Bound: Grafiche Stella srl, Verona, Italy
www.grafichestella.it
© 5th edition 2017 Verlagshaus Würzburg GmbH & Co. KG
© Photos: Roland Gerth
© Text: Reinhard Ilg

ISBN 978-3-8003-1872-8

Details of our programme can be found at
www.verlagshaus.com